DELTA JEWELS

DELTA JEWELS

In Search of My Grandmother's Wisdom

ALYSIA BURTON STEELE

CENTER
STREET.

NEW YORK • BOSTON • NASHVILLE

Center Street
Hachette Book Group
1290 Avenue of the Americas
New York, NY 10104

www.CenterStreet.com

Printed in the United States of America

WOR

First edition: April 2015
10 9 8 7 6 5 4 3 2 1

Center Street is a division of Hachette Book Group, Inc.
The Center Street name and logo are trademarks of Hachette Book Group, Inc.

The Hachette Speakers Bureau provides a wide range of authors for speaking events. To find out more, go to www.HachetteSpeakersBureau.com or call (866) 376-6591.

The publisher is not responsible for websites (or their content) that are not owned by the publisher.

Library of Congress Cataloging-in-Publication Data has been applied for.

This book honors the woman who raised me and loved me very deeply,
Mrs. Althenia A. Burton, my paternal grandmother. She stood in the doorways,
always watching her loved ones drive up or drive away. I know for sure
that I am because she was.

I am grateful to all of the giving, strong, independent, and loving Jewels
in this book for sharing such personal stories so that others could learn. I feel like
I have 54 wonderful new grandmothers.

I dedicate this book to all the strong matriarchs on both sides of my family,
but especially my loving and kind maternal grandmother, Mrs. Constance M. Larson
(Duncan), who always supported my education and growth. Oh, many memories
of museum visits and exposure to art. Thank you for all that you have done
and continue to do for me. I love you, Gram.

My mother, Ms. Stella Duncan, always believed in me, and when I was 15,
she would let me roam downtown Philadelphia to take photographs. You dragged
Angela (my little sister) behind me when I wanted to get street scenes. You always
told me I had "the eye." Thanks for believing in my dreams, Mom. Thanks for
loving me enough to have that little brown baby when interracial marriages were
frowned upon. You loved me before I was born and fought for me. I cannot
even tell you how much I admire your strength. I love you.

Aunt Tiny—Mrs. Marie Williams, Grandmother Burton's sister and the matriarch
of that side of the family—stay strong and know that I treasure you. My aunt,
Ms. Marie F. Burton, my big sister, my rock, you're the one who constantly pushed me.
Oh, the fights we had, but I know it was because you wanted more for me. I greet
your photograph every morning when I walk into my office. I talk to you almost daily.
You are sorely missed. My aunties, Mrs. Jane Larson and Mrs. Vicki McCargar,
I have always been close to and admire you both. You continue to inspire me
in ways you didn't even know. My cousin, Ms. Robin Williams, one of the most
giving women I have ever known, you are not my cousin, but my auntie.
To my aunt Patricia Wright, thank you for all that you do.

I am blessed to have very fond memories of my great-grandmothers:
Mrs. Marie Aiken, Mrs. Ione Kelly, and Mrs. Lillian Morris—all strong women.

A Delta Jewels scholarship fund is being established to honor the women featured
in this book. To learn more, please visit www.alysiaburton.com.

CONTENTS

Hugh Aiken · b. 1768

Ballymena, Ireland

William Aiken *(FAIRFIELD, SC)* · b. 1818
& Sarah Mann *(FAIRFIELD, SC)* · b. 1815

Louis Aiken *(FAIRFIELD, SC)* · b. 1836
& Ruthie Young *(FAIRFIELD, SC)* · b. 1855

David Aiken *(FAIRFIELD, SC)* · b. 1888
& Eliza Stewart *(FAIRFIELD, SC)* · b. 1888

Walter Aiken *(SPARTANBURG, SC)* · b. 1910
& Marie Edwards *(SPARTANBURG, SC)* · b. 1915

Althenia Aiken *(SPARTANBURG, SC)* · b. 1930
& William Burton *(HARRISBURG, PA)* · b. 1928

Walter Burton *(HARRISBURG, PA)* · b. 1949
& Stella Duncan *(COLORADO SPRINGS, CO)* · b. 1952

Alysia Marie Burton *(HARRISBURG, PA)* · b. 1969
& Bobby D. Steele, Jr. *(SAN ANTONIO, TX)* · b. 1966

TENNESSEE

Mississippi River

Memphis

Tunica

Dundee

61

Marks

Clarksdale

Lambert

Shelby

Tutwiler

Charleston

Mound Bayou

Coffeeville

Sumner

Tillatoba

Merigold

Webb

Cleveland

Drew

Benoit

Ruleville

Grenada

Shaw

55

Leland

Greenwood

Indianola

Greenville

MISSISSIPPI

Hollandale

ARKANSAS

LOUISIANA

ALABAMA

Yazoo City

Oxford

Tupelo

Meridian

20

Vicksburg

Jackson

Natchez

Mississippi was admitted to
statehood in 1817 as the 20th
state in the nation. It is the
32nd largest by land mass,
covering 48,430 square miles.

Almost 40 percent of the land
is farmed with a little more
than one million acres planted
in cotton.

Mississippi ranks 31st in the
nation in population density
with 2.9 million inhabitants.
It also has the largest African-
American population.

By many measures, it has the
most churches per capita and
ranks as the most religious.

Mississippi was the second
state to secede from the
Union in 1861 and finally voted
to ratify the 13th Amendment
in 1995.

N

W E

S

Gulf of Mexico

DELTA JEWELS

THE INSPIRATION

My paternal grandmother, Mrs. Althenia Aiken Burton, died in 1994. Although I've taken photos since I was 15 years old, I never thought about taking Gram's photograph or recording her voice when she was alive. When we're young, we think we're going to live forever and just assume our family will, too.

I missed her increasingly over the years. Time didn't stop my brain from trying to remember, having regrets, wondering what I could have done to preserve every single thing about her, before her ways, her tone, the color of her nail polish, her mannerisms, her looks at me became a shadow of a memory.

Gram was originally from Spartanburg, South Carolina, not too far from Aiken. My great-grandma Marie Aiken never talked about her upbringing, but their name, "Aiken," and roots made me think they were enslaved. As a Northerner, when I ventured to Mississippi to accept a teaching position in 2012, I saw cotton for the first time and began to wonder about my black family.

Gram Larson, my white grandmother, is amazing at family history. That side of my family knows our history from County Meath, Ireland. This photographic journey began because I wanted to connect with my black side, the black women of my grandmother's generation. How many picked cotton, were treated poorly, and took beatings? That's what I wondered when I saw the rows of cotton growing in the Mississippi Delta and took my first photo of it in 2013. I

have severe asthma and allergies, which worsened in Mississippi because all this greenery doesn't agree with me, but even with allergies, it's beautiful. It feels just like the cotton balls that I buy in a plastic bag at a drugstore. When I drove past the cotton fields, darn it if I didn't start thinking about my grandmother and how much I missed

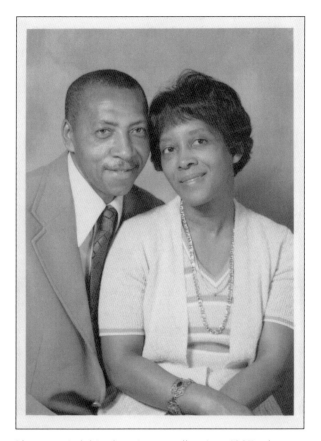

I have carried this photo in my wallet since 1987, when my grandparents, William and Althenia Burton, gave it to me. This was their 25th wedding anniversary photo, which was taken in 1972.

her. I wondered what she would think if she saw the cotton.

I had a successful career as a newspaper photojournalist and picture editor for 12 years. I was on the *Dallas Morning News* photo staff that won a Pulitzer Prize for its Hurricane Katrina photographic coverage. I was a picture editor on staff and called my supervisor before the storm touched down. "The storm sounds worse than expected," I told him. "I think we should send more staff." "You make a decision," he told me, and so I started calling the staff to see who would start the trek to New Orleans. As I photographed vast fields of snowy flowers, I wondered if Gram would be proud of my accomplishments, what she'd think of me living in the South, if Gram would be proud of me teaching at a university. She never wanted me to be a photographer. She worried I would not find employment and make a decent living. "How many black girls from Harrisburg made a living in photography?" she'd ask me. I would do anything to hear her voice one more time. How I wish I'd captured her image and voice.

"I could honor her memory by recording stories from other grandmothers of her generation," I said to myself. I began to interview and photograph grandmothers in Mississippi, my new home state. These Delta grandmothers are matriarchs to their families, like my grandmother. They are ordinary women, like Gram, who have lived extraordinary lives under the harshest conditions of the Jim Crow era and were on the front lines of the Civil Rights Movement. They are church women.

I needed help finding the women who would help me find memories of my grandmother and honor her. "Would you help me find black pastors who might introduce me to their 'mothers of the church'?" I asked Clarksdale mayor Bill Luckett, a white man. Bill e-mailed me five names and churches and told me that Rev. Juan Self pastors the first church where Rev. Dr. Martin

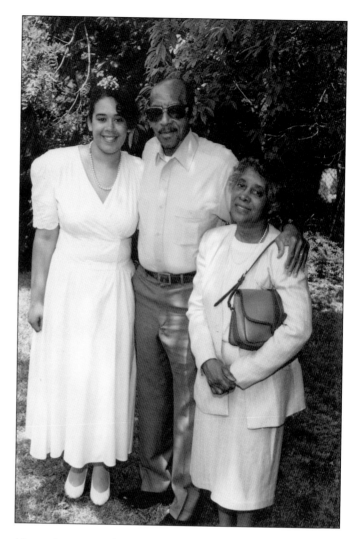

Me and my grandparents when I lived in Pittsburgh, Pennsylvania. This photo was taken in 1992, two years before my grandmother's death.

Luther King Jr. spoke outside Atlanta. Going to the church where King spoke gave me chills. Rev. Self is also the architect who renovated the Civil Rights Museum in Memphis. (The museum celebrated its reopening in April 2014.)

Rev. Self sounded young when we talked on the phone, and he asked, "What is this project you are doing? How can I help you?"

His youthful voice surprised me and I asked myself if he might be too young to help me find elder women. "I'm doing a book to honor my grandmother, the woman who raised me. She passed away 20 years ago, but I want to honor her by interviewing other people's grandmothers."

A close-up of cotton in a field on Route 278 East heading toward Clarksdale.

Silence for a second. "I have a mother in mind. She's our eldest. She's 105 years old. I will call her family and talk to them and call you back. Why don't you come to church, have dinner with my family, and talk to me more about this project?"

I agreed and we scheduled the soonest time he could meet—a Sunday two weeks away. That July morning I drove more than an hour to First Baptist Church in Clarksdale. The plaque outside noted King spoke there and the church was used for Civil Rights meetings. I nervously entered. During the service, I make eye contact with Rev. Self and with my eyes say, "Please don't make me stand up. Please don't make me stand up." I am a professor who commands attention when I speak, but still a true photojournalist. We do not like being the center of attention. But he asks me to talk. I start to tear up and my voice quivers as I stand and talk about why I am there.

I hear someone say, "That's okay. Speak. Go 'head, girl."

I tell them that I miss my grandmother and I'm doing a book to honor other people's grandmothers because I will never hear her voice again. I can't sit down fast enough and hide within myself, but when I'm done, I hear someone say, "Bless you." And I cry.

MRS. TENNIE (TENNESSEE) S. SELF, 89

CLARKSDALE
BORN MARCH 1926
MARRIED 29 YEARS WHEN WIDOWED
5 CHILDREN
15 GRANDCHILDREN
9 GREAT-GRANDS

The first person to greet me when I tearily attend that Sunday service at First Baptist Church is Rev. Self's mother, Mrs. Tennie Self.

"Good morning," she says, and hugs me, her nature welcoming, even with her raspy voice. I had no idea this friendly woman was his mother.

Service is in the church basement because they are renovating the sanctuary upstairs. We sit on foldout chairs. There's a good mix of elders and children. The choir is singing a slow hymn. I am getting weepy. The music warms my heart and takes me inside myself. After the congregation greets one another at the end of service, Rev. Self approaches me and we shake hands. "I'll be leaving in a minute. You can follow me to my mom's house." Outside, he and his wife climb into their black SUV and I drive behind them just a few miles west of the church to a well-manicured gray brick ranch with a two-car garage and bars on the front door. It's a nice neighborhood—all ranch-style homes, a better area of town where black folks live.

I follow the family through the garage and enter the kitchen to a welcoming spread of baked chicken, potato salad and fruit salad, cornbread, and candied yams, which Mrs. Self prepared before she went to church. She's known for her cooking. Everything is staying warm, wrapped in aluminum foil on the stove, ready to be served on her round kitchen table with ruffled cloth place mats. The house, full of people, smells like home. Rev. Self and his wife, his three sisters, and his niece with her family visiting from Portugal all sit at the table and Ms. Tennie joins us. I am getting shy; I didn't expect so many people. Sitting next to me is Mrs. Self's 11-year-old great-granddaughter Alyca, visiting Mississippi from her home in Portugal. Alyca is watching me. "You're a good person. I can tell," she says. The family gathered around the table then opens up with questions.

"Why are you doing this?"

"Where was your grandmother from?"

"Where are you from?"

"Where do you live now?"

"What do you do at the University of Mississippi?"

"What kinds of questions are you going to ask?"

Everyone takes turns asking me questions and I answer them all, and then show Rev. Self my portfolio on my laptop. "You're pretty good. I like your photography," he says. "I will help you. This is a good project."

I know Ms. Tennie, as I affectionately call her, is going to be a handful the first time I photograph her. She ends up giving me less than five minutes. She is wearing a bright red dress with a long strand of pearls. Her short hair is curled at the ends. She reminds me of Gram with her hairstyle.

"Where do you want me to take your photograph?"

"It doesn't matter to me, just make it quick." Ms. Tennie moves fast and doesn't like to be slowed

down. I thought she was going to give me more time, but after I take 13 photos, she says, "Hurry up and take the photo; I have food on the stove."

"I'm trying to take a nice photo. Please be patient." She looks at me. I don't say another word.

We are in her formal living room, where everything is in its place. I have her sit on the sofa because the big windows facing her cast light on her face. I don't want to use a flash or lights for any of the women. Recording their voices and using a digital camera are intimidating enough; I don't want to add another element. It's about the connection.

After our short photo session, she quickly walks back to the kitchen to check on the food. Nothing has burned, and she goes into her bedroom to change into more comfortable clothes. I just took my first photograph for the book.

I was excited as Rev. Self's mother began to talk with pride about her experiences when a car dealership refused to sell her a Cadillac and when she insisted on having "Mrs." next to her name in the local telephone book.

I went to a Clarksdale dealership to look at a car in 1949 or 1950, something like that. This Cadillac was sitting on the display, and I said, "Ooh, what a pretty car." Black folks didn't buy no Cadillac back then. This white man said, "C'mon over here and I wanna show you a car." He didn't want me to look at that Cadillac. I said, "But I like this." And he acted funny. I said, "No, I like this." I thought, I bet they'll sell me one in Memphis. So I went to Bud Davis Cadillac in Memphis and bought me a Cadillac! I drove past the business where they didn't want to sell it to me—"Toot, toot, hello!"—and showed them my Cadillac. It was a big one, a DeVille or whatever it was, and I would drive by there in the morning when I go to the post office so they'd see it.

⬩ ❖ ⬩

The telephone company wouldn't put "Mrs." by black folks' names. Put your first name down there and that's it in that book. So I went down there and told them, "Well now, you put the 'Mrs.' for the white folks' names and I'm a Mrs., too, I'm married, too. They didn't do nothing but change it. I don't know if I was the first, but anyway, I had it done. When the next one [book] came out, it had my name like it was supposed to be written. If you can write those white folks' names down as Mrs., you can write mine Mrs. After all, I'm married, too. What's the difference? That's what I wanted to know. I just—I'm just real vocal about things and I've never, never stood back.

"I've never had a problem speaking up for myself. I just speak," she says. "Especially during the Civil Rights Movement. I just speak, and if I have to die for what I believe in, then so be it." Her tone has changed from almost playful to stern. I know she means it.

One day, she says she parked the wrong way on the street while going into the post office. She saw Whites doing it, so she did it. After she left the post office, she drove down a street on the white side of town. A police officer followed, then stopped her, walked up to her car, and told her she was out of her area of town.

"I felt like he was just bothering me, so I drove away. He was talking and I didn't even listen to him. I was so mad I stormed into the police chief's office, walked right up to him, and said, 'I wasn't doing anything wrong. Call your dogs off. Don't start with me,' and I walked out of his office. Someone told my husband and he came home and said, 'Tennie, please watch yourself. One day you're going to say something and I'm going to have to defend you and we may get killed.'" She laughs as she remembers this.

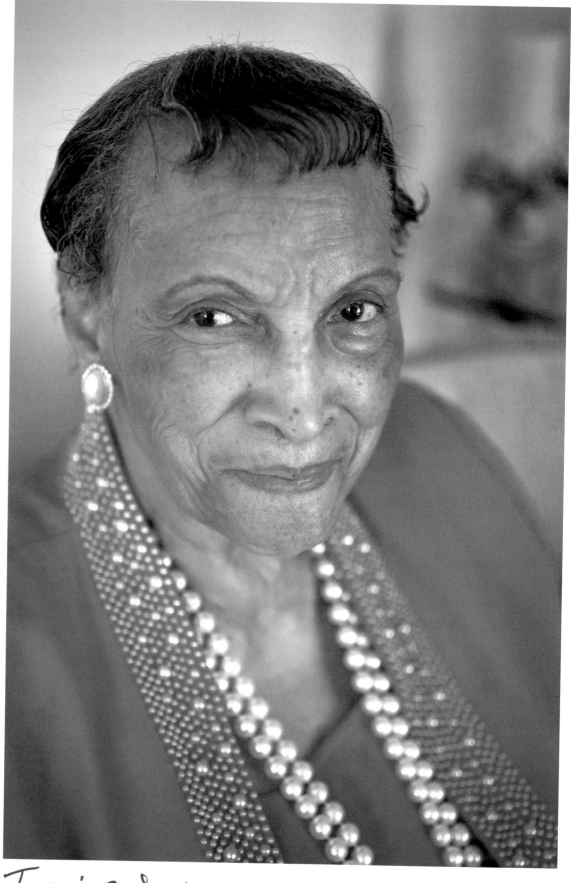

Tennie S. Self

MRS. ALBERTINE T. REID, DIED AT 105

SHERARD
MAY 1908–JULY 2013
MARRIED, 40 YEARS, TO LEDELL REID
8 CHILDREN
17 GRANDCHILDREN
30 GREAT-GRANDS
20 GREAT-GREAT-GRANDS

"I have a mother in mind," Rev. Self had told me during our first phone call. "Mrs. Albertine T. Reid is our eldest. She's 105 years old. I will call her family and talk to them and call you back."

I was elated as I waited to hear from him. When I finally spoke to Mrs. Reid's granddaughter Juanita Reid Virdure to make an appointment for the interview, she said, "Mama has been waiting for you, but Mama has taken a turn for the worse and is tired. Mama says she's ready to go home. We can schedule a tentative appointment. Call me the day before to see if Mama is up for your visit."

When I call back, Mrs. Reid is not up for the visit. "Thank you," I say, "why don't I call you another time? The last thing you need to worry about is me bugging you for an interview." She thanks me. I plan to call in two more weeks. During that time Rev. Self tells me that Mrs. Reid has died.

I don't want to call, but I want to show my respect. Mrs. Virdure starts to cry as she tells me that her grandmother passed away. "I'm sorry. This is just hard. She lived a good life, but it's hard," Mrs. Virdure says.

I start to cry, too. "I understand. It's been 20 years and I still miss my grandmother. The good thing is that she had you."

Silence. I hear her sniffle. I'm jealous of Mrs. Virdure for a fleeting moment. News of her death

reminds me how fragile and unpromised grandmother time is. I regrieve Gram. Right then I decide I will interview Mrs. Reid through her granddaughter's memory, and nine months later, I call Mrs. Virdure again. "Mrs. Virdure, this is Lisa Steele. I called you about your grandmother for my book last summer. Do you remember me?"

"Oh yes, I remember you. How are you?"

Mrs. Reid in 1929, when she was voted Miss Alcorn.

Juanita Reid Virdure for Albertine T. Reid
(granddaughter) *(grandmother)*

"I'm fine. I want you to know that I didn't forget about you. I am almost done with the book. Would you like to be a part of it?"

"Yes, thank you for calling. You would do that? I would like that very much. Mama had great stories. We know all of them. We have her history. You could use one of her photographs in the book."

Mrs. Reid lived on the family farm in Sherard, Mississippi, for 77 years—from 1930 to 2007—but the Virdures live north of Memphis in a well-manicured, upper-middle-class neighborhood of brick homes. Their home has an open design with tiled floors and big windows. There's cheerful peach paint in one of the rooms and family photos everywhere. Mrs. Virdure immediately welcomes me with a hug. Her husband, Ledell, introduces himself and invites my husband, Bobby, to have a drink on the wood deck in the backyard. Bobby looks like he's hanging out with an old friend, and I exhale as Mrs. Virdure sits down next to me and hands me a photo of her beautiful grandmother, Albertine Reid. Mrs. Reid was 105, her daughter is probably around 80, and this granddaughter must be about 60, although she seems younger. One granddaughter to another, we talk for almost two hours.

She had moved her grandmother from the Delta to live next door to her in Memphis. I was living three hours away, more than 200 miles, from Gram when she died. She has a book of her grandmother's photos and framed photos of her grandmother from her twenties sitting on a bedroom dresser.

I have been taking pictures since my youth, yet I don't have any of that. She knows stories about her grandmother's childhood. I don't know anything about my grandmother's. As happy as I am that she is sharing, I grow mad at myself for never talking to Gram *about Gram* all those wasted years I lived with her. I spent most of them being rebellious and fighting curfews. I didn't stop to learn how she came to be the kind and thoughtful woman I knew. I wished I could go back in time and not be that narcissistic teenager.

Mama [Mrs. Virdure's grandmother] went to a boarding school. Her parents wanted her to have a good education, so at 4 years old she went to boarding school in Moorhead, Mississippi. She said that it was a good experience. There were other little girls there the same age as she was. They each had their own little cot or bed that they slept on, with their little trunk at the foot of their bed with all their clothes in it. They came home for holidays and sometimes in between. They had to travel by wagon to get back and forth to school. They would warm bricks and put the bricks at the bottom of the wagon to put their feet on to keep their little feet warm. Her mother fell ill after my grandmother was delivered by cesarean section in 1908. She passed away when my grandmother was 12, but she fell ill after my grandmother was born. Mama was the last child born to her mother. Her older sister was born in 1890; there were 18 years between her and her sister and 8 years between her and her brother. And that was the other reason she had to go to boarding school: her mother physically was not able to take care of Mama after that.

Mama used to say she grew up knowing "God don't like ugly," and that she married her husband of forty years because he was a sweet man, well read, and loved classical music.

When Mama passed away, it was a beautiful moment. She called my mother to her chair [they live next door to Mrs. Virdure] and told her she was ready to go to bed. It was only 8 o'clock and my mother said, "You want to go to bed this early?" She said, "I want to go to my room. I want to go to my bed—to my room." She had gotten very feeble, so my mother called me to help put her to bed, like I did every night. When I went over, it was hard to get her situated because her arthritis had gotten so bad. I'd lay her down and ask, "Mama, are you comfortable yet?" And she'd say, "No, move this shoulder." So we moved that shoulder. I went to her back to pull her shoulders back some more and she sat up real quick and said, "Ooh." "Mama are you okay?" I asked, and she said, "I just can't breathe." I sat her up and all of a sudden her little head just drooped to the side, right on my shoulder. "Mama, can you hear me?" I asked. She didn't answer. It was a beautiful moment for me because I felt like she was where she wanted to be and where I wanted her to be. I had always told her when I moved her up here next door—which took some convincing, but I finally convinced her that they needed to be closer to me because her children were getting older and it was harder for them to take care of her or to take care of themselves—"Mama, this is your place. This is where you're going to be and I promise you that there will be no nursing home, there will be no assisted living, this is where you will take your last breath. I'm going to see to that, no matter what I have to do." That night, she just went to sleep on my shoulder. I sat and held her for a while, then I laid her back down on her bed and called hospice.

MRS. FLORIDA B. SMITH, 88

CHARLESTON
BORN JANUARY 1927
MARRIED 8 YEARS, FIRST HUSBAND
REMARRIED 16 YEARS WHEN WIDOWED
10 CHILDREN
29 GRANDCHILDREN
9 GREAT-GRANDS
4 GREAT-GREAT-GRANDS

"If there's anyone who can help you, it's Rev. Hawkins. He knows everyone. I've already talked to him about you. He's expecting your call," Rev. Self said, referring me to another pastor, Andrew Hawkins, who pastors Mount Olive Missionary Baptist Church in Mound Bayou. He answers my call with a jovial voice, and his reception of me isn't as hesitant as Rev. Self's was, perhaps because I've passed Rev. Self's test. He sounds older, and instinct tells me we will hit it off. Mound Bayou is an all-black town of about 1,500 people, just over two hours from my house. On my drive there, I pass one field after another. I'm a city girl; I have no idea what I'm looking at. Turns out it's soybeans, corn, or cotton. Those are the staple crops. Sometimes I make phone calls as I drive, but most

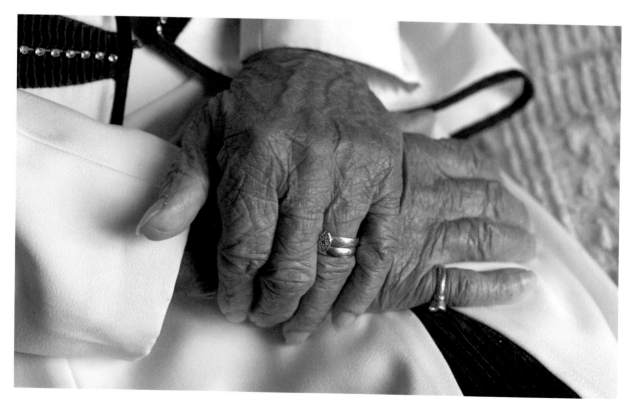

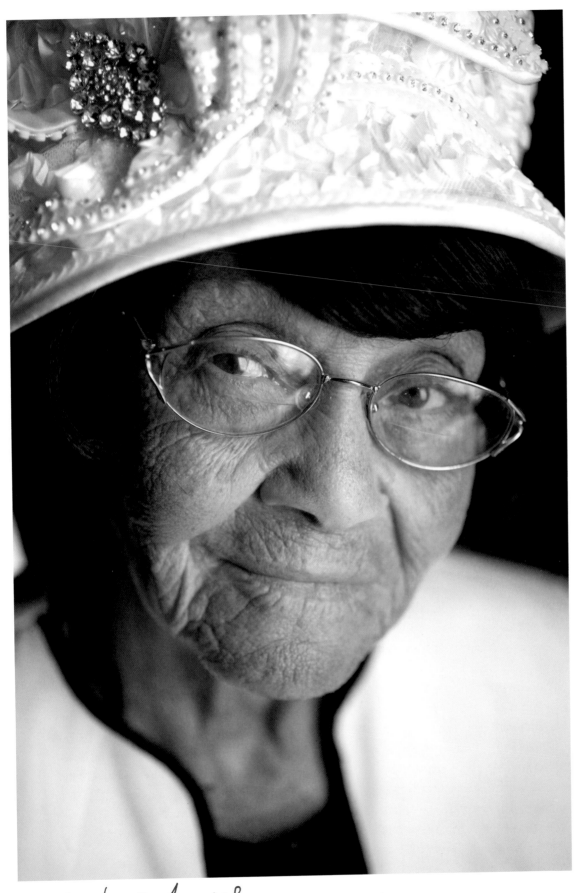

Florida B Smith

of the time I just drive, with no music. I enjoy the quiet. I have to pay attention to the little signs, for tiny towns like Alligator and Duncan. I'm aware of my surroundings.

I gave myself more than enough time to drive to Mound Bayou. (I'm an eager beaver. I like to arrive early.) I'm not sure what I expected, but there's no Dollar General, no grocery store, only a hamburger joint and a gas station that sells fried chicken and other snacks. An abandoned hospital across the street from Mound Olive appears under renovation. I pull into the church parking lot and wait for Rev. Hawkins.

Shortly after we meet, he tells me, "Mound Bayou is called the Jewel of the Delta. It was started by a few free Blacks in the 1800s. This is a significant town in Mississippi."

"I knew it was all-black but I didn't know it was the Jewel."

We talk about my upbringing, and I repeat the story I told Rev. Self about my grandmother, that I'm doing the book to honor my grandmother's memory. I never got her story from her, and so to honor her, I decide to interview other people's grandmothers.

He nods his head with understanding and decides to share some of his story with me. "I didn't initially want to be a pastor. I wanted to leave Mississippi and I did; I moved to Chicago. I went to college there. I could play the piano, and a pastor up there, a family friend, paid me a few dollars to play for the choir at his church in 1966. He was pushing for me to play on a regular basis. I resisted, but he kept after me. I went to play at rehearsal one night and saw this little bit of a woman walking down the sanctuary. And, well, I decided to play for them. I married that woman. We stayed in Chicago for several years and I moved back to Mississippi to be near my parents, who were getting up in age. We've been here ever since." Rev. Hawkins agrees to talk to some church

mothers he knows, and a few days later, I receive Mrs. Florida Smith's name.

I get lost driving to her house in Charleston. It takes me almost three hours to get there. I am frustrated, and my phone service keeps dropping. I have two other interviews scheduled for that day. I call Rev. Hawkins and he talks me through it.

Mrs. Smith has a fair complexion with deep wrinkles. She has strong eyes and a raspy voice. She's no-nonsense. I know people didn't mess with her. I'm nervous interviewing her.

One of the first things she tells me is that she was married twice and both husbands are dead. "I didn't kill them," she says.

I laugh. "Mrs. Smith, I didn't ask you if you killed them. Is there something you want to talk about?"

She laughs and says, "No, I just wanted you to know that I was married twice."

"Fine. It doesn't matter to me."

I stayed married until he died and I didn't kill him. [She chuckles.] He died in my lap. I had took him to the doctor. He used to smoke a lot. Doctor told him to stop smoking, but the harm was already done. So we came back home and he was sittin' right over there in the chair. He died in my lap.

He was lovely and kind, and he loved my children. So many good memories. I knew I was gonna be his baby 'cause he was 22 years older than I was. Got me an old man, old as black pepper. When he had to work, I knew he was comin' where I was. He wasn't goin' out there lookin' for nobody else. He made me feel good about myself. My life was sweet. He always told me he wanted to leave me where I wouldn't have to be with anybody for nothin': "You ain't gotta throw yourself away to get nothin'."

From what people call "in love," I ain't never been in love. The way I see it, if you love me, you

don't hit me. I don't let nobody do me like that. I had them understand, "If my momma didn't raise me, you can't. Now, I know we not gonna agree on everything but let's talk this thing over. Please don't hit me." I gotta lot of whoopins when I was comin' up. I was a little devil. I get into stuff and my momma would tear me up. But neither one of my husbands hit me. Neither one.

I would say to young women—think. Think before you jump and check things out. You don't know what you jumpin' into. Just because a person or a job looks good, ain't mean it's good. It might to be good to you but it's not good for ya. So think and then pray and ask for wisdom. And if you get something good, know how to treat it after you get it because a lot of people get something good, they don't know how to treat it until they have lost it. You can stay with a person for years and that don't say you know them. Things change. Good-lookin', tell you how beautiful you are, he's got his hair do'ed up and maybe driving one of them big cars. He the one! Well, he might not be the one. The one might come knocked-knees and slew-footed. He might be the very one that's gonna set you up top. That knocked-kneed guy. You want somebody not love you for what you got, but love you for who you are.

She's wearing a dress when I get there, but when the interview draws to a close, she doesn't want to be photographed in it. "I want to change for my portrait," she says. "I love me some clothes. My girls buy me so many clothes. They spoil me. I love shoes, too."

"Put on whatever you want. This is your photograph. I want you to be comfortable." I wait on the sofa while she goes into her bedroom and changes. She comes back out wearing an all-white skirt suit with a bejeweled white hat. She looks majestic. I think to myself, "I do believe I have my first diva in the book." She lets me take hundreds of photos of her. I have her sit on the corner of her bed, where soft light is coming through the curtains. She is a dream to photograph. Deep, heavy, intense eyes, but warm in nature. The way Mrs. Smith gently lays her hands on her lap reminds me of Gram. There's stillness in the moment she intently looks back at me. The pain of missing Gram hits me. I can see Gram's big eyes staring into my soul. I'm snapped back to reality when Mrs. Smith asks me, "Are you almost finished?" Those eyes must know a lot. I ask her if she was afraid when Emmett Till was killed. "Yes," she said, "everyone knew that the white people killed him." When I ask if she was afraid for her safety, she said she tried to stay away from Whites during that time. Then she shared something that shocked me.

"Mrs. Smith, did you say Whore's Lake? W-H-O-R-E?"

"Yes, I said Whore's Lake. W-H-O-R-E."

"What is that?!" My eyes are popped.

"The white mens [yes, she said that] would rape and kill black women. They would tie bricks around their bodies and dump them."

"What?" I ask, disgusted by this information. "Did you know anyone who died like this?"

"I didn't know anyone, but my second husband knew some of the women who were killed. He knew them."

"Where is this lake?"

She gives me directions. I'm not sure I understand where to go, as she doesn't give me route numbers or names. I don't write down her instructions. I'm not sure I want to know. It's another ugly reminder of harsh Mississippi history. Later I look up Whore's Lake and find some written history, which no one talks about; at least, that's my impression. I call Rev. Hawkins: "Rev. Hawkins, Mrs. Smith just told me about Whore's Lake..." My voice trails off.

"Oh." He sighs. "Yes."

MRS. KATIE M. RICHARDSON, 88

TUNICA
BORN AUGUST 1926
MARRIED 49 YEARS WHEN WIDOWED
12 CHILDREN
30 GRANDCHILDREN
42 GREAT-GRANDS
2 GREAT-GREAT-GRANDS

Mrs. Richardson is a woman of long-enduring relationships. She started as a private cook for a family in 1947, and continues to cook for them. She and her husband, Nathaniel Richardson II, founded the Friendly Gospel Singer group with her children, which performed from 1965 to 1994. "If I had to marry again, I'd choose him," she says of her deceased husband, to whom she was married 49 years.

When I pull up to the driveway of Mrs. Richardson's home, she is wearing jeans, a sweatshirt, and baseball cap. No smile from her as I get out of the car to introduce myself.

She greets me with a nod and a simple hello. Her daughter Larry Etta is with her. They walk to the front door. "C'mon in," says Mrs. Richardson.

I follow them in and sit on the floor while Mrs. Richardson sits on the sofa. There are blankets and extra pillows behind her. As Larry Etta gets ready to leave, I say, "Please stay. Don't you want to hear what we talk about?"

"Yes, but I didn't want to interrupt."

"Oh no, please stay. I like it when the children and grandchildren stay. Sometimes they remind the mothers of stories they've forgotten. I like it when family are around."

Sure enough, Mrs. Richardson talks about picking cotton and how hard the work was, but she neglects to mention one horrific detail. "Mama,

did you tell her about the dead animals they'd put in your drinking water?"

I'm so shocked by this, my mouth hangs open.

"Oh yes, girl, they did that to them," Larry Etta says, shaking her head. I hear her suck her

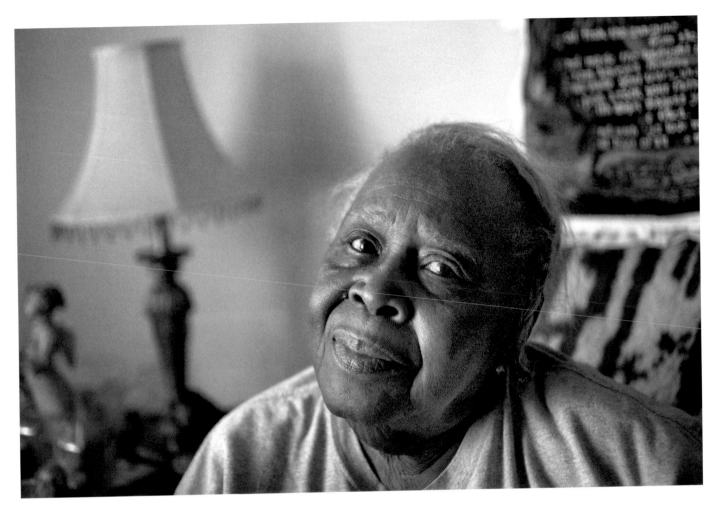

Katie M Richardson

teeth as her mother shares a memory from the days of picking cotton:

The [white] agent's two sons didn't work, but they would pump water and bring it to the field for us [Blacks] to drink. They were water boys; they brought barrels of water, everybody picking cotton drank out the same barrel. My daddy caught them boys in the barrel taking a bath—in the barrel!—getting cool 'cause it was hot. They were cooling off in our drinking water. We had to drink that water. That's all we had. I was getting 15 cents a day. They used to drop possums down in the well. We had to drink that water. I would get a little bucket and carry some water out with me.

This is so painful to hear. By the time she finishes this story, I am crying. I am ashamed that I am half white. I don't have the guts to ask her how she feels toward white people; I'm not prepared to hear the answer, so I let it go. Tears fall down my cheeks. I oftentimes wonder if the women see me as a black or biracial woman. I wonder if they are comfortable with me. Then as I sit in her hushed living room, she describes the tornado that killed three of her children on February 5, 1955:

The day before the storm, I had seven living children. Three children was at school and the rest were at home with me. All of them was outdoors playin'. The day before the storm, my son Nathaniel Junior, he was 7, was crying. He

used to always see things. We got used to him seeing things. He come in the house, and I said, "Every time somethin' always happen, you see somethin'. What you see now? What you see now?"

I said, "Go back outdoors and play."

He said, "I don't wanna go back outdoors and play, Madea, let me go back in the other room."

I said, "For what?"

He said, "A tornado comin', a storm comin' and gonna kill all of us."

"I told him, 'Oh no, you don't know what you talkin' about. Go back outdoors.'"

He went to cryin' so, I told him to go on back in the room and just hush.

The next morning about 11 o'clock, tornado came. My husband went back to work at the Leathermans' [the family they worked for] before the storm come. They live in a big, great house on the mound, the hill. Junior was in the back room. I grabbed him. I grabbed Dorothy. I had the baby, Katie Joyce, on the table in a box. Dorothy said, "Get the baby, Madea, don't leave her on the table. Don't leave the baby."

I said, "I can't carry all y'all." I put Dorothy between my legs. I was tryin' to get in the back room. We all scattered in different directions. Dorothy said, "Hold me, Madea."

I said, "I can't." At that time my arm went down and broke. I had gashes. Junior blew out of the house. A stick went through him.

I was runnin' around tryin' to find my childrens after the storm, when the Leathermans come down. I went to their house and they bathed me and put some clothes on me in the bathroom. When I came out their house, I could look down and see people at my house. I runned and someone said, "Don't look, Katie Mae. Larry down there with half his head cut off." Told me I had to get away. The ambulance and things comin' from Hernando, everywhere. Back in those days the ambulance was the hearse. Me and my husband were in the ambulance with Essie Mae on the floor. Essie Mae screamin, cryin' for her daddy, cryin', "Daddy, Daddy, Daddy, Daddy, ohh Daddy." She died hollerin' for her daddy. They got me to the hospital. My momma got Junior, the one with the sick in him. She wrapped him up with a bedspread. The bedding on my bed now, what Momma wrapped him up in. The doctor come in and give him some medication and broke the stick and pulled it out both ways. Junior lived for a couple days. The storm took an effect on Katie Joyce. She was the baby and they said breathe stayed away from her for too long. She was about 3 years old before she walked or did anything, she didn't talk. I had three childrens killed in the tornado. Essie Mae, Larry, and Junior.

"A tornado comin', a storm comin' and gonna kill all of us."

MRS. LILLIAN B. MATTHEWS, 87

INDIANOLA
BORN FEBRUARY 1928
STILL MARRIED, 62 YEARS, TO REV. DAVID MATTHEWS
1 CHILD
5 GRANDCHILDREN

Rev. and Mrs. Matthews have a lovely home. I can tell they've lived there a long time. Family photos are everywhere. From the garage, I enter a TV room, where Mrs. Matthews greets me. She's wearing an apron, baking fruitcake cookies. It smells like comfort. The TV is on.

To the right is a wall with a built-in bookshelf full of cookbooks. Through a doorway to the left is the formal dining and living area. It's after Christmas, and her fine china and silverware are sparkling at the dining room table. Each seat has a full setting with formal white cloth napkins in Christmas-themed napkin rings. A huge crystal chandelier above the table is unlit, and light coming through the curtains causes rays to shine on the walls.

I don't see Rev. Matthews, who's run an errand.

Mrs. Matthews and I sit at the dining table. "What about your childhood would you want people to know about you?"

"I love basketball. My brothers and I—we taught each other." She tells me that she moved from the hills of Mississippi to the Delta when she was in the ninth grade, but she started playing ball in the hills. "We would walk to the different schools and play the game. Wasn't no such thing as a gym, we played outside. I could play any position—forward or guard, or whatever—and I loved it so, they called me 'Bad Banks' [her maiden name]. I mean, I had to put my hand on that ball."

She tells me the girls played against the boys in her family. She didn't get to play ball in college at Valley State in Itta Bena, Mississippi. They didn't have girls' basketball. When she was a teacher, she also coached the girls at school. "I was a coach for the girls—about 17 years—when I was teaching, and, baby, we didn't lose no games." She chuckles. She retired after 33 years as a home economic teacher.

She also talks about the team she organized at her church in Indianola. "The mothers didn't like it too much, but we wasn't doing nothing but playing. We played basketball and we played softball. They didn't think we should do that to lead the young people in church, but I said, 'The Lord understands, we wasn't doing nothing but developing our bodies.'"

When I ask her if they played basketball with any white children while growing up, she says no. "Whites rode the bus to their school and we had to walk to our school. When they had their friends with them, well, they would throw rocks at us. They didn't want their friends to know they associated with us. They would come to our house, eat with us, and play with us, if their friends weren't around."

I muse on her glowing testimony about marriage, and then Mrs. Matthews moves on to a much heavier subject—voting in Indianola.

I've been married 62 years, 62 sweet years. My husband is so gentle. He just loves me to death.

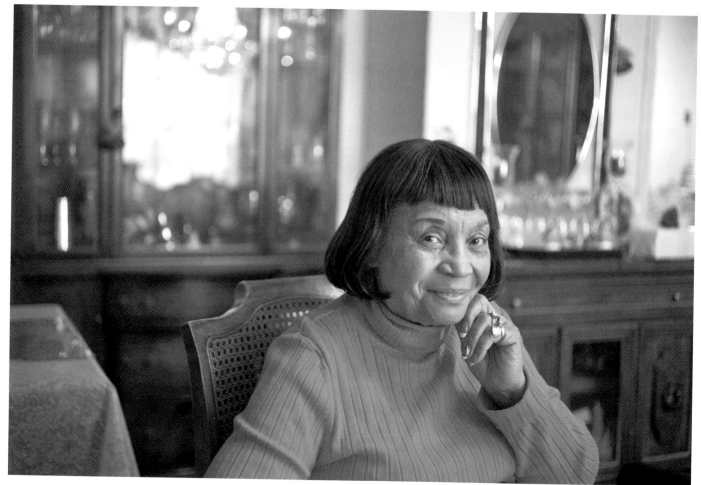

Lillian B. Matthews

We love each other. They call us the lovebirds. When I first met Rev. Matthews, I ran from him and he just ran me down. So finally he came down to my home. My sister-in-law's mother was there and she said to him, "Nobody here but Lil and me."

He said, "That's who I wanna see." So, he came on in, sat down. I sat at one end of the couch, and he sat on the other side. I was so excited and scared. He said, "I'm lookin' for a wife and I don't want no long courtship."

I said, "What?—Oh, Lord. I really don't want no minister for my husband and the reason for that was, our house was the minister's house and they [all the ministers] would all come in and eat up all the food from us and sit there and argue about the Bible and start eatin' again until they eat everything off the table. No, I don't want no minister."

"Well," he said, "I'm a modern minister."

But anyway, we fell in love and from there we went on. He's just so soft and easy.

• ❖ •

The first time I voted, of course, they [Whites] didn't want to us to vote anyway. Had us pay poll tax, and all that, but still couldn't vote. We were the only two, my husband and I, and one or two other [black] people here with good reputations, were allowed to vote. Just anybody [black] couldn't vote.

The mayor's wife and I were tallying votes,

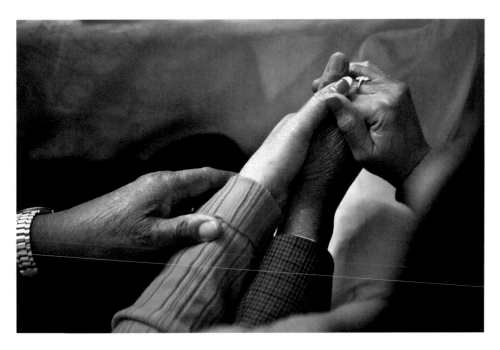
A tender moment with Reverend Matthews holding Mrs. Matthews's hands during our interview.

"Rev. Matthews, would you like to join us?" I ask. "Perhaps tell me why you chose this lovely woman to be your wife?"

He smiles when she looks at him, dotes on her. He grabs her hand and tells me their story about asking for her hand in marriage. She has long nails that are polished with red and white Christmas designs. I stand over them: "I'm going to take this photo. Don't stop. Just continue to hold her hand. This is lovely." It's as if they're playing music with their bodies as I watch them move closer and lean into each other.

As I shoot, he tells me he's a Morehouse man. He went to college when Dr. Martin Luther King Jr. was there. "What was he like? What story would you tell us that no one else knows?"

All he says is, "Well, Dr. King was an average student."

I chuckle and watch their expressions of deep-down love. He lets her walk in front of him, and he ushers her with his arm on her lower back. I think about Gram and Pop-Pop's marriage. Even until Gram's death, Pop-Pop always held her hand. They'd walk down the street and he'd hold her hand. They'd sit on the sofa and he'd reach for her hand. One time in high school I caught them making out in the kitchen. He was kissing her in the middle of the kitchen by the sink. "Ugh. Gross," I remember saying, and walked out. I feel happy I have those memories. Pop-Pop was giving Gram a bath when she was dying of cancer, and I leaned against the closed door to listen to them. I heard her say in her soft voice, "Oh, Bill, thank you."

you know, takin' the names down and puttin' it on the book, and she always referred to us "Nigras." She pretended she couldn't pronounced Negroes. When she called us Nigras, I stopped and I said, "The word is 'Negro.'"

She said, "Well, I can't say that, I have to say like I say it anywhere else."

I said, "Well, we don't like it like that." I didn't take it any further, I just let her know I didn't like it.

A lot of things, we went through. In the courthouse, they had the black fountain for the water—Well, it said, "Colored"—and the one for white. Well, I just decided I wouldn't be thirsty. I didn't drink out of the place. I said I'll work all day without water. We couldn't use the same restroom. I didn't like that. I couldn't change it myself, but time did.

An hour or so later, Rev. Matthews returns. He's a handsome man, about six feet tall. He has a trimmed mustache, his wavy hair brushed back high off his forehead. I imagine he was quite the looker when he was younger because he's striking now.

MRS. LILLIE B. JACKSON, 88

TUTWILER
BORN JUNE 1926
MARRIED 61 YEARS WHEN WIDOWED
13 CHILDREN
40 GRANDCHILDREN
43 GREAT-GRANDS
6 GREAT-GREAT-GRANDS

It's a summer day with clear blue skies. I'm listening to music while driving either to or from a grandmother's house. I'm still learning the Delta region, and I get confused about where the Jewels live. I've just put a Kool & the Gang CD into the player and am listening to "Too Hot." My phone rings, and it is Mrs. Lillie Jackson from Tutwiler.

"Hello, Mrs. Jackson. How are you?"

"What are you?" demands Mrs. Jackson.

I chuckle, knowing exactly what she means; she wants to know what race I am. "I'm biracial. My mother is white, my dad is black, but I identify as a black woman."

"That's okay," Mrs. Jackson replies. "I just needed to know who was coming to my house. We got some of them, too," she says, referring to her own family, before hanging up.

I holler laughing. I love that these women just say what they're thinking and they hang up. Some say "good-bye" and a few say "I love you," but most just hang up when they're finished with a conversation, no matter how brief.

I love Mrs. Jackson—straightforward, just a bit of attitude. I'd been trying to get her to interview with me for months. I expected a sweet, little old church lady—and she is that—but oh, she's got spunk! She didn't want to interview then, but I left hopeful.

When we finally sit down, she says, "I can't imagine what you want to ask me. I'm not important."

"You are most certainly important. All of you mothers are. I just want to ask you some questions about your life. I want to record your stories so your children, and their children, and their children will know you. We want it in writing. Is that okay?"

"Yes, it's okay, but I'm not important."

I learned that her husband was the funeral home director who prepared Emmett Till's body.

"He never talked about work when he came home. He never brought it up. Didn't like to, he just didn't let things get to him," she says.

"Were you ever afraid of white people after that—before that?"

"I was never afraid of them white folks!" she says, shaking her head. Mrs. Jackson clearly wants to use a few choice words, but she doesn't fully say them. I know what they are, and I chuckle. "But that's why Tutwiler so scarce now 'cause when everybody heard about Emmett Till, folks was leaving here," she says, referring to the fact that Blacks moved away from Tutwiler after Emmett Till was killed. Mrs. Jackson lives in Tutwiler. Emmett Till was killed in Money, Mississippi, which is about 30 miles south of Tutwiler. The torture to Emmett's body spooked everyone. So much so, people moved away from Delta towns.

They [stores] sold out all the luggage. Couldn't find luggage no way around here. People puttin'

they thangs in cotton sacks. People was leaving everythang. We used to pick cotton out there on that plantation and folks left they house—everything, furniture, everything. They left with just they clothes. Folks was leavin' and goin' to Chicago wit' they kids. They was just scared for their chil'ren, that's why they was leavin'. They figured if they done that child that, they would do somebody else's chil'ren like that. Everybody who had chil'ren left Tut-wiler. A lot of my friends in Tutwiler left. They went all over the country and every which way. But I wasn't afraid after Emmett Till.

My husband worked for the funeral home. He picked them [bodies] up, embalm them, take them to the cemetery. His bossman, he owned the funeral home in Tutwiler. Bossman called him [my husband] for to go pick up Emmett Till. He couldn't go by himself. He couldn't go alone.

He had to have police escort him. After he did the body, he took him to Memphis and put him on a train then from there sent him back to Chicago. Now, I'mma tell you, my husband, he didn't like to talk about it, stuff like that. He kept it to himself. He was upset. He was really upset.

"Did you worry about your sons after Emmett Till?" I ask.

No. My boys was younger. I tried to teach my children the right way to go. Bring 'em up in church. Love them. I try to do the best I can—what a mother supposed to do. I loved my kids. Still do now. Don't nothin' come before my kids. My kids always come first. If I had food and I didn't have enough, I would let them eat first. If they left anything, I'd eat. If they didn't, I would just wait until next time.

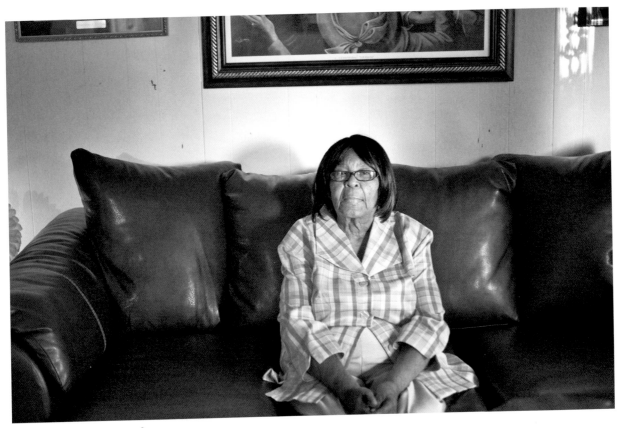

MRS. DELORIS M. GRESHAM, 64

DREW
BORN JULY 1950
STILL MARRIED, 43 YEARS, TO REV. JESSE GRESHAM
5 CHILDREN
14 GRANDCHILDREN
3 GREAT-GRANDS

"I don't want to tell a story. I have a story, but I don't want to be in your book," Mrs. Gresham tells me when I phone her. But she keeps telling me stories while we talk on the phone.

"Mrs. Gresham, I know you want to be in this book. You know you need to be in this book. I know you have stories and I can tell there's something you're not telling me."

Silence on the phone.

Several people in the Delta have asked if I've interviewed Mrs. Gresham. I reply that she keeps telling me no, but she's helping me find more women to interview. Rev. Hawkins tells me I must include Mrs. Gresham. "She keeps telling me no, Rev. Hawkins." He says, "Keep trying."

Mrs. Bearden, another Jewel, tells me Mrs. Gresham is the same age as one of her daughters, so I know she is much younger than most of my Jewels. Perhaps she's refusing the interview because she doesn't want to be viewed as old.

Teaching a full load of classes and doing this traveling, transcribing, editing photos is wearing me down. I'm tired and irritable. Bobby tells me to buckle down and finish. Rev. Hawkins and Rev. Self pray me through my frustrations. "Maybe I should lower the age for the book. Maybe I should make it 65 and older," I suggest to Rev. Hawkins on the phone.

"Well, if you do that, I can give you more women. I know younger women who have stories.

What you need to do is get Mrs. Gresham," he says.

"What is her story?" I ask.

"You have to ask her," he says.

"She keeps telling me no."

"Women keep canceling appointments," I whine to Rev. Self. "Maybe I should stop now? This has been a long road and it seems like it is falling apart." I start to cry.

Rev. Self tells me, "Do not to let the devil win. I'll reach out and find some more women for you to interview. I have a family friend, Mrs. Curtistene Davis, who lives in Leland. I think she can help you out."

Strengthened, I call Mrs. Gresham again, the fourth time.

"Hello, Lisa."

"Hello, Mrs. Gresham. I need to interview you for the book. I know you have a story and you know you need to tell me. I lowered the age for the book. I'm interviewing Ms. Myers next week."

"Okay, Lisa." She sighs. "You know some people from the Library of Congress contact me for my parents' story. I got a certificate. I will be in your book. Besides, I can't have Ms. Myers in the book and I'm not in the book. I referred her to you."

I have both of them scheduled for the same day. I interview Ms. Myers first. Then I head to Mrs. Gresham. She doesn't like to be photographed. She turns her head to the side and cuts

her eyes at me. After I take ten or so photos, she says, "That's enough. You have enough shots."

"I like to shoot a lot of photos. I'm not sure that I have it. Be patient with me. I want to give you my best," I plead.

"I don't take good photographs. I don't like to have my picture taken."

"I don't either, Mrs. Gresham, but I promise to use a nice one for the book."

I move closer and stand over her.

"You're making me uncomfortable. You're too close."

"Just be patient. I'm almost done. Just relax as much as you can," I say.

She doesn't think she's pretty. She's gorgeous, and I keep clicking. She continues cutting her eyes at me. She must see and approve the photos before I leave, and insists I delete the ones she dislikes. I delete one or two that I don't like, but I refuse to delete the rest. I already know that I'm going to use one of her cutting her eyes at me, especially after I hear her story.

The most pivotal moment in my life was growing up without my parents because of the tragic day in their lives when my father was murdered by a white man. He [the white man] asked for a full tank of gas and said, "No, I didn't ask for a full tank of gas. I asked for $2 worth of gas." My father told him, "No, I distinctly heard you ask for a full tank of gas." The service station owner said, "Yeah, you did ask for a full tank of gas." The white man, Mr. Elmer Kimbrell, said, "You got a smart-ass nigger working for you. Don't be here when I get back." After Kimbrell left, the service attendant said to my father, "I'll tell you what, why don't you go home and we'll take care the rest of the night." So, he was about to leave. He was getting gas because he was going to take his mother to Greenwood to the train station because she was going to

Chicago. He gets in the car, getting ready to leave, this guy drive up and just start shooting. He shot my dad in the hand and in the head. He threatened one of the other workers 'cause he said, "Don't do that. Don't shoot him." And Kimbrell told him, "If you get in my way, I'mma shoot you, too." The other man ran into the back of the store. I read, and I'm not sure how this happened, but he did end up with a bullet wound in the shoulder. They wanted to say that my father shot him, but they could never find the gun. Mr. Kimbrell ran when he did it.

After my father was murdered, four days before the trial, my mother, Beulah; my oldest brother; and I were in the car together. All of a sudden we end up in the river. I think we were forced off the road. The car was turned upside down. I remember distinctly my brother telling me, "Water gettin' in my face, water gettin' in my face." I kept feelin' around in the car until I found him. I pulled him up close to me and I told him, "Just hold on, hold your head up, keep your head up." I was searchin' for the door lock. The door was locked. By that time I heard somebody outside. I was feelin' the inside and I could feel my mother's face, but she wasn't movin' or anything. I found the lock and unlocked the door and someone let us out.

Just like Emmett Till, he [Mr. Kimbrell] was acquitted. The same people that was involved with my father's death were involved with Emmett Till. They had an all-white jury. You know, if I had my way, I would convict the jury because they're guilty. They know that he did it. They're just as guilty as he is. They're the one that let him go. I'm sure they have a conscious, I'm sure. Everybody got a conscious and I'm sure this has been on some people's mind for a long time.

I remember that day, I remember the night that my aunt came to our house and told my

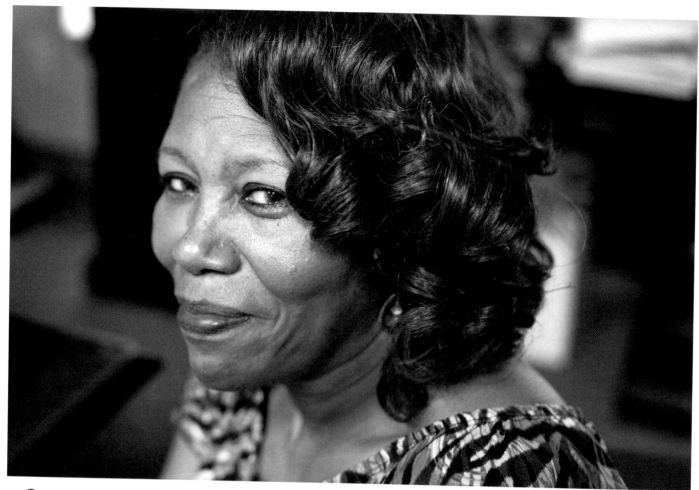

Deloris M. Gresham

mother. It was a rainy night, I remember that. I can tell you the house we were living in, how the furniture was arranged. I remember when my dad used to come home, I used to get angry because first thing he picked up was my sister. I wanted to be first. If I could tell my dad anything right now, I'd tell him now how much I love him, how much I miss him. You know how girls are about their dads? I look at my husband and his girls. I'd tell my dad, hey, I kept the faith. I never doubted God and I know through it all, He brought us through. You know, my aunt raised us, I know that she loved us, but it was something different without having that mother and father there. I used to wonder, God, why did You let us live? But later in life, I realized what it actually was—that He had a purpose for us. For me, especially, because I been a caretaker to a lot of people and I think that was His purpose for me being here. I just thank God for that purpose.

My baby brother was, like, 8 months old. It was so ironic, years later a film director who was doing a movie on Emmett Till showed us a video recording of my mom. And for the first time my baby brother got a chance to hear her voice. When he looked at it, he asked me, "Lois, whatcha' doin' in that black-and-white picture?" I say, "That's not me, that's your mom." He say, "Is that the reason why I love you so?" He thought Mom was me.

MS. JOYCE DIXON MYERS, 66

RULEVILLE
BORN JUNE 1948
MARRIED 10 YEARS; DIVORCED
2 CHILDREN
3 GRANDCHILDREN

The same day I met Mrs. Gresham and relived the racist, still unpunished murder of her parents, I was uplifted by this retired teacher, who currently works part-time at Parks Elementary in Cleveland, Mississippi. She teaches the English language to foreign students every day and loves it.

Ms. Myers sees me pull up. She has just returned from a trip to Atlanta and is across the street collecting mail from a neighbor. She is wearing a colorful silky robe and has on lounge clothes underneath. Youthful, with a mocha complexion, she has very few, if any, wrinkles. Her relaxed, shoulder-length dark brown hair is in curls that bounce when she walks.

A neighbor is with her. He is about the age of my father. He immediately starts flirting with

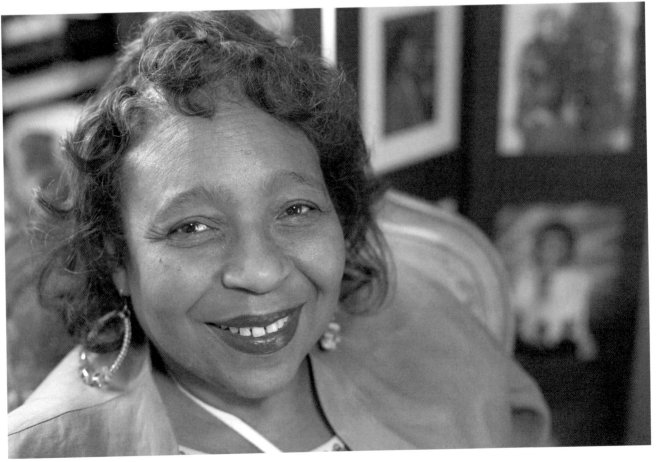

Joyce Dixon Myers

me as I pull my photography gear out of the car. "Good morning," he says, giving me that once-over look.

"Good morning. How you doin'?" I ask.

"Fine now that I've met you. Are you married?"

"Yes, I'm married." I flash my ring.

"Oh. I'm looking for a good wife."

I've heard this line recently from Rev. Matthews, but what worked for the good reverend 62 years ago is tired. "I'm sorry. I don't think my husband would approve."

"Good day," he says, and walks to his car. He looks back at me and shakes his head.

Ms. Myers just looks at him, then says to me, "I wasn't sure what you were by listening to you on the phone. You sounded white. I almost said no. I don't want some white lady to come in and do a book about us and take advantage of us. But I was curious to hear what you had to say. Come on in."

Her neatly decorated home has teal blue vases and bowls decorating the dining and living rooms. We sit in the open living room area amid a flat-screened TV, a coffee table, and pictures, pictures, pictures. A wicker room divider displays 8-by-10 portraits framed in it. She sits next to me on the sofa and within 15 minutes she shares, "My daughter has been gone a long time, but you never get over that grief from losing a child. I have some stories to tell you. Stories about what it was like growing up in Ruleville." Her voice starts to quiver, and the tears flow. I am choking back tears; my throat hurts because I want to release the cry, and when I can't control it anymore, we are both crying. "I'm sorry for crying," she says. "We just met and I'm getting emotional. I have stories to tell about my mother and what it was like growing up here. I moved to California when I was grown, but when my mother was sick, I moved back to take care of her."

"Ms. Myers, I really want to put you in the book, but you're too young. I'm asking for women over 70. I'm sorry." I'm having this conversation with myself: "If I lower the age of 70, people may not connect with the stories as experiences from elders. Most of the time I have to pull stories from the Jewels. Their children and grandchildren have to coax them to share anecdotes with me, but here is a younger woman eager to share life experiences."

She is visibly hurt but says, "I understand. I want to be in the book, but I understand. I think what you're doing is a good thing." On the spot, she asks, "Do you have time to go for a drive with me?" She takes me to a community center in town. We drive five minutes through Ruleville and she points out the homes of relatives of Mrs. Fannie Lou Hamer. She tells me who lives where, she tells me the history of the churches we pass. "Mrs. Hamer's family still live here in town. They don't like to talk to outsiders. I think they're hesitant to share because they don't want to be taken advantage of. I think there were some issues from outsiders before."

"Wow, I wish I could talk to some of the family. I'd love some history of Ms. Fannie Lou. So much history." I am sad to think that they won't talk.

At the community center, she says, "Leave your stuff in the car. Let me introduce you. We have to ease into this." We go inside, and I get a tour of the Fannie Lou Hamer Museum. I am in awe of her accomplishments and determination to stand up for rights. I meet Mrs. Hooper-White, who knew Ms. Hamer because she helped deliver food to Ms. Hamer when she was making her rounds in Mississippi for Civil Rights. She used to listen to her at meetings. I can see from her big and round and beautiful eyes that she is very interested in the project. As I explain it, she seems as if she's figuring out what she's going to wear for the photo portrait.

Excited, I chuckle and ask her, "You're already thinking about what you want to wear, aren't you?"

"Yes," she says, "I am. How should I wear my hair?"

While walking back to my car with Ms. Myers, she laughs and says, "I knew she would agree to do it."

I think about ways to add Ms. Myers to the book. She has such a giving spirit. A few months later I call her: "Ms. Myers, this is Lisa. I've been thinking about you."

"I've been thinking about you, too. How is the book coming along?"

"If you want to share, I want to include you in the book. I shouldn't say no to someone who has something valuable to add and who wants to talk."

We schedule a time. I go back to her house, where she greets me with a warm smile and hug. "I'm so glad you called me and invited me to do this. This is important work you're doing." Inside I smile because I know I'm doing the right thing by including her.

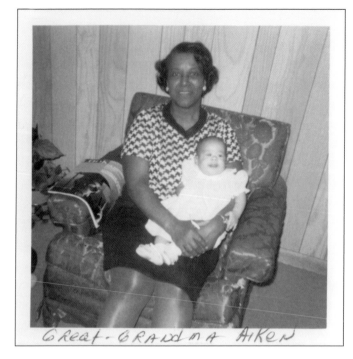

My great-grandmother Mrs. Marie Aiken, whom I called "Gram Ree," holding me in 1970.

I used to share lots of stories with my kids. I played *Eyes on the Prize*, about the Civil Rights Movement. It showed where they put the dogs on the people and they were spraying them with water. The kids watching bust out laughing. I broke down and cried like a baby. I mean I just cried, and they thought I was crazy. I turned it off and I told them, "I lived through this. Don't do that. These are your ancestors, you laughin' at. This is our blood and the same thing that they did then, they would do now, but the law won't let them. That's the only reason you're not being treated that way. A lot of people died for you to have the rights that you have." A lot of the kids didn't know about Fannie Lou Hamer. I told them, "They beat her because she wanted to vote, because she tried to get people to vote. The school that you're in right now, we couldn't even walk down that street in that area. We couldn't walk down the streets in the white folks' area. It was a certain way [route] that we had to go. Black folks couldn't walk over there, and if you walked over there, you were stopped: "What you doin' over here, nigger? You don't have no business over here. Get back on your side of town."

Black people couldn't come into town after 12 o'clock without permission. If you didn't get permission from the police department, if you were coming through, driving through, they would put you in jail. If you had your lights on after 12 o'clock, they'd knock on your door and ask you what you was doin', scared you were having some sort of meeting. This was during the Civil Rights. We had a lot of Civil Rights workers here and they were havin' secret meetings and what have you. It was just like being in a prison, living in Ruleville at that time.

Like so many Blacks in the South who moved north and west in waves of migration, Ms. Myers had moved away. Gram Ree, my great-grandmother, moved from South Carolina to Pennsylvania in search of a better life. She wanted to be able to provide for my grandmother, who remained in

Spartanburg and would ride the train north during the summer months to visit Gram Ree. It ached me that I never asked Gram how she felt about her mother migrating for better opportunities. As Ms. Myers shared her initial reluctance to move back to Mississippi from California to care for her mother, I ached with regret that I had never mined Gram and Gram Ree for their memories of my family's move north to Pennsylvania from South Carolina.

It wasn't until I came back home to take care of my mother, that I got to know her. My mother grew up around a bunch of boys. They would joke her and she would fight them. At first they would whoop her, but then she learned how to fight and she would beat them up. I found her to be a compassionate person, but it was hard for her to be soft because she always had to be hard. She did what she thought was best for her children. She had to be hard because my daddy was a softie. We had the soft, loving kind and then that strict person. I grew to respect my mother and love my mother so much.

When I first came back, on the plane I asked myself, "Why am I going to Mississippi?" After I got home, I found out why God had sent me back here. It was so we could build that bond together. And you know, it was wonderful. I took care of her until she died. We became best friends. She didn't want nobody to do nothing for her but me.

We lived up in the compress quarters [at the cotton gin]. The train ran through and hobos would be on the train. Now today, nobody would fool with hobos 'cause they're scared of 'em, but my mom would feed them. They would come to the back door and she would have their food in one of those brown bags. She would hand it out to them. She was just a wonderful person. When you're growing up you don't see all that, 'cause she was so military-style with her discipline, but as you get older, you start really reflecting on who your mom was. I would say, "This woman is crazy," but once I got older, I started really to reflect on the things she did and who she was. And you know, she was a real, real woman 'cause a lot of people wouldn't have fed those hobos. They would have been afraid of them. But she would just hand them a bag out the back door. They knew where they could get some food. Evidently the other guys had told the other guys. Every time the train came through, she had those bags sittin' on the table. She would hand them out to them, to people she didn't even know. So, she was a jewel of a woman.

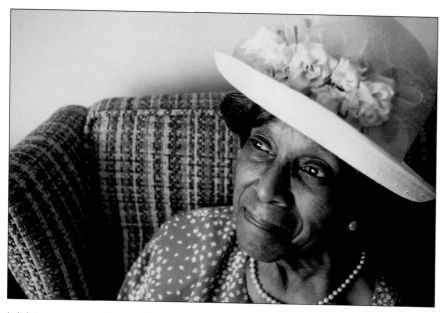

I didn't realize I had taken this photo of Gram Ree in 2001. So actually, to my delight, this is my first Jewel photo. My cousin Robin Williams found this photo. Gram Ree was about 85 years old when I took this in her home in Harrisburg, Pennsylvania. She passed away in 2008.

MRS. RUBY HOOPER-WHITE, 75

RULEVILLE
BORN DECEMBER 1939
MARRIED FOR 13 YEARS WHEN WIDOWED
4 CHILDREN
5 GRANDCHILDREN
6 GREAT-GRANDS
1 GREAT-GREAT-GRAND

Mrs. Hooper-White is still working full-time. After serving as a social worker at Head Start for 37 years, she is now the site manager at the Senior Companion and Aging Program in Ruleville. She stays busy. And she's outspoken. That hasn't changed since she was a child.

The black children went to school when it was convenient, when we didn't have to go to the field. That bothered me greatly. The school bus would pass and the white children would be on the bus. I couldn't understand why we, as little black children, couldn't go to school when the white children went to school.

I had finished picking cotton [for the season] and we didn't have any shoes. I stopped the plantation owner, or the person that was supervising, and asked, "Could you give my daddy some money so he could buy us some shoes 'cause we want to go to school?" He told my daddy, "I told you to talk to that little girl. Now she askin' for money. She wants shoes to go to school." That did something to me; I felt like he was belittling my daddy, you know, not looking at him as a man who was the head of his family. He was down-talking to my daddy. My daddy spoke up and said, "Well, yessir, they do need some shoes. They not doin' anything and they could be goin' to school now if I could get the money."

Ms. Hamer and all of the Freedom Riders, they were coming from a march at Ole Miss, they were coming to Jackson. We were to meet them in Belzoni with some food. We took the back road to meet the people who were to get the food. Some of Ku Klux Klansmen got on our trail and I thought, "Lord, if you was ever gonna bless me, bless me tonight." Somehow, somebody, who knew what was going on, informed the Ku Klux Klansmen and they got on our trail. I thought, "Lord, these white folk can't win now, they can't. Please don't let 'em." They had some kind of light and they were trying to find out where we were. We had to go down in a ditch, to hide, to make sure the car couldn't be seen. We got out in case they located the vehicle, we could hide our bodies. So they [the Klan] got lost from us. We didn't know where they were, where to go, or what to do. We stayed there, I guess, about three hours. We finally heard a noise. They had dogs, and the dogs let us know that they were leaving. We got out of that situation. I had kept thinking, "These white folks can't be winnin' tonight, they just can't, they just can't, they can't."

Later on, when I was talking to Ms. Hamer, she would say [to me], "I like you, girl. I like you.

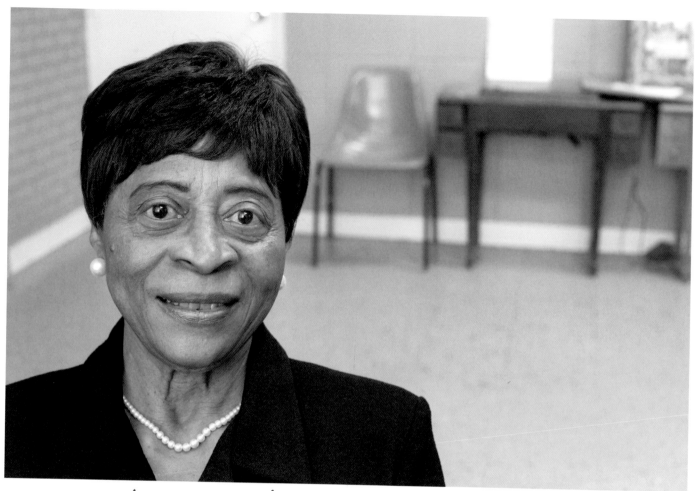

Ruby Hooper-White

**I like yo' style. You keep it up. Don't let your education make no fool out of you. I like you."
And I would say, "I like you."**

I like Mrs. Hooper-White. She is warm and welcoming. She has the most beautiful big eyes, and I make a note to take a photo close to her face so I can focus on those eyes.

"I love what you're doing," she says. "We mothers need to help you tell our stories. There's something about the warmth of your personality. It's just easy talking to you. I feel like a grandmother to you." I feel close to her. I like the fact that I could read her face when I asked to interview her. She's asks me what it's like being a professor.

"I love what I do," I say. "I didn't know I would have the patience for it. I grew up with a grandmother who would tell me to sound out a word and figure out how to spell it. Kids today want you to hold their hand through everything."

She nods her head. She reminds me of a memory I haven't thought about in years.

It was in 1979. I was trying to write a letter to Michael Jackson's fan club when I was almost 10 years old. It was right after his hit "Rock with You." I was in love with Michael. My letter started, "I think you're so cute." I couldn't figure out how to spell "cute." I kept looking for words that started with the letters "qu." Gram told me that wasn't how it was spelled. "How do you spell it?" I asked.

"Look it up," she said. "It starts with the letter 'C.' Go look it up in the dictionary." Gram didn't hold my hand. She wanted me to be self-sufficient. Mrs. Hooper-White reminds me of Gram. She likes people to stand on their own two feet and tells me about a program for teenage girls she ran at Head Start years ago.

I had a class for teenage girls called Self-Sufficient at the Head Start program. I always had to explain for 30 minutes what self-sufficient meant, but a few of them caught on. You're trying to get them to get the gold, and they don't see the journey. Every once in a while I would meet someone who had gone through that training and would say, "I know you proud of me," and I would say, "Yeah." I met a young lady three years ago and she said, "Mrs. Hooper-White, I just want to thank you. I came to your office one day. I was pregnant and had had one child. You said some words to me that hurt me, oh they hurt me, and I went to my car and I cried and I cried and I cried. I told myself that I'm going to school and I'm gonna get me a desk job and I hope that old woman comes by my desk," she said. "I had that baby and got my GED and I enrolled in a junior college. Then I enrolled in a senior college. I got my degree in early childhood development, but I was not satisfied. I went back to school and next summer I will graduate with my master's degree. I'm a nurse! And I just wanna thank ya."

I remember what I said to her that hurt her. "Darling, let me ask you one thing—don't you know how to do something other than just open your legs and have babies?" I said, "I love you." She sat there, said, "That's okay," and she left. I don't know what made me say that to her in those terms, I really don't. She said when I asked her that question, I had tears in my eyes.

I remember telling Gram that I couldn't wait to leave so I could live by my own. I remember getting mad at her rules. It's painful now to reflect on how little I appreciated her. She wanted me to slow down. I think she wanted me to know and understand my worth before becoming involved with a boy. I didn't have a clue what she was trying to show me. But now I do.

A field near Merigold.

MRS. JEAN C. WOODLEY, 86

DUNDEE
BORN FEBRUARY 1929
MARRIED 55 YEARS WHEN WIDOWED
5 CHILDREN
14 GRANDCHILDREN
2 GREAT-GRANDS

Mrs. Woodley and I meet at a community center that houses an adult literacy program. The room is filled with tables and chairs the right height for children. The center is closed; the room is quiet. She's always been a teacher, except for 18 years when she drove a school bus. She's now teaching a 70-something-year-old man how to read.

Learning is fun. I tried to make learning fun, not just reading, reading, reading. Gotta put a li'l fun in it. This man said, "Ms. Woodley, if I had had somebody to take the time and have the patience with me that you have, I wouldn't be in the shape that I'm in." And when I looked up, across the table, tears was just comin' down. Now you talkin' about an indescribable feeling? I don't know how I felt, I can't describe it. It was joy and it was sadness, a mixture. Here this man, he's 77 now. He was 69 or 70 then. That was my joy feeling, I reached this grown man, like I used to reach the little fellas. I'm tellin' you, rain, shine, sleet, or snow, he gonna be out there in that li'l white truck. He's gonna be here every day. He feels good about himself. Now he's beginning to read his mail; he's reading receipts. I pull that book away from him and try to deal with things from his environment, so he can relate to what's going on in his home. I can see the pride in his face. I'm teaching him how to read things that pertain to his life. Sunday school book? Let's talk about it. Let's see what we're gonna do in Sunday school. You can't keep him away from here. It took about four years to get him to read on a fourth-grade level. It's not how fast you go, how many pages you cover. He is my greatest success story because of the age.

You gotta make learning fun, make it interesting. When he was younger, he left, went up north. He didn't think education was important, so went into barber, to cut hair. Thought that's all the skills he needed. I came in—not a stiff-neck teacher—I came in trying to get acquainted with him, to find out how am I going to work with him to bring him from this level to another level, what's the best method? You gotta find what method is best. I tried all of them. Right now we're goin' to lesson 20. Guess what it's about? Barack Obama—how he got his start, what he went through as a child. See, he can relate to that. Barack wasn't born with a silver spoon in his mouth, but because you're down here now doesn't mean you'll live forever down here. It's hope for all of us if we put it into practice. My hope is that I can build a confidence in him to show others, "C'mon, there's hope."

He got a friend that's in the same shape. A lot of them ashamed to go back and try to learn how to read. "I'm too old to learn." They'll tell

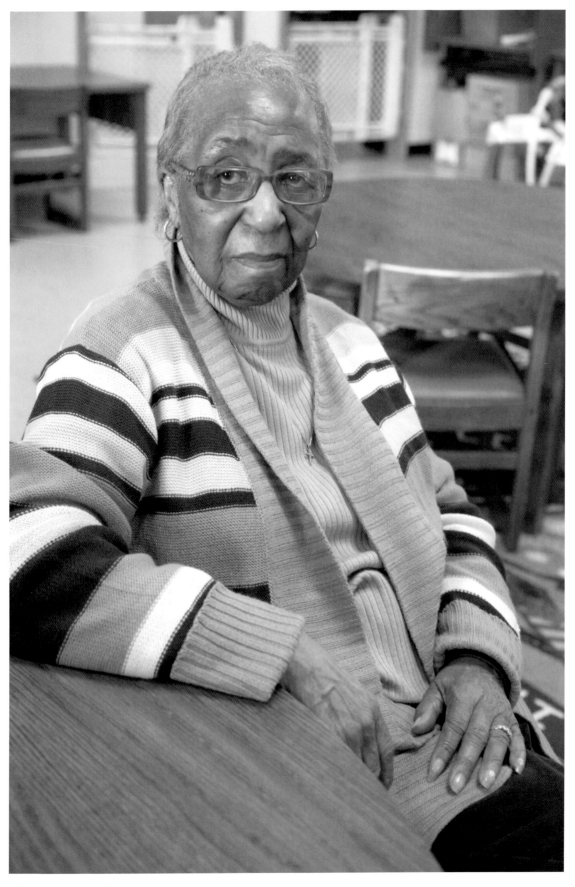

Jean C. Woodley

you that in a minute, but he's proof, he's in his seventies. If he's learning, others can.

When I was teaching third grade, they were paying 10 cents for lunch. I noticed this little girl and her brother never had a dime for lunch. Never. I asked the bus driver, "What kind of home they comin' from? They never have lunch money." She told me the mom died when the little girl was two and there were two boys and three girls. Daddy worked on the river somewhere. Daddy was an alcoholic. They had a shotgun house. Daddy slept in the room where the heater was, the girls slept in the next room, no heat, and the boys slept in last room, no heat. Daddy up there where the heat was.

They always came school so stinky, wet. Put on clean clothes on top of the wet clothes. You could smell that pee.

I went to a store and bought undies for this little girl and gave them to her. Well, didn't see them anymore. Next day or two they stinkin' again. Bought me another set and said, "When you come to school, you put this on." I had my teacher's assis⸱ ⸱lp me take her down and sponge her ⸱ ⸱ soap and water from the kitche⸱ ⸱etable bucket and we cle⸱ clean clothes. Befc⸱ ⸱se clothes o⸱

⸱the

⸱le

⸱s lady's ⸱y than the ⸱t that house daa. ⸱ and this⸱ pass at her. She

was about 13 or 14 years old then. She came to me and asked me if she could stay with me until she found somewhere to stay. I talked to my husband and he said as long as she acted like a nice little girl, everything was cool.

She finished high school, she graduated, and she went to Chicago. I called her up there one day and said, "C'mon, girl, you goin' to college." She went to Jackson, Tennessee, and got her degree. She came out and taught in Memphis.

She said if it hadn't been for me, she wouldn't have been where she was. I said, "No, you needed a li'l help but you had it in you. You needed some help and I gave you that help." Now she'll come see me, take me out to dinner. She hasn't forgotten me. I picked her up in third grade and she still hangs on to me.

Mrs. Woodley reminds me that Gram said, "Get an education because they can't take that from you." After a long meditative silence, I ask Ms. Woodley, "Who is Jean Woodley?"

I don't know who I am. My mother come down here pregnant to Mound Bayou. I was born there. Mother left me in Mound Bayou and went back to Ohio. I never saw her again. I never said, "Oh, that's my mother over there."

There was a distant cousin from my mother's family, came to Mound Bayou, her name was Mary Alice, and got me. She married umpteen times and every time she married, I had a different last name, so I didn't know what it was on my birth certificate growing up.

My dad—I was 33 years old before I ever laid eyes on him. Saw him one time.

I grew up with people thinking Mary Alice was my mother. We were living in a very isolated house in Tunica County. I was 13 years old. She wanted to go to Memphis and I wanted

to stay with another lady, I called her My Mary. And she [Mary Alice] got mad at me. She wanted me to stay in her house with her husband while she shop and come back. I didn't want to stay. I'm 13 years old and I'm knowing what could have happened when the doors closed and lights go out. She fussed at me and that's when she came up with the truth. Of who I really was. "You wanna go down there and stay with Mary Brown?" See, I thought Mary Brown was my grandmother 'cause she was one of the mothers of the men that she [Mary Alice] had married. She said, "You wanna go down there and stay with Mary Brown? She ain't no kin to you." My hair stood up like Buckwheat.

"What you mean she ain't no kin to me?"

She said, "I'm not your mother. Mary Brown ain't no kin to you."

And I wanted to die. I was 13 years old. I finally asked her where are my people?

She said "Well, your momma got a sister named Virgil in Gary, Indiana."

I asked for the address, she finally came up with the address, and Virgil and I started writing. That is when everything opened up to me, when I got over the heartache. I wanted to meet my biological people. I know The Man Upstairs was in this plan. The family sent me a ticket to come to Gary. When I got there, and they looked at me, it was just a joyful time.

My dad was in Ohio and I got a chance to see him. He was a short guy. They took me to this house and he came in and shook hands.

This is my biological father and I'm looking at him. He sat down and said, "No doubt about it. This is my child." I'm 33 years old and sheer bumps. I just went through something, when he sat there beside me. He got over the shock; I guess we were both in shock.

I thought all these people were my relatives and then one day I had no relatives. I cried. I wanted to die. Then the Lord gave me strength to come out of it.

When Mrs. Woodley tells me this story, I think about people who told me they didn't want my parents to marry, asking, "What would happen to the child?" as if I were a disability. To worry about how biracial children will cope is a cop-out. All children struggle with identity. We all need communication from our parents. If my family had been transparent about race, perhaps I wouldn't have had such identity and self-esteem issues. Most teenagers just want to fit in. When you don't, you feel like there's a big scarlet letter on you.

I could relate to Mrs. Woodley. I never expected a woman of her generation to say she was still trying to find out who she was. That shocked me. I appreciated her openness. Not every woman I approached was open or receptive to the idea of talking to me. With the joys of my private history lesson from the Jewels came the frustrations of encountering women who did not trust strangers. Because of my own story, I couldn't really blame them.

MRS. VELMA T. MOORE, 79

BENOIT
BORN JUNE 1935
MARRIED FOR 49 YEARS WHEN WIDOWED
15 CHILDREN
145 GRANDCHILDREN
33 GREAT-GRANDS
26 GREAT-GREAT-GRANDS
14 GREAT-GREAT-GREAT-GRANDS

When I meet Rev. Jerry Walker on the side of a country road in Grapeland, he directs me to Mrs. Velma Moore. She's a beautiful woman, with high cheekbones. She tells me her daddy was Cherokee. I know immediately from looking at her that I will take a photo that highlights those apple-shaped cheekbones.

Inside her tiny living room are more than a dozen relatives. I wasn't expecting that many. Emergency scanners are going off, someone is heating food up in the microwave, and everyone is gathered to listen to our interview. All eyes are on me. I feel the pressure. Everyone is wondering what I want to talk about.

I ask Mrs. Moore about her childhood and she tells me that she has a twin sister named Thelma, who now lives in Washington State. Mrs. Moore is fine giving an overview of her life, but she tightens up when I ask for specific memories of her childhood. She is still pleasant, but tight-lipped. After an hour, I'm still struggling to get interesting quotes from Mrs. Moore. She has a twinkle in her eye, and I know that she was a handful when she was younger. "Mrs. Moore, I know you are not telling me something. Don't you have a story that you like to tell your grandchildren?"

She shakes her head no. Her grandson Contrell asks her if she's told me the story about pulling a woman out of church and punching her.

"What?!" Did I just hear him correctly?

"Boy, be quiet," she says. Everyone is laughing. I'm the only one in the room who isn't in on the joke. I am the outsider.

"Ms. Moore, what are you not telling me? I've been here for over an hour and you're holding out on me?"

She just smiles.

"Ms. Moore, you know you're wrong," I say.

She is silent for a minute and then says, "If somebody is flirting with your husband, talkin' about how fine he is, like you ain't even there, what for you to do? I pulled her out the church so we could talk about this."

Everyone busts out laughing. Her daughter Thelma, named after her sister, is looking at me.

"She said she didn't know he was my husband, but she meant what she said," says Mrs. Moore, who is shaking her head while telling me. "So I said, 'Well, I mean to show you who I is,' and I punched her in the face. Right between the eyes." She laughs.

"Ms. Moore, you pulled her out of the church?" I ask.

"Oh, yes, I did." She pokes her lips out.

I notice the attitude still present in her. This feisty woman makes me smile. "What did you pull her out by?"

Nelms T. Moore

"I pulled her out by her arm, but I would have pulled her out by whatever."

"Then what you did do?"

She says her mother came out of the church and said, "Velma, you know you're wrong. I said, 'Mama, I ain't wrong. I pulled her out the church. I didn't hit her inside the church.'"

"What did you do then?"

She says she told the woman to get up. The woman refused, so Mrs. Moore walked back into church.

"Then what did you do?"

"I sat quite comfortably."

We are all laughing. I learn Mrs. Moore was deeply in love with her husband. They had 15 children. I've never met anyone with a family this large and tell her that she doesn't have a family, but a town, with 145 grandchildren, 33 great-grandchildren, and 26 great-great-grandchildren.

You talk about love? Mine [for her husband] was deep down. I reckon because I loved his style. I loved his style and he was wild about mine. When we get together and get to talkin', I thought he was beautiful. I just really loved the man. He wasn't real tall. He wasn't no fat neither, 'cause I never liked a big ole man. He had a stylish walk, the cutest walk, and I loved that walk. With that walk, he was mo' better looking. He dressed real neat and he talked real kind. He was kind, nice and kind.

I wouldn't say how my style was to him, but I knew I was cute. Everybody would tell to me, "You is one pretty young lady." And when he told me, I knew I was. And that made me feel really, really good.

When I ask her about divorce, her jaw tightens. She frowns. Her tone changes, and gone is the laughter.

If you gonna marry somebody, you supposed to marry them 'til death do us apart. You hang there. It's gonna be dark days, light days, but you supposed to hang there until death do you apart. I always said, "Lord, I want one husband. I want all of my children to be by that one man." And God fixed it so. We got 15 heads. He was the first man I married; never been married no more and never will. No, I will not. And I got 15 children by that one man and I thank God. I did just like He say: we was not divorced. I'm still Mrs. Moore. I be Mrs. Moore until I'm dead and gone.

"I'm still Mrs. Moore. I be Mrs. Moore until I'm dead and gone."

MRS. MYRLIE EVERS, 82

JACKSON
BORN MARCH 1933
MARRIED 12 YEARS, FIRST HUSBAND, WHEN WIDOWED
REMARRIED 19 YEARS WHEN WIDOWED
3 CHILDREN
6 GRANDCHILDREN
1 GREAT-GRAND

Mrs. Evers was married to Civil Rights leader Medgar Evers for 12 years when he was slain; she remarried a very good friend, Walter Williams, and was married for 19 years when he passed away. She spoke about her first husband, Medgar, at the Ole Miss campus, where I teach. I attended the event with Bobby. She is gorgeous. She has neat, short, natural hair. Her voice is eloquent and strong, and she pronounces every syllable. She commands attention. She's a powerhouse. She is history. I decide to take photos, move around, and capture more than 300 images. After the program, Bobby and I introduce ourselves to her, and she asks if I will make sure she gets a few images. I instantly develop a feeling of awe and want to include her among my Jewels.

It took me only nine months to get her.

I reach out to our school's Overby professors, Bill Rose and Curtis Wilkie, who give me the e-mail of Mrs. Evers's attorney, and I send him sample pages of my Jewels interviews. He's intrigued but informs me she is out of state for a month and doesn't have her phone. (He thinks her son took it from her so Mrs. Evers is forced to rest.) He introduces me by e-mail to Ms. Susan Glisson, director of William Winter Institute of Racial Reconciliation, who agrees to meet with me. I Google Susan and I find out that she's a white woman who's been voted one of the most influential Civil Rights leaders in our country!

I am intimidated as I wait in a cozy nook in the hallway near Susan's office on campus. She strolls in wearing jean overalls. She's short, wears glasses, and is youthful looking with long, naturally curly brown hair. "Hello, Alysia!" We shake hands, immediately hit it off. Kindred spirits. I enjoy her warm smile and fun-loving disposition—not at all what I'd expected. We sit side by side in two chairs in her office and I explain my project, read some interview material, and then ask if I may play some audio of the women. "Yes, please, I'd love to hear it." I play the audio, and she responds, "I love it."

"Dr. Glisson—"

"Susan. Call me Susan."

"Thank you. Susan. I'd like to interview Mrs. Evers for the book. I've heard you know her. Can you help me?"

"Oh yes, Mrs. Evers is like another mother to me. I know her and her daughter, Reena. I will reach out to them."

My newfound friend tries over the next several months to arrange an interview, but Mrs. Evers is hard to reach because of her schedule. Months pass, and Susan tells me she is still holding on. I have moved on, telling myself, "If it is meant to be, it will be." I'd reached out to everyone I could. It's like she is behind a steel curtain.

Eight months later, Susan calls my office. I'm about to go give a final exam to my students. "Al, I'm at the Lyceum with Mrs. Evers and Reena. I showed them the *Southern Living* article." (Six pages of my unpublished book ran in the May 2014 issue.) "If you can get here in the next few minutes, Mrs. Evers has agreed to meet with you. She loves the article."

"She loves it? Oh my God! I have to give a final in 20 minutes. I don't know if I can make it..." *Wait...What am I thinking? I'll never be able to reschedule with Mrs. Evers. Drop everything and go*, I tell myself. "Susan, I'm coming. I'll be there right away. Wait for me." I dial Paula, the Journalism School receptionist. *Please don't be out to lunch.*

"Meek School of Journalism?"

"Paula, this is Al. I have to give a final in 20 minutes and I just got a call that Mrs. Evers will see me. Do you think you can help me by starting to give my final? I shouldn't be long. Please?"

"Of course, Al." Everyone in the school knows about my book and that I've been trying to reach Mrs. Evers.

"Good luck," says Paula when I drop off the final, thank her, and dash out the door.

I run to the Lyceum, the historic building where James Meredith stayed when he integrated Ole Miss in 1962. My asthmatic chest is tightening as I sprint. I don't have my inhaler. *Am I having a panic attack as well as an asthma attack?* I arrive at the Lyceum and walk inside the building. Susan and one of her staffers are in the hallway. I am a hot mess. Sweaty, wheezing, and flushed red.

"Are you okay?" asks Susan.

"No, I'm having an asthma attack and I don't have my inhaler," I wheeze.

"Okay, calm down. Take a few deep breaths. Are you going to be okay?"

"Yes, I'll be fine," I whisper, determined not to miss this opportunity.

We walk toward the conference room, where Mrs. Evers is waiting for me. My heart is beating a mile a minute. I cannot believe this is finally happening. I've photographed famous singers and unforgettable concerts in my day, but nothing compares to meeting Mrs. Myrlie Evers. I walk into the conference room and there she is, sitting at a long, oval-shaped conference table with her attorney and Reena. I've met her before, but as I look at Mrs. Evers now, I'm starstruck. She smiles to set me at ease, and I sit down next to her, surprised and flattered when her attorney takes cell phone photos of me with Mrs. Evers holding up the issues of *Southern Living*. I feel my emotions surface. Oh damn it! My throat tightens. My nose turns red. I'm going to cry.

Mrs. Evers sees the tears forming, watches my throat quiver, and gently asks, "Child, why are you crying?"

"I cannot believe I am sitting here next to you. I have been trying to meet you for almost nine months. I want you in my book. I would be honored to have you in my book. And I cannot believe I am sitting next to you. I have admired you all of my life and you're right here."

She's laughing warmly now. "I'm only human, too," she says simply. "I'd love to be in your book." Then she stands up.

"For real?"

"Yes." And she walks out of the room.

I haven't had a chance to read any of the book to her and Mrs. Evers has walked out of the room. How will I ever get her scheduled? I am speechless. It happened so fast, I had less than five minutes. I bawled. I am so mad at myself.

Reena is standing there watching me and, once I get a grip, says, "Okay, let's schedule this." She hands me her business card and tells me to call her later that day, when she will know Mrs. Evers's schedule. "Her schedule is tight. It will have to be done in Jackson."

"I know. I know. I will cancel whatever is on my calendar to drive to Jackson," I say, undismayed by the two-and-a-half-hour drive. I hug Reena and cry again, while she chuckles. "She'll do it, right? She'll do the interview?"

"She is a woman of her word," she said. "She said yes, didn't she?"

I hand Reena my freshly printed manuscript—the only copy I have. "Perhaps you or Mrs. Evers can read it on the way back home?"

"I'll only take it if you sign it for us. Write something."

"You want *my* autograph? Mine?"

She laughs. "Yes, yours." I don't remember all I wrote on that last page, but I do remember writing, "To Reena, The next generation of Jewels." Reena is executive director for the Medgar and Myrlie Evers Institute. When I asked her what that means to her, she replied: "I am the guardian of the legacy. I very proudly hold that position, to further the legacy of both of my parents for future generations."

A week or two later I drive to Jackson to interview Mrs. Evers. Bobby is with me. He will divorce me if I don't take him to meet Mrs. Evers. The door opens. It's Mrs. Evers, wearing a beautiful jewel-toned purple sweater. She shakes our hands. When we sit down to talk, she immediately starts talking. I don't have my recorder on. I am nervous. She's talking and I don't want to interrupt her. I hadn't asked for permission to record her, so I don't want to just start recording.

After a few minutes I ask, "May I start recording?"

She says, "I thought you were. I only have an hour and I'm tired."

Bobby, Mrs. Evers, and I took a selfie after her interview for this book in May 2014. We were in her office in Jackson. It took me nine months to get this interview. She was delightful and shared with me many stories about her childhood.

I've screwed this up already, I think to myself as I start the recorder. She talks about Medgar. I listen intently to this, a private history lesson. But then I ask her about her grandmother. When she realizes I want to know about her childhood, her life experiences before Medgar, she becomes truly candid. She talks openly about her maternal grandmother and her aunt Myrlie, for whom she was named.

My mother and father were married. She was very young, almost 17. My dad was about five years her senior. My maternal grandmother, Annie Beasley, felt that this gift, meaning me, the child, should have the best life that could possibly be given to her. She thought my mother was too young to really do the best job in rearing me. I was born in 1933, that was a time when the elder women in a family felt free to take the infants home with them and rear them if they felt that they would not get what was needed at home. So that's what my grandmother, Annie Beasley, did. She walked across the street, to my mother and my father's home, and I'm told that she said, "This baby needs me. Wrap her up, Mildred. I'm taking her home." Home was just across the street from my mother. They

lived on the same street, but on opposite sides. My mother was so young, and what my grandmother was about to do was something that was acceptable in our neighborhood. She knew she could see me and be with me. And you usually gave in to what the elders wished. So, I was packed up, taken across the street. My grandmother decided that she had to retire from her job—she was a schoolteacher—and devote her entire attention to this precious child that had been given to the family. That's the beginning of my being Mrs. Beasley's granddaughter, rather than Mildred's daughter.

Prayer was always important in life. I had to pray every night. She sat there next to me as I knelt at the bed. Sometimes she would do this hum [she hums it], "Baby. Come on. It's time to say your prayers." And I would think, "Oh my goodness, I don't want to say my prayers. Do I have to say my prayers tonight?" But I wouldn't dare say that to her. Obediently, I would turn and kneel down next to the bed and always say the Lord's Prayer and always ask for blessings for those who had less than I. Then I would jump up, as a child would do. Okay, I've said my prayers. She'd always wait until I almost got out of the bedroom door. "Baby." I knew what she was gonna say. "Come back. You didn't finish your prayers." "Yes, Mama. What didn't I do?" "You know what you did not say. You get on your knees and you ask God to make you a blessing." To this day, a day doesn't pass that I don't ask God to make me a blessing. I didn't understand it then, but you live and you learn,

and if I say nothing else in terms of prayer, I ask that: make me a blessing.

It's a miracle what grandmothers and older nurturers can do for you in training. She never ventured from telling me that I had special talents, and that she and God expected me to use them in the right way. How blessed I was. I've lived by those teachings over years and, honestly, I believe it has been the only way I have survived everything that I have been through. If that were to be taken away from me, I don't know who I would be, I don't know what I would do. I choose not to venture into that, but to just be thankful for her and all that she gave to me.

• ❖ •

(Speaking of her maternal grandmother, Annie Beasley, who later worked as a housekeeper:) Every Thursday, Grandmother would bring home the leftover food from this white family's home. She was a superb cook. I was introduced to strawberry tarts, cookies with chocolate frosting, chicken prepared in a different way other than the boiled or the fried. And she would bring home clothes for me from the young girl in this white family. All of the women in my family were great seamstresses. I remember my [other] grandmother, Annie, and my aunt Myrlie taking those clothes, ripping them apart, and sizing them to fit me because they were too large. I had my first full-length mink coat by the time I was 13 years old. My take: "What is this? What is this fur? I don't want this." My aunt Myrlie said, "Baby sister"—which was my nickname—"don't you know what this is?" "No, I don't know what it is." She went on to explain it to me about the mink coat, what it meant society-wise. It's upper-echelon. [She said,] "You can wear this." I have a photograph of myself in that mink coat that Medgar took of me when I was pregnant with our first child.

But I reached a point that I was weary of wearing that girl's clothes. I said to my aunt, my mother, and my grandmother Annie, "I want my own clothes." They said, "Well, baby, we don't have the money to get you clothes like that." "I don't care. I want my own." My grandmother took it upon herself to take a croker sack and make skirts out of it. We called them broomstick skirts. A broomstick skirt is one that has a band around the waist and you take the other cloth, the long part of the skirt, and you gather it on this band, pin it, and that's it. The cloth came from the flour sacks. You'd go to the store and you would buy Rit Dye and you would dye those croker sacks different colors and cut it and make yourself skirts. I preferred that over the clothes that were given to me from the white house.

Two hours after we'd begun, she is giggling and blushing when I ask, "I do have one question about you and Mr. Evers."

"Yes?" she asks.

"What was your first kiss like with him?"

She looks at me.

I wonder if I've crossed the line.

Then she bursts into a laugh, lays her head on the desk, and giggles. "I was just glad he wasn't a sloppy kisser, like the younger boys I'd kissed."

Mrs. Evers, Bobby, and I laugh.

"Mrs. Evers?"

"Yes?" she asks.

"What was your song? If you had one song with him, what was it?"

She smiles again and says, "'It Had to Be You.'"

At the end of our conversation, she agrees to take a selfie with me and Bobby. For the first time in my career, I have a selfie with a celebrity. She is a living legend and I have something in common with her—I was raised by my gram, too.

HAT. COAT. PURSE.

My mother is white. My father is black. They met in 1968.

Mom said, "I dated him to shock Mom, to push the limit." Her mother, my grandmother Gram Duncan, was a recent widow, and Mom was full of anger because she missed her dad. Mom's father, Joe Duncan, the grandfather I never knew, was an FBI agent who died of lung cancer when Mom was 14 years old. It was a terrible time for her and her siblings. "I was unhappy," she said. "I had low self-esteem because I wasn't popular in school. I didn't have the blond hair and blue eyes that was popular; I had freckles and brown hair. I wondered what I could do to rock the boat. I know, date a black man."

My dad, Walter Burton, was a sweet talker. Short, about 5 foot 6, and slim, with an athletic build, he cocked his head to the side and wore Big Apple hats.

Gram Burton wasn't keen on Daddy dating a white girl. She didn't like the idea at all. I never asked her or my grandfather why they objected, but it's fair to guess that she worried about my dad's safety. Men were killed because someone thought they were flirting with white women.

My grandparents lived in an all-black neighborhood. There were parts in Harrisburg where blacks could not buy homes. They couldn't just buy anywhere. Pop-Pop told me they lived in the projects while he was in the Army and afterward they struggled to save up enough money to buy a house.

If my parents married, and my mom moved into the neighborhood, my grandparents wondered what the neighbors would say. I suppose they worried about Mom's safety, too. It was 1969. It was a hostile time in Harrisburg.

"The Black Panthers had a meeting spot in the neighborhood," Mom says. "People didn't like me there. They never said anything to me because your grandparents were very well respected and well liked. I think people left me alone because of

My mom said when I was 2 years old I used to say, "Hat. Coat. Purse." when I was mad at her and wanted to go see my paternal grandmother. Here I am walking the three doors from my parents' home to my grandparents' home in Harrisburg, Pennsylvania. We lived on Hoerner Street.

My mom, Stella, laughing at me as I ran to my grandmother, Althenia Burton. This photo was taken around 1971. I would have been around 2 years old.

the influence of your grandparents, but I worried, too. Things were hostile with race relations."

Did Gram Burton, who would raise me and whom I honor with this book, have a memory about her childhood? Did she see a lynching? Did she witness black men being killed for false accusations? I'll never know. She never talked about it, but after my private lesson with these women, I had so many questions.

When Gram Burton called Gram Duncan to say, "Your daughter is dating my son and it needs to stop," my white grandmother, Gram Larson, didn't know how to respond. She thought the issue was race, but Gram Burton was concerned about my dad's maturity level and ability to care for a wife and child. I know for a fact that Gram loved my mother. "Truth be told," Gram Larson said, "I wasn't keen on them dating either, but by then your mom was pregnant, in her senior year of high school, and she wanted to have you. Your parents were too young. Both me and your grandma Burton wanted her to put you up for adoption." Mom fought to keep me. "I told your grandma [Larson]

that I was 17 and a minor, yes, that was true, so I would have to do what she wanted me to do. But I looked her in the eye and told her that when I was 18, I was going to go back and get you," Mom told me. "I suppose the way I looked at her, she knew I meant it. And I did."

My parents married when I was a bun in the oven in June 1969. There was nothing their parents could do. I was born that December. There were never any issues between grandparents. They genuinely liked one another. My grandmothers kept in touch after my parents divorced when I was 3 years old. The grandparents were more cordial to one another than my parents were to each other. My grandmothers visited and kept in touch with each other until Gram Burton died in 1994. Gram Larson came to the funeral and kissed me. Gram Larson still keeps in touch with my aunt Tiny— Gram Burton's sister. I love that the families still talk.

When my parents married, they bought a row house that was three doors down from my black grandparents William and Althenia Burton in Harrisburg, Pennsylvania. Gram Burton used to buy me the prettiest little outfits, matching hat and coat, always with patent leather shoes and a purse. I was a little lady, just like my Gram Burton. We were thick as thieves. I was attached to her even as a baby. Mom says when I was 2 or 3 years old and mad at her, I would say, with my little temper, "Hat. Coat. Purse." That meant that I was walking to Gram's house and I didn't want Mom to accompany me. Mom would call Gram and say, "Here she comes. She's mad at me. She's walking up now." I wouldn't let Mom walk with me. She would stay on the sidewalk or porch and watch me walk the three doors to Gram. Gram waited for me on the porch, smiling, arms reaching out.

Gram told me that after they got custody of me, I would wake up in the middle of the night, touch her face when she was asleep, and say, "Gram, I'm

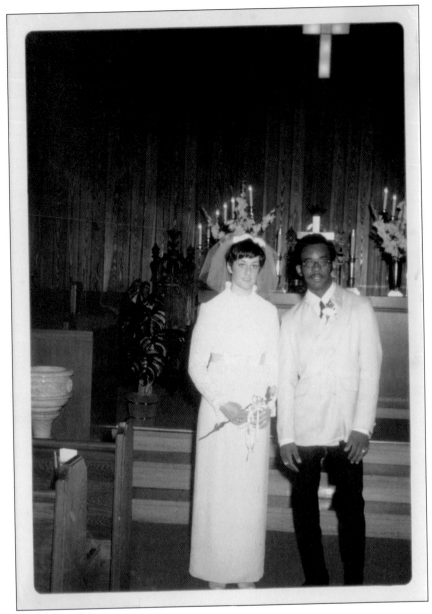

My parents, Stella Duncan and Walter Burton, on their wedding day in June 1969. They were married at Capital Presbyterian Church in Harrisburg, Pennsylvania. My paternal grandparents were church members.

Although they didn't have much materially, my fondest childhood memories are bubble baths and sitting on the swing on the front porch with my grandparents, Gram and Pop-Pop. It was Pop-Pop's job to give me a bath. He did this until I was 7 or 8. I liked bubble baths but we couldn't afford to buy bubble soap, so Pop-Pop took the label off a vegetable can and punched holes all around it, saved pieces of soap, and put them in the can. He would hang string from one side of the can to another and when he put it under the running water it made bubbles for me. As a child, I didn't know we couldn't afford bubble bath; I only knew I enjoyed bath time. After my evening bath, Pop-Pop and Gram would let me put on my two-piece halter-top pajamas [popular in the 1970s] and sit on the swing between them at dusk, when the streetlights were on. They would both sit close to me, Pop-Pop with his arms around both of us—calling me Peach, his name for me—and Gram holding my hands. They didn't have much, but I know for sure that they loved me.

with you. I'm here?" And she would say, "Yes, baby, you're with me."

My parents had an ugly divorce. My mother moved to New Jersey and I cried for my grandmother for months. Mom also worried about raising a black child in a white rural neighborhood in New Jersey. So my mother called my black grandparents and asked them to take legal guardianship of me when I was 4.

The memory of my grandmother grows less dim, even makes me weepy from time to time, as I work on this project. Interviewing other people's grandmothers and those like Mrs. Evers, who were also raised by their grandmothers, makes me feel closer to Gram. If I close my eyes, I think I can still hear her voice.

MS. CURTISTENE SHORT DAVIS, 67

LELAND
BORN JULY 1947
MARRIED 40 YEARS WHEN DIVORCED
1 DAUGHTER
2 GRANDCHILDREN

Mrs. Curtistene Davis says she wants to help me with this book. "I love what you're doing," she says. "I'll help you find more women. How many more do you need?"

"I need three more."

"Can they all be from Leland?"

She is the first from this town that I photograph. I tell her I don't mind because I don't have any other women from Leland.

She shares local history on the plantation where she was born and lived—Heathman Deadening Plantation. "We lived in the southern end of the huge plantation. Deadening literally meant 'dead end.'" The irony doesn't escape her that hard living during slavery, Jim Crow, and segregation was dead end because she adds, "It was a hard life, but there was a lot of love, too. There was a lot of love individually, but also shared between families." She says lots of families lived on the plantation, where they chopped and picked cotton. Her parents were sharecroppers. "Every family had to produce their own food. We had what we called 'truck patches,' which meant we grew our own food. We harvested and canned food—like beans, greens, peanuts, and watermelons." She explained that each family had their own area and they would share with one another. "During the winter months we had what we called 'hog-killing time.' That meant we came together for hogs that were raised throughout the year and we butchered and cleaned the hogs and shared."

I miss my mom when she died. Her name was Mary Bell Short. I was the oldest child at home—I was 17. My dad was amazing, he just took over and become mother and father. He was everything after she died. His name was Vertis.

I couldn't cook. I remember—this is funny—my dad was trying to teach me how to make biscuits, and I would forget the ingredients, especially cutting the shortening in there. I would forget to do that, and you would have to eat my biscuits when they were hot. Daddy said if they got cold, they would knock the dog out! My rice always stuck to the bottom of the pot. I really didn't learn how to cook rice until I got married. It's humorous, but like I said, it was hard. I had to learn how to cook fast. I had to take care of my little brothers and sisters.

She was 46 when she died. She died in 1965, the year I graduated. I went to school that morning. We got up and got dressed and got on the bus. She was really sick. She was in her bed. I went in and I said, "Madea, I'm leaving for school. I'll see you when I get back." And she said okay. Got on the bus, went to school. I had been to school less than an hour and was going down the hall and the principal walked out of his office and begged for me. I went into his office. He said, "Your momma passed." And I just went to pieces. I just saw her. I left her

sittin' in the bed. She didn't look like she was gonna die and then, bam, she was gone. Something just knotted up in me and it wouldn't release. I just hurt.

The day of my baccalaureate, we buried my mom. It was so ironic, all of my friends from school from Indianola came out to my mom's funeral.

I just ached and it took a long time to go away. I mean a long time. That pain stayed with me so long. I would just pray that the Lord would move that pain. I just hurt, I just hurt, I just hurt for a long time.

We didn't know what to do. Madea was our rock; she was the glue that kept us together.

I am much, much better than I used to be. For a long time Mother's Day would just absolutely leave me crushed. I just could not function. I even had a child who was trying to honor me for Mother's Day and I was just not functional that day. All I wanted for that day was for it to just pass. I would be almost like steel—nonactive 'cause I wanted the day to end, so I could pick up the next day and I wouldn't have to relive memories. Thank God I got delivered, but it was painful for a long time.

My mom, back in the day, was considered a fashion trendsetter. Listen, my mom used to dress for church! We were poor, but

Curtistene Davis

my daddy loved my momma. Oh my God. Oh my God. She had dress, hat, suit, shoes—everything match—because my daddy made sure. I don't care, whatever extra money. She would order from this book back in the day called the National Bellas Hess. She would order from that book, the whole outfit. She was a trendsetter in the day when black women didn't do that, other than the preacher's wife. And the women would be so jealous. We laugh about it now when we get together at family reunions. "Well, you're here because they went out that night. You're here because they came back with you." They would sneak off, go to the movies together, go riding together—those type of things. What I remember most about her was her dress.

When the Freedom Riders came to Indianola, I was a junior, I believe, in high school. First I went out of curiosity, went to the meetings. It was right down the street from the school called the Baptist Building. I went there the first night and it was just jam-packed. These black folks and these white folks. Plantation owners was there. I'm sittin' there and lookin' at the man that owned the plantation next to us. I'm just lookin' at all these people. Didn't really know what was goin' on. I was so intrigued. I went back. My daddy was just furious because back in the day, if the plantation owner found out that you were involved in the Freedom Movement, you'd have to move from the plantation. So my daddy was just furious, he was scared to death.

I had a best friend on the plantation where we lived; he was involved, too—much more outspoken than I was. That plantation owner found out, said something to his father and his father sent him away, sent him up north. He finished school up north 'cause his father was afraid. My dad came home one night, rantin' and ravin' 'cause I had been out at meetings. He was just furious. He said, "Don't you go back up there. I'm gonna send you up north wit' ya brother." My mom said, "You are not sending my daughter anywhere. She's gonna stay right at home where she's supposed to be." I loved her. I never forgot that. She told me, "Be careful. Don't get yo'self hurt out there." She never tried to stop me or anything.

You know, it's amazing. I did not know we were in bondage like that, as black people. Going to school every day, being B+ students—just not cognizant of the fact that we were in total bondage, that we were practically in slavery. Just not aware of it until it was shown to you in these meetings. It was a way of life and you didn't question it. Until it's right there in your face. You realize, wow, you're a second-class citizen. You can't even drink out of fountain uptown at the courthouse, you can't go in the restroom at the courthouse, you can't even vote. It just kinda hit you. I got feverish about it. I wanted to do somethin', I wanted to be part of the change, and I took an active role. Not a verbal role, but wherever they were, I was.

We went up to Ruleville, where Ms. Fannie Lou Hamer was. That was the only time I can remember seeing her, hearing her talk. Very quiet lady. She didn't look anything like you thought she should look, to be that brave. She just looked like a grandmother.

MRS. ROSIE H. BYNUM, DIED AT 101

LELAND
BORN NOVEMBER 1913
MARRIED 58 YEARS WHEN WIDOWED
14 CHILDREN
77 GRANDCHILDREN
139 GREAT-GRANDS
42 GREAT-GREAT-GRANDS
8 GREAT-GREAT-GREAT-GRANDS

After I photograph Mrs. Curtistene Davis, I am delighted that she rides in my car with me and takes me to two more Jewels. "We're going to Mrs. Bynum's. She is quite a handful," Mrs. Davis laughs. Mrs. Bynum is 99 years old. "Mrs. Bynum is a good interview but her memory isn't so good sometimes," Mrs. Davis confides. "It can be hit or miss. I think she's battling early dementia, but her daughter Patricia has agreed and will be there."

Mrs. Bynum lives within a mile or two from Mrs. Davis's house. We arrive at a two-story brick apartment building. She lives on the second level. I am shocked.

"She's 100, right?" I ask Mrs. Davis.

"Yes, she is." Understanding that I am surprised she is able to walk up and down the stairs, Mrs. Davis adds: "Listen, she'd still be driving if she could."

Mrs. Bynum's daughter Patricia is standing in the doorway waiting for us. We shake hands. Young men, probably in their mid-twenties, check me out. I nod and say, "How you doin'?" They return the greeting. As I drag my camera gear up the stairs, one of them asks if I need help. I am used to hauling it; I shake my head no and say thanks, as they watch me walk up the steps.

The room is dark, and I immediately wonder how I'm going to take photos inside. Mrs. Bynum is sitting on the couch, just looking at me.

Something about her eyes tells me she's a spitfire, a handful. "What do you want?" she asks, turning her head down and looking at me over her glasses.

I tell her I'm doing a book about grandmothers.

"Are you going to give me a book? I want one." I tell her that every mother gets her photo framed and a signed copy of the book as my thanks for sharing. She smiles and says, "Well, all right. That's what I'm talking about. Ask your questions."

"Mrs. Bynum, how many children do you have?"

"What? How many children? You sit there and listen good. I had 14."

"Did you want that many children? Did you want more?"

"Did I want any more?!" She laughs. "Naw, I didn't need them. The good Lord gave me them, but I didn't need them."

"How long were you married?"

"I can't tell you. Long enough to have them 14 children." When asked what she liked about her husband, she replies, "Sometimes I liked him. Sometimes I didn't. 'Cause you know sometimes men are hell. I ain't gotta tell you." She laughs. "You got a husband."

I was a good baseball player. I was the first baseman. They couldn't do without me. I just got out there and do good. Well, I played

against the boys. There was a girl team and the boys team. We used to win. They ain't had nothin' to say about it. If you win, you win. My dad didn't think nothin' of me playing.

I was driving my own car. If someone passed me driving slow, I would make them drive faster. I would get close up behind them and they'd know I was driving for them to move. And if they didn't move, I would pass by them in the other lane. I would get right on their butts if they didn't go. I would go about my business. I was a fast driver, I didn't drive slow. I didn't have nowhere to go, I just hate to drive the car slow. I learned how to drive when I was grown, about 25 or 26. I learned my own self. My husband had the car; when he'd leave the car, I'd go out there and crank the car up. Pull up and back up, pull up, back up, 'til I learned how to get on the road and go. My oldest child, my boy, would tell me how to turn the wheel and back up. He was a li'l ole boy, but he knowed how to do. He'd be in the car, telling me to turn the wheel this way and that way. I don't drive no more, don't have nothin' to drive. Some of my children came and took it from me, but I could drive now if I had a car, that what it is. I'd drive now if I could.

Rosie Bynum

Patricia and Mrs. Davis are cracking up about this driving story, and Mrs. Bynum says, "Listen, I had no problem riding on someone's butt until they moved out of my way."

"Did you tell Lisa about how you were at the high school?" asks Mrs. Davis.

I wonder what they're talking about: "Mrs. Bynum, what did you do at the cafeteria?"

She just looks at me.

"Mrs. Bynum, how did you like working at the high school?"

She doesn't understand my accent, they tell me. So her daughter repeats my question. Then Mrs. Bynum looks at me and says:

Sometimes it was good and sometimes it was hell working down there [at Leland High School cafeteria, where she worked for 19 years]. The children worried the hell out of me. When we would run out of napkins, I would tell them to do without them. Use their paper. All these different children want this, want that. They used to make me mad and I had to say some words. They'd say, "So-and-so got more than me. So-and-so got this." I would tell them to go on, get down the line, and get on out. I would give more to some others, though, but I didn't treat the Whites different from the Blacks. Sometimes it was hell with all them children.

MRS. EASTER W. SUMMERVILLE, 92

LELAND
BORN DECEMBER 1922
MARRIED FOR 11 YEARS
6 CHILDREN
20 GRANDCHILDREN
24 GREAT-GRANDS
6 GREAT-GREAT-GRANDS

Mrs. Curtistene Davis and I have spent half a day together, and as we drive to the last interview she facilitated for me, she said, "I'm really enjoying sitting in on the interviews. Thank you."

"Oh no, thank *you!* You have been a big help with breaking the ice. You are someone they know and trust, so this is helpful to me."

"But this is so much fun for me." She smiles, and I wish can make her understand how much she has done for me.

Mrs. Summerville is wearing her Sunday dress and hat when Mrs. Davis and I walk inside her home. She and her daughter Debra have been patiently waiting and I'm running late. They called Mrs. Davis at Mrs. Bynum's to make sure we were still coming. Mrs. Summerville has a picture of a White Jesus hanging on the wall. Gram had one hanging in our home. We had the Last Supper with White Jesus and Dr. Martin Luther King Jr.

She tells me that living wasn't easy when she was younger. She made $10 a week cooking and cleaning for Whites, but she progressed and eventually retired as a county employee. "What was hard, what else do you remember?" She says sleeping on the mattresses made of leftover cotton.

There was a portion of that cotton that you didn't use because some of it had so many cotton hooves in that bale of cotton. You see, that would be cast aside. Well, you could get that cotton and make you a mattress if you knew how to sew. Put that cotton it in. And when you gather your corn, you gather the shucks and mix shucks, cotton, and hay together to fill that mattress. That's what you had to sleep on. First you made the mattress out of the cotton sacks because after you get through pickin' cotton, well, some of those sacks were worn. They give those sacks to the tenants, you know. Fix those holes and the ladies would make the mattress and put that shuck and hay in it.

You had to stir it up wit' your hands every morning when you get up to make your bed leveled. You had a split in the middle and you would put your hand in it and stir it up. Then you would put your sheets and quilts on there. A lot of times you would get some more cotton sacks, you would open them and wash them, and that would be your sheet. The quilts, the ladies that could sew, they saved those quilt pieces and box 'em up. And during the winter months, sittin' around the fire, you'd piece your quilts—whatever pattern you want—you'd use that sew and needle. You'd take a cotton stalk, make that cotton fluffy, and put it in that quilt. That would keep you warm in the wintertime, 'cause you didn't have no heat like you do now. During the night, you see, the

Easter W. Summerville

fire would go out, because you had to have that wood to build a fire, and when that fire go out, you would be cold and that quilt was what kept you warm.

It felt good to sleep on that mattress. It was a long time before I bought a bed in a store. It was much better. I was grown and married when I could buy a mattress and spring from the store. I was about 24 years old when I bought one. We came a long ways. It was wonderful. Oh yeah, because you had a leveled head and was laying on top.

I cannot imagine how her back felt, and when I ask her what else she remembers from her younger days, she smiles.

I was converted in 1936 on a Wednesday night, the 26th day of August. I can't forget it. That's a happy day, oh happy day, and I met Jesus. A moaner's bench in the church. They had three benches. One on each side and one in the middle, and there was a chair in the center. They called that the pool, and the preacher would ask the sinners to come to the front and sit on the moaner's bench, and that's where the Christians would pray for the sinners. And when they would sing they song and go 'bout at that chair to pray for you, you were 'bout on your knees at the bench. You pray for yo'self and they pray for you. I was 13 and that's when I was converted.

They baptized me the next month on the fourth Sunday in Deer Creek; trees and bushes,

A sunny day on an old country road near Merigold.

snakes and fish, and everything was in there, but I was not afraid. See, Jesus was wit' me. That was a good day.

Mrs. Summerville recites the names of all the pastors and deacons, and who stood next to whom.

"How can you remember so much detail from that day?" I ask her.

"When you meet Jesus, you never forget that. Um, um, no, you don't forget that."

"Do you remember all the songs from that day?"

"No, because they would sing different songs. That Wednesday, when I was goin' to church wit' my mommy and daddy, the sun was settin' over in the west. You know just before the sun go down, looks like it gets bigger and it's orange-colored, just above the treetop. And I was talkin' to the sun. I told the sun to tell Jesus, 'I'm over here. I don't wanna go home a sinner tonight.' I talk to the sun, and while I was talkin' to the sun, I heard a moan in the air above my head." She starts to sing, "Lord, have mercy. Lord have mercy."

Her daughter Debra sits three feet from her, her hands in her lap, and hangs her head down while listening to her mom talk. Now she leans closer, "Lord, have mercy," she whispers, so softly I can barely hear it. "Um, um, um," Debra says, shaking her head. Mrs. Davis begins shaking her head. She is quiet. Mrs. Summerville's voice quivers and she starts to cry. "It just sound like a choir up in the air over my head, that they was moanin' and I was so happy. See, Jesus was wit' me, and when we got in the church and I sat on the moaner's bench that night, that's when he touched me and the fire was burnin'. I couldn't hold my feets."

We all look at one another. Something touching and magical has happened between us. We all know it. Each of us is shaking our head, crying. "You got me cryin' over here," I say. "That was beautiful. Thank you. Thank you very much. That was a beautiful story."

"Um, hmm," Mrs. Summerville says.

"Is there anything else you want?" asks Debra.

"I don't think there's anything that can top that."

Mrs. Summerville rocks in her chair saying, "Um. Hmm."

"Are you in a good place with that memory, Mrs. Summerville?" I ask.

"That was a good time," she says, and rocks in her chair.

As Mrs. Davis and I walk back to the car, I ask, "That was powerful, wasn't it?"

"Yes, it was. This is good work you're doing for us."

I think, *They are teaching me history.*

MRS. RACHEL J. SCURLOCK, 88

CHARLESTON
BORN MAY 1926
MARRIED 65 YEARS WHEN WIDOWED
HELPED RAISE 2 CHILDREN

As a teacher [educator for 42 years,] I don't mind sharing this, it wasn't popular for the black teachers to belong to these Civil Rights programs and the like. When you got ready to get a contract for your job, you had to list everything you were a member of, like the NAACP. I never joined the NAACP. I did have questions. What I did, I would write a note to whoever needed to answer that question that I had. I would have them meet me at school and ask to talk to them.

I went to closed rallies. The Bethel Church down the road from me—that was their headquarters. They would meet every Monday morning, but teachers were afraid to go there, anywhere where there was a meeting for the NAACP. It was disallowed for the teachers, but I would go to that meeting at old Bethel Church. The man that ran that meeting was Solomon Gort. Oh, he was powerful. He had strength. I would take notes.

People that lived on the plantations went so they could be able to tell their boss. He would know what was going on. What I'm sayin' is true. Some of them there were spies, so they could go back and tell what happened in the meeting. It's not hearsay on my part. I would go by the bank every day; I had to leave money for the school for which I was the principal. When I walk in, the banker would look at me and say, "That was a good speech you made last night." Didn't ask me a direct question; would tell me. I would just look. I wouldn't look surprised or anyway. I knew how he knew, but who it was [who spied], I don't know. He said, "You said some real good thangs." At those meetings, I would tell the ones on those plantations, "Civil Rights and all gonna come to you but you gonna have to be your own destiny and fight for it. You'll never, you'll never earn it as long as you're on that plantation."

MRS. MAUDE W. COLEMAN, 102

GREENVILLE
BORN SEPTEMBER 1912
MARRIED 49 YEARS WHEN WIDOWED
1 DAUGHTER
2 GRANDCHILDREN
4 GREAT-GRANDS

I'm doin' things that I know I ought to do. Like for now, when I say my prayers, I thank the Lord for the things He allowed me to do. I didn't do it. He was there wit' me. All these walls full of congratulations—I didn't figure I was doing it myself, I figured the Lord put this into me. That it was a natural incarnation that I received.

My greatest accomplishment was to live and get old and to see my children [all her offspring including grands and great-grands] grow up to be useful and to see segregation change. The world is a better place. Until they start all this shootin'. Then I wonder where somebody failed. "What they didn't teach you? Did you teach them about all that shootin'?" It's the wrong thing to do.

Did I ever pass [for white]? No. My father was white, and my mother was biracial, but my [black] stepfather raised me. I had opportunities with my color. With my ambition and my ways, I got a lot requests from white guys wanting me to say I was white altogether. I said, "Look, I don't wanna do that. That won't be me." I identify as a black woman and I didn't worry about it. You know, I have always had enough common sense to accept what I couldn't change. I never had a hard time. I had a good time. People always treated me right. I don't think people around in Winterville and Greenville thought anything of it. I really don't

think they bothered. You see, back then they weren't so inquisitive. I never wanted to pass as white. Never thought about it. I didn't have to do it, wasn't going to change. I was much lighter than I am now, before I got old.

I married a black man. We got married when I was about 21. He died 'bout two days before we would have been married 50 years together. I never remarried, no indeed. I never had to. My husband treated me like I was somethin'. People would say, when we would go out, "Oh, he just puttin' on airs," but he treated me like that at home.

I loved him because he was a hard worker and a selfless person. He didn't do a lot of comin' in and out, and all that kind of stuff. He was very protective of his mother, my mother, and myself and our daughter.

◆ ❖ ◆

(When asked about the Civil Rights Movement:) Oh, I remember all that, honey. Back then, a long time ago, I went to the bank, First National Bank, with a paycheck. You know about segregation? You get in a line to cash somethin' and white folks get ahead of you; they would call around and get the white person. I didn't like that. I went to Trustmark and I have done banking business with them ever since I was 18.

The Civil Rights was sad and yet it was necessary. You out there and you being treated unfairly and inhumane. I thought it was terrible not to break that situation down and make everybody have the same privileges. The only way you can do that was to change the attitude that Whites had against Blacks, and Blacks, I guess, had to adjust attitude against them, too, I reckon. The most I remember was the killing and the bad experience that people had to go through.

· ❖ ·

(When asked what is hardest about getting older:) It would be all right if I could walk. I would still be working [as a high school counselor], I guess, doing stuff for somebody. But I just can't walk now. That's the hardest part; and then I forget so much. My memory's not always there, [but thoughts] will come back finally. When I say my prayers, the first thing I say, "Thank you, Lord, for allowing me to do Your work. I didn't do it. You did it. I did it at Your command." And I close my prayer with the one thing I want to ask, "Is there somethin' in my life that You want me to do, that I have not done? Please make that demand on me and then take me home." If the Lord commands me to get up out that chair and go on home, I'd go right on. I'd get up and go. I'd be ready. I had already promised Him that when He did the last thing for me, to take me home. That's my prayer, every day. That's my prayer. Every day.

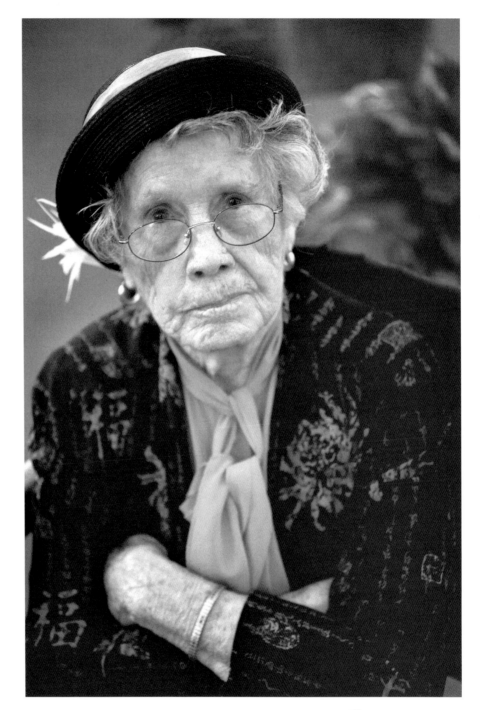

MY MISSISSIPPI BURNING

My mother took me to see the movie *Mississippi Burning* when I visited her in New Jersey when it was released in 1988, a few days before my eighteenth birthday. We both cried throughout the movie. I remember leaving depressed and afraid.

I remembered that day when my husband, Bobby, exclaimed, "You wanna move where? Mississippi? Oh, hell no, didn't they make a movie about it burning?!" It was 14 years later, and he was reacting to my wanting to teach at the University of Mississippi, a school some affectionately call Ole Miss. According to school research by David G. Sansing, the name comes from the Greek organizations who started a college yearbook in 1897 called *Ole Miss*. Elma Meek, a student from Oxford, suggested the term—a title that enslaved domestics used to distinguish the mistress of a plantation house from the young girls of the deed-owning family. Within two years, students and alumni were referring to the University of Mississippi as Ole Miss.

I can barely put a shirt on that says OLE MISS. (Some black professors won't wear anything that doesn't read THE UNIVERSITY OF MISSISSIPPI in full, but it's hard to find that design.) I like wearing our colors of red and blue, I'm proud of being a part of this university, I love teaching here, but I refuse to wear anything that says REBELS. I won't go to the football games because they play the Dixie song, the ultimate song for racism in my opinion.

I never imagined I would ever move to Mississippi until I heard about James Anderson, a black man who was run over killed by a group of white teenagers driving a pickup truck in Jackson in 2011. At that time I had been thinking of applying for a job at the university. A former colleague told me about a position at the University of Mississippi. I grew up hearing about Mississippi when learning about black history in middle school and from watching TV programs about the Civil Rights Movement. I went to after-school programs that taught me the Black National Anthem; I grew up singing "Lift Every Voice." I grew up hearing about Medgar Evers, James Meredith, the boycotts, the segregation. It was a scary, unknown state to me. I was fine with never visiting. Something about those teenagers killing Mr. Anderson sent a cold chill down my spine and renewed my fear of the state. When a black man is run over because white kids feel like killing a "nigger" in 2011, it's not exactly good public relations for a state or its university system, I thought, with angry sarcasm. I was offended by the actions, that this was still happening in 2011, by their defense and lack of accountability for horrific actions. I was angry that people still thought it was okay to hurt people just because of the color of their skin. But after talking to a former colleague who was newly hired as an assistant professor, I told Bobby I wanted to interview at the school. I expected him to put his foot down, to draw his proverbial line in the sand, and although he wasn't enthused about the idea, he didn't. I arrived on campus for the interview when the temps were in the eighties in April.

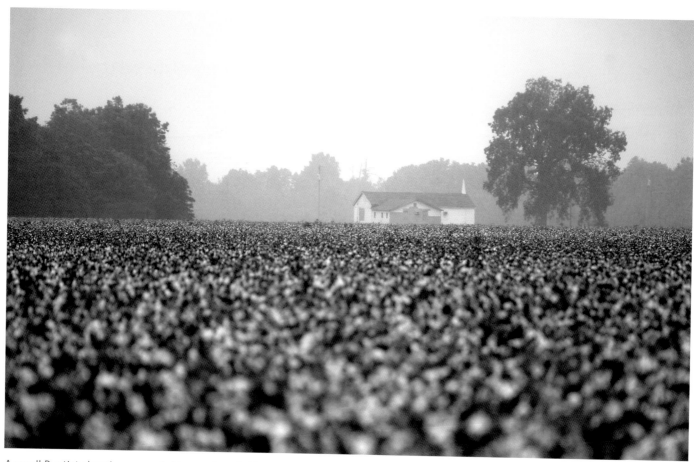

A small Baptist church surrounded by a cotton field on Route 278 East heading toward Clarksdale.

I'm not even a flower person (Did I already mention my allergies?), but the magnolia trees smelled especially fragrant, as well as the pink azaleas, and I was charmed. After talking with Charlie Mitchell, the assistant dean and an assistant professor of the Meek School of Journalism, and Will Norton, the dean of journalism, I was more than interested. I wanted the job. Deans Mitchell and Norton told me Oxford "is forward thinking and liberal compared to the rest of the state." They tell me it's an extension of Memphis. Something was calling me to come to the university.

As cotton fields became a canvas I'd see daily while driving in the Delta as I began to interview these magnificent women, many who had worked in the fields just as their ancestors had planted, chopped, and picked the fluffy little white crop, I reflected on how such a soft plant had such a

harsh history for Blacks. Most of the women I interviewed had parents who were sharecroppers. These beautiful women, like Ms. Bessie Thompson, had no schools open to them during cotton season or were forced to quit school to pick cotton to help their families make money. Mrs. Leola Dillard lost her home on the plantation because she and her husband refused to have their children pick cotton; Mrs. Bettie Clark dreamed of the day she'd walk away from the crop and have a better life.

In 2013, I touched a cotton plant for the first time, having only looked at it for almost a year. I was on Route 278 East heading from Oxford toward Clarksdale. I was on my way to photograph a 101-year-old in Greenville, Mrs. Coleman. I talked Bobby into getting up at dawn with me to get photos of cotton in the first morning light. There

was fog in the air and the crop smelled metallic, like it would be chalky if you bit into it. All kinds of emotions came over me. "I am thankful for my life now. And I'm so thankful to the women who have so graciously shared their stories with me, no doubt opening some old wounds," I said to Bobby. "They open these wounds so others can learn from them."

Another time, Bobby and I were driving to Memphis for retail therapy. In Oxford, there are no malls. I needed retail therapy. I needed traffic. We were on Route 55 North when we saw the cotton fields. We both wondered aloud how many black folks worked in those fields. It saddened me. I was hit in the face with the history of race in this state—my new home state. As a photojournalist, I was fascinated. But as a black woman, I was offended by the cotton fields, which looked like rows of popcorn. I knew that I wanted to take photos of the crop, but fear of the history of slavery, plantations, intimidation made me hold off for a year. I couldn't go near for over a year. It raised my own demons with race that I have had my whole life. I'd had enough racial tension in my life.

Growing up in Pennsylvania, a child born in 1969 to a white mother and black father, I was teased by the blacks for not looking like my black side of the family. Whites made fun of my kinky, curly hair. Blacks said I had "good hair," and whites said it was "woolly." I couldn't win. I got in constant fights. Kids in the neighborhood where I lived with Gram and Pop-Pop called me "Oreo" or "half-breed" like I was a dog, and that often sparked a fistfight.

After Mom took me to see *Mississippi Burning*, I left the theater feeling more afraid of racial hate than in my younger years. Later that year, I went to the Indiana University of Pennsylvania college campus in western Pennsylvania where a pickup truck of white men followed me one summer

evening. I was walking off campus at dusk to visit a boyfriend. The men in the truck revved the engine every time I stopped to cross a street. They stopped the truck when I stopped. They started when I started. They watched me and then finally decided to chase me when I ran to get away from them. Luckily I was able to hide from them. The streets weren't busy during the summer; the town was basically deserted; there would have been few, if any, eyewitnesses. I felt unsafe, vulnerable, and scared. In fact, I was terrified. The IUP college campus was the first hostile place where I dealt with open racial tension. The Ku Klux Klan in that region was just miles from campus. I was called "nigger." I'd never been called that before; I lived in a predominately black neighborhood, and it wasn't a word I heard my neighbors or classmates say. (Although it was the mid-1980s, I didn't listen to hip-hop.) We just didn't say the "N" word—at least, I never heard it. No one in my family ever said that word around me. No one in our circle said it. My grandparents didn't even cuss in front of me. It was not tolerated.

When I interviewed my grandfather William Burton in November 2013, I took a photo of his hands. He was 85 years old then. He still wears his wedding ring, along with Gram's, on his finger. Gram Burton passed away 20 years ago and he's never taken off these rings. He wants to be buried with these rings on.

I had my own race demons, as I wondered about Gram and her people, and collected other grandmother stories. But I kept getting hit in the gut that I don't have any stories from my Gram. Every time I got a call from home, I worried something had happened to Pop-Pop or Aunt Tiny. I braced myself when I saw the Pennsylvania phone numbers. I headed back to Harrisburg to try to interview Pop-Pop and Aunt Tiny.

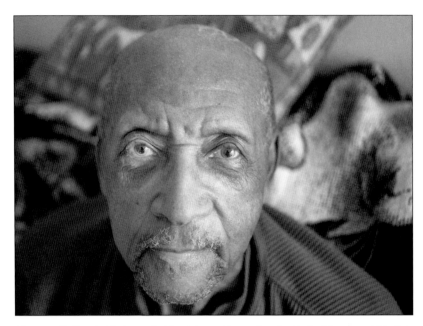

My grandfather in his home in Harrisburg, Pennsylvania. He is 85 years old in this photo taken in 2013.

I'm interviewing Pop inside his one-bedroom apartment. He doesn't look as tall and strong as I remember as a child. It's hard watching elders age. You want them to be as you remember them, youthful and strong. To interview and photograph him is very hard for me. His blue eyes aren't as clear blue and vibrant as they used to be. He's 86 years old and moving much slower. He's had several health scares this year. He's sitting on his brown love seat. I can see the age on him.

Pop's eyes used to be bright, vibrant, and playful, I daresay mischievous. Everyone talks about the twinkle he had in his eyes. I suppose as he ages, the twinkle isn't as noticeable. It is hard for me to watch the change that comes with aging. In 2008, I flew home to visit during the holidays. Pop picked me up at the airport.

I saw him waiting for me before he saw me. I almost dropped to my knees. My reaction to seeing his aging hit me right in the gut. He was hunched over more, wearing his tattered Pittsburgh Steelers baseball cap with his black winter jacket. Long hair dotted his cheeks. I held back tears when I saw the tall, strong male figure in my life become a physically weaker, older man. God, it hurt to look at him! When he saw me, he smiled. I was happy to hug him. He gave me a quick hug. I wanted to hold on a little longer.

"Hi, Pop-Pop," I say, trying to hold on.

"Hi, Suga," he says quickly. "Let's go."

Flash back to his apartment in 2013, when I try to interview him about Gram: "Pop-Pop, what did you love about Gram?" I thought it would be an easy question, something to make him smile. Instead he turns his head to the left, away from me, and looks out the patio glass door. He doesn't make eye contact with me.

His blue eyes glaze over as he says, "Everything."

The interview doesn't go well. I worry that I've made him sad. He and Aunt Tiny allow me to photograph them, but they are very tight with information. "I've interviewed all these strangers. They've told me their stories and I can't get my family—the people I've known all my life—to open up?" I say to Bobby when I return to Mississippi and the bare, just-picked cotton fields, so disappointed.

MRS. ANNYCE P. CAMPBELL, 90

MOUND BAYOU
BORN DECEMBER 1924
MARRIED 69 YEARS WHEN WIDOWED
9 CHILDREN
32 GRANDCHILDREN
58 GREAT-GRANDS
3 GREAT-GREAT-GRANDS

"My husband was mischievous, let me just say that. Just as mischievous as he could be. He was always that jolly, jolly guy. He was always jolly." (He had passed away in May 2013, three months before our interview.)

I tenderly ask her the same question I later ask Pop-Pop: "Mrs. Campbell, what did you love about your husband?"

She's seated on a sofa in her cozy bedroom, furnished with a queen-sized bed and seating area that consists of two chairs, a table, and a love seat. A flat-screen TV is on. I'm seated on the sofa next to her. Her daughter Alma is across from us. Mrs. Campbell doesn't make eye contact with me. She is silent for what seems like minutes. Finally she says—still not looking at me, "Alma, go get me that photograph in the next room."

"Mama, she don't want to see that," Alma replies.

"I don't know if she does or not, but hand it to me." Still no eye contact with me.

Alma hands her a framed photo. Mrs. Campbell holds it and runs her finger across the glass. She still hasn't made eye contact with me. I don't have video rolling, but as I'm watching this, I know I can't reach for my camera to take photos or record video because it would seem callous. But I know something magical is about to happen, and I'm kicking myself for not being prepared.

Mrs. Campbell still doesn't look at me. A single tear falls down her cheek. I try to remember my question, but I'm caught up in this quiet moment before I remember I asked her what she loved about him. And then almost on cue, with the tear and picture in her hands, she finally looks at me and says, "Everthing. Everything. He was the most gentle person you wanna see. Loving and caring. Loving and caring. He was the first somebody that I loved."

I cry. Alma is crying. We are all sniffling. I don't know how to move forward with the interview. I'm caught off guard by such a personal moment.

Then Mrs. Campbell tells me that one of their proudest moments was taking their daughter Frankie to college. Frankie was the first of her children to go to college and she put a brave face on and let her 16-year-old leave home.

"I wasn't sure she was ready," she says.

We made up our mind that we would take her [daughter Frankie to Fisk University]. Didn't look like we were ever gonna get to Nashville. Thought maybe this is the wrong place to take this child. Frankie was going on 17. Maybe she needed to wait another year. The further that place was, I wanted to tell him [my husband] so bad, "Let's go back home." But we went on, got there, got her enrolled and everything. We

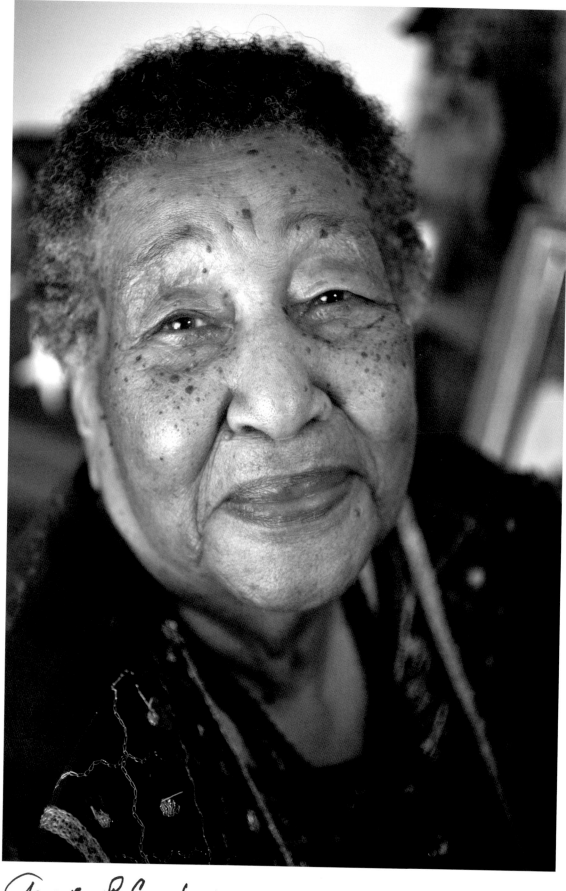

Annylee P. Campbell

Mrs. Campbell removed her grandchildren's photos from the entryway to hang one of President Obama.

roamed the campus with her until she found her a little girl that she hooked up with. The last thing we did was have supper with her; took her and the little girl and we went out to eat.

For her scholarship, they gave her a little job before we left as a dormitory major. This would be applied to her schooling. She and this child were back on campus. And we started home. Last thing, I saw her up in the window looking at us driving off the campus. I said, "There is she watching us." He wouldn't say a word, didn't say a word. We got on the road a long ways. I don't know where we were when he heard me crying. He said, "You wanna go back?" I said, "Yeah."

We turned around. I guess we drove 100 miles back to Nashville, I betcha it was. Really and truly I don't know how long, but I know it was a long ways. I didn't say nothing to him and he didn't say nothing to me, but he heard me sniffle. That's the only thing he asked, did I wanna go back? I said, "Yeah." I don't know where he turned around in them rocks, but we turned around and went on back. Campus was

just as still and quiet. I said, "They catch us; they put us in jail." Everything running across my mind roaming around on campus, but we roamed around and roamed around. Didn't see nothing. I looked up at that window; wasn't nobody there. He say, "She all right." I said, "Yeah, but let us let her know that we just leavin'." He said, "She thinks we did." I said, "Yeah, but I just wanna go in the dormitory." I went into the dormitory. There she was, but she hadn't gone to bed. She in there with the young ladies. Told her how far we made it and came back. She said, "Y'all go on home. I'mma be all right." I was just a cryin'. He reached into his pocket and gave me his handkerchief, then he wiped my eyes. I knocked his hand down. "It isn't me; you need your own handkerchief—trying to act like I ain't mature." We left we worked our way back to Mississippi.

I'm transcribing Mrs. Campbell's story one night, and I go to bed thinking of her. She has this slow, drawn-out voice. It's very deliberate, very low, very eloquent with a flair for quiet drama. She reminds me of Maya Angelou. She speaks so softly, so melodic, that I can't ever imagine her raising her voice. Her daughter Alma corrected me when I said this: "Oh no, Mother was the disciplinarian."

I'm on my way to Shelby to see another mother, but I'm very close to Mrs. Campbell's house. I want to see her. I always want to see her,

and I plan to come by before visiting the other mother. It has been raining all morning. With heavy rain, I concentrate on the funnel-looking skies and miss my landmark, the sign on Route 61 that reads, MOUND BAYOU, THE JEWEL OF THE DELTA. I thought Mound Bayou was before Shelby, but it's not. It's after. I call and ask Mrs. Campbell if I can come by afterward instead of before. "I'm old, where am I going?" she says. "Just come on by."

I am giddy pulling into her driveway. The rain has stopped but my feet are soaked in my sandals. I knock on her front porch and take my shoes off. I don't want to bring water in her house.

She opens the door. "Where are your shoes?"

"They are on the porch. Right here. I took them off, so I won't bring water in your house."

She sucks her teeth. "Alma, get this child some socks." In a few seconds she hands me a pair of freshly laundered white tube socks.

"No thank you. I'm fine."

"You young people are so hardheaded. Put the socks on."

I politely decline.

Mrs. Campbell sucks her teeth again. "I'm worried you're going to get pneumonia."

"I won't." It's in the eighties and humid—Mississippi in September. "Mrs. Campbell, please sit down. I want to read your story to you."

She walks into the living room, a little hunched over and slow, and eases into a recliner. There is no seat next to her, so I sit on the floor by her knees, like she's at her throne. She sucks her teeth about me sitting on the floor. "Pull up a chair," she says.

"I'm fine, Mrs. Campbell." I smile at her. I can tell by the look in her eyes that I've slightly aggravated her.

"You young folks are so hardheaded."

I don't say a word. I know better. After a long pause, I feel forgiven and begin, "Mrs. Campbell, I'm excited. I want to read your story to you and

show you your photograph." I covet the mothers' approval. I want them to like my work, to know I'm doing right by them, that this project is something good.

After she lets me show her what I have done with the pictures, she asks, "Lemme see Mrs. Self. Lemme see some of the others. I like looking at their photos." Alma stands next to her and bends over her shoulder to look at the photos. They wonder if they know some of the other women. "Mrs. Jackson! You have Mrs. Jackson?"

"Yes, ma'am." My project is becoming a book of popular girls in the Mississippi Delta. Mrs. Campbell loves looking at the photos of the other mothers. They all do. I show her the pages that I have designed, and I read her words back to her.

She is quiet. She doesn't say a single word, but that's Mrs. Campbell. She's often quiet, and I don't know if that's a good or a bad sign. I'm finished and she finally says, "Oh, this is just too much for me. All these emotions." I see a single tear slide down her cheek. I smile because I know that I have done right by her.

"I love you, Mrs. Campbell."

"I love you, too."

"I have a girl crush on you," I say, still sitting on the floor by her knees.

"That's okay, 'cause I have a girl crush on you, too."

We smile at each other. I resist the urge to lay my head on her knee. I haven't told her she reminds me of Gram. I was never allowed to let my naturally curly hair air-dry because Gram was afraid I would get pneumonia. I wasn't hardheaded about that, so it wasn't until my mid-thirties that I wore my hair naturally. I had no idea until then what texture my hair was when it air-dried. I don't dare tell Mrs. Campbell that I now let my hair air-dry—even in the winter months—because she would say, "Child, you gonna get pneumonia, put a hat on."

MRS. LEOLA W. OVERTON, 77

CLARKSDALE
BORN APRIL 1937
STILL MARRIED, 44 YEARS TO SECOND HUSBAND, REMUS OVERTON
6 CHILDREN
5 GRANDCHILDREN
2 GREAT-GRANDS

My mother died in childbirth with me. My father had three wives; he was married three times. My mother only had six of us; I was the youngest. He just gave us all away to anybody who wanted us. My adoptive mother made sure I knew my sisters. I was blessed with two lovely adoptive parents. My sister knows more about our father, and I don't know anything about my mother. We've never seen a picture of our mother, no one has ever told us anything about her. All we know is that she came from Arkansas. That's it. I know her first name, but we don't know her last [maiden] name, because on my birth certificate they just got Emma Buggs. That was her married name. It just bothers me. I wish I had a picture of my mother. Not being around that part of the family—it was just horrible. And for us to be, you know, gave away like little puppies.

I ended up growing up in Clarksdale. My sister Laverne grew up in Round Lake, a few miles from here, because that's where our father was. That's where we were born. My adoptive mother made sure that I knew my sister. I have two brothers and she made sure that I knew them. She would take me to see my sister. She wouldn't buy my sister clothes, but she taught me how to share. I had to share my clothes with my sister and I could not give her anything that I did not like.

I had to give her some of my best clothes. So my sister Laverne and I are very close now. I could have grown up not even knowing my biological family.

That's the beginning of my life. My adoptive [mother] knew my mother and told me that I look more like my mom than my sister does. She knew my mother. I didn't have any information on her, only on my father's side of the family, and that's sad. She was just like somebody never been born.

I raised my children. First thing—I wanted to make sure that they knew that I love them. And I talked to them. We did everything together. First thing, we prayed together. I taught them they were sisters and brothers and they had to stick together. Love each other and they had to always be there for each other. Always taught them that. They had to always share with each other.

(Mrs. Overton tells me that she was divorced from her first marriage and was struggling to find work before she met her second husband.)

I was about 30 years old. God had to take me all the way down—didn't have a job, didn't have any money and had children. I'd get up every morning and go look for a job. One morning I got up and I didn't have any food in the house.

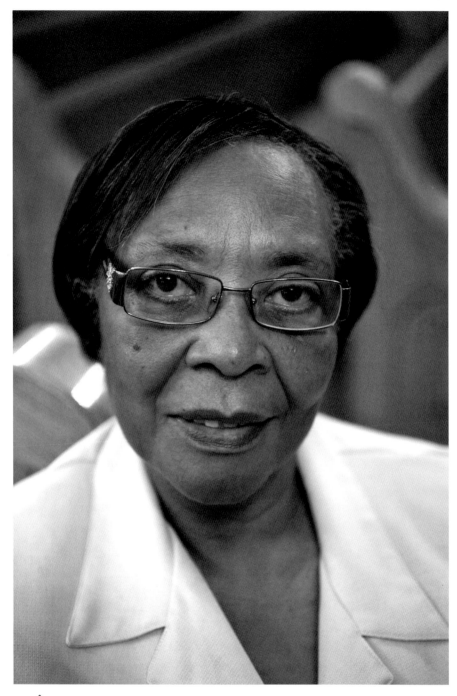

Leola Quenton

was walkin' down the street, thinking, I don't have any food, I don't have any money. I went home and looked at my children; all six of those children were looking at me 'cause they were ready to eat. I went in my house and I went straight through the back door to the next street to my godmother. I walked in her living room and said, "Honey, my children are hungry and we don't have any food." That was first time I ever let my pride down and ask anybody for anything. I had so much pride, I would not ask for anything.

She had a fit. "What?!" She got in her refrigerator and just started pulling food out her freezer. Then when she did all that, she gave me some money. My children talk about that now, every time we get together. She gave me some money and she gave me other food to cook. I went to the store and bought chicken wings and a loaf of bread. I went home and fried chicken wings and cooked some rice for those children and they ate. Last time they were home, they were say-

I told the children, said, "I'm goin' lookin' for a job and when I come back I'm gonna bring you some food." They said, "Okay, Momma." I went to several places, and now I need to go home. I was walking. I didn't have a car, and I ing, "Those were the best chicken wings we've ever eaten, Mother." That's one of the things that they remember. I didn't really understand until I had gotten older, much older. God had to show that to me I had so much pride.

I FELT LIKE AN ORPHAN

Hearing Mrs. Overton's story brought me face-to-face with the fact that Gram and Pop-Pop essentially adopted me. I remember when I was in elementary school, I tearfully phoned Mom and asked her, "You didn't want me because I was black?"

"No," she said immediately. "I loved you. I loved you so much, I asked them to raise you because I knew they would do a better job than I could."

Her words didn't stop the fresh pain. "Was I wanted? Was I loved? Was she ashamed?" Those are questions I had already asked my mom years ago. I remember us talking about it after I dropped out of college my sophomore year, in 1989. Before then, I always wondered, but I had never had the guts to ask her. At least I didn't remember asking.

"You know your father and I divorced when you were 3. I took you and moved to Michigan to live near Gram [Larson]. I needed the help," Mom said. Gram Larson had moved away from Harrisburg after Mom married, taking Mom's younger siblings with her. As mentioned, Granddad had died of lung cancer four years before Mom married Dad. Gram Larson needed support from her own mother, so she moved back to Michigan. After Mom's divorce, she followed, taking me with her. Then she met husband number two, and they moved to Jersey.

"The judge said I was unfit to be a mother because I was living with a man I wasn't married to," Mom said, retelling painful history. "He told me to get married. So I married Steve."

I have fond memories of Steve. He was good to me.

"You cried constantly after we moved to Jersey. You missed Gram Burton," Mom said. "You cried all the time. It was terrible. I felt like a bad mother. I couldn't stand you crying like that. You wanted to telephone Gram Burton. You would even crawl into the closet and sit in the back of the closet and cry. No one was being mean to you, you just missed your grandmother. You did this for months and I couldn't take it anymore. And I wondered what kind of life you would have as a black child with a white mother, her white husband in rural Jersey. I called your grandparents and asked them to take legal custody of you. I was working at a factory, was poor, and knew they could do a better job than me. It hurt me, but I wanted more for you."

Memory of going to court flooded back. I was nearly 4 years old. I remember the judge's chamber and him questioning me. I don't know why the judge ruled the way he did. My grandparents got custody of me when I was almost 4 years old. I lived with them until I was 18.

My mom and I were very close when I was little, even though I lived with Gram and Pop-Pop in Harrisburg, Pennsylvania, and Mom had moved with her second husband to Browns Mills, New Jersey. I remember seeing my mom every month. She would come to Pennsylvania to get me, usually in the 1973 Dodge Dart she loved that barely ran. It was already hand-painted black

when she bought it; you could see the paintbrush strokes. Then I hit that awkward age where I was embarrassed to walk beside her because I was ashamed of being half-black when I was with my white mother. I remember exactly the moment the shame began. It was after Christmas when I was about 14 years old. Mom's sisters, my sweet aunts Jane and Vicki, would send my sister, Angela, and me checks for Christmas. We would split their $25 checks. Mom always took us to the mall after Christmas so we could shop the sales. It was the highlight of my teenage years. Mom and I were inside a junior clothing store at a mall in New Jersey. I was looking for a sweater, and when I found one, I loudly called out to her. No answer.

"Mom!" I yelled when she didn't hear her irritated teenager.

Every white child in that store stared at me. I thought they stared because I was not white like my mom and sister. The attention when I called Mom made me very aware that I was different from my mother and sister. As I replayed the scene prompted by Mrs. Overton's interview, I realized maybe the Whites in that store stared because I was *loud*. But it never dawned on me at the time. I thought the looks were racially motivated. I thought everyone was thinking, *Who's the mother of* that *child?* I thought Mom was embarrassed about me because I was not white. I turn red when I blush or become embarrassed, and I remember feeling flushed in the face, a terrible feeling, especially as a biracial child. After that—until I was 18 years old—I walked behind or in front of Mom and tried to resist calling her "Mom" in public. I don't think she ever knew that.

I did the same with Dad. He's short, stocky, and was really built when I was younger. He wore bell-bottom pants when it wasn't popular

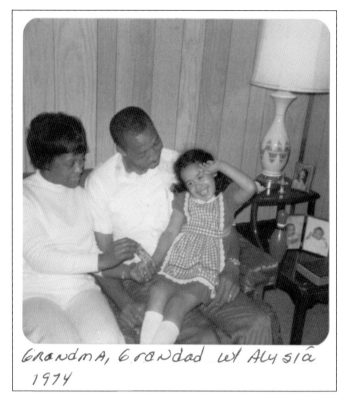

Grandma, Grandad w/ Alysia 1974

My grandparents William and Althenia Burton holding me in 1974. This would have been around the time they were awarded legal guardianship of me. This was in our home on Hoerner Street in Harrisburg, Pennsylvania.

anymore. It was well into the late 1980s and he was still wearing those outdated pants. He had a pair of black ones that tied in the front with a little string, right above the zipper. He wore them with his black Big Apple hat. He'd do that black man pimp-and-walk slide of black men who grew up in the 1970s. He thought he was cool, with swagger. I was embarrassed. I hated walking next to him. Why couldn't he be like a normal dad? Why he always gotta be cool?

I would look at both of my parents and feel resentment. I didn't look like either one of them. Didn't get my dad's wider nose, though everyone says I am a spittin' image of him. I don't see it. I also didn't get my mom's pretty, hazel eyes. I didn't look like anyone. I was just there. I was an orphan.

MRS. JUANITA W. TURNEY, 95

GREENVILLE
BORN AUGUST 1919
MARRIED 58 YEARS WHEN WIDOWED
NO CHILDREN

Bobby and I got up early, left at sunrise so we could get photos of cotton fields along the way, drove two and a half hours—more than 130 miles—to Mount Horeb Missionary Baptist Church in Greenville, where Rev. Albert Calvin Jr. was the pastor. When he invited us to the 11 a.m. service, I forgot to ask the name of the mother I was to photograph.

As we got out of our car, members of the congregation greeted us warmly. We noticed a lot of children, which was a good sign for growth in the church. Seated in a pew near the back on the right side of the sanctuary, I looked at every church mother and wondered, *Is she the one I'm to interview?*

Bobby noticed an older woman and leaned closer to whisper, "Do you think that's her?"

"I don't know," I whispered back.

A mother got up to make announcements. She was short, classy, stylish, thin. I couldn't tell how old she was. *I hope I age as gracefully as her*, I thought to myself. She wore a sharp suit and her short hair was curled. She had the same skin complexion as Gram, a mocha brown. I liked the tone of her voice. She reminded me of actress Ruby Dee, with that air of sophistication. The program said her name was Mrs. Turney. I had told Pastor I wanted the eldest mother of the church, but when I saw Mrs. Turney, who couldn't possibly be the oldest, I didn't care—I wanted her in my book.

After the energizing service, where I was touched by the choir and his delivery of the sermon, I asked Rev. Calvin if she was a mother of the church. He said, "Yes, but she's not the one I had in mind. You asked for the oldest."

"Yes, I know, but there's something about Mrs. Turney. I'm going to ask if she will let me schedule an interview. Is that okay?" I asked.

"Of course. I'm sure she'll agree."

I introduced myself and explained my project to Mrs. Turney while dinner was being served in a dining hall. The food smelled good! They served baked chicken, macaroni and cheese, and green beans along with other vegetables and a variety of cakes and pies. A host of ushers helped Bobby make my plate. Mrs. Turney agreed to the interview, but I knew I had to do it on the spot. Dinner would have to wait. Bobby was seated at the head table talking with Rev. Calvin as Mrs. Turney and I connected.

"I know how this works," she said. "I've been interviewed by several television stations. This year I was voted 'Ms. Hot Tamale' [an honorary title in the pageant held annually in Greenville]. You won't need much time to talk to me."

I wanted to tell her that, unlike TV interviewers, I prefer to take my time with an interview, but when she said she could give me about ten minutes, I didn't mention I'd like more time. She planned to leave immediately following service. I was unprepared to interview in the sanctuary, but I grabbed my audio recorder and camera.

She started to talk and controlled the conversation, giving me an overview of her life. I

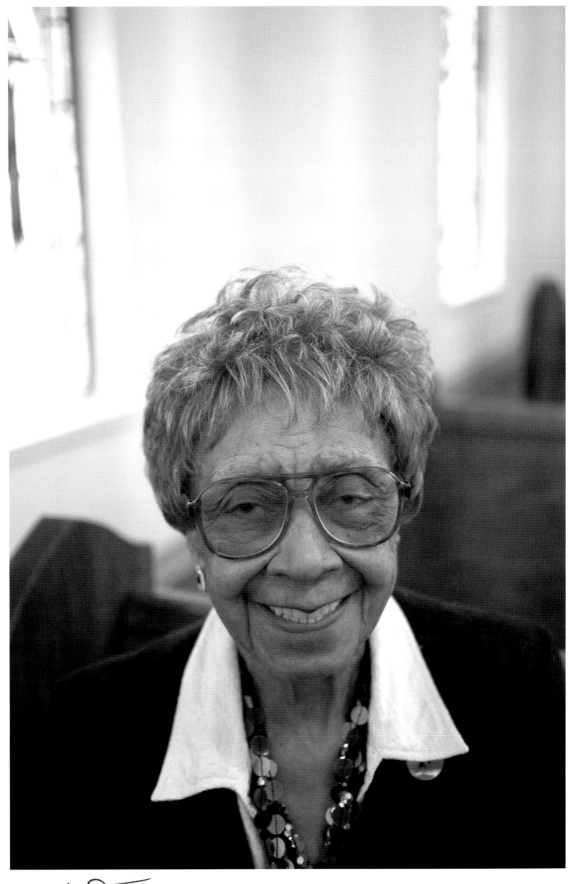

Juanita Turney

appreciated the good background information, but when she let me talk, I told her I was looking for specific stories and asked specific questions: How old was she when she fell in love? Did she marry her first love?

She gave me 12 minutes. I took only a dozen photos, the least for any Jewel, but she was delightful!

Oh, I had a happy childhood. I'm the only child, the only girl grandchild for 12 years. I got all the attention from all the uncles, aunts, cousins. I didn't know my grandfather, but my grandmother was a great force in my life. My mother was a teacher here, and then, when my father and she divorced, she married a blacksmith. I stayed with my grandmother, who always said, "Your word is your bond." When I give you my word, that's what I follow.

As far as my youth, I had all the attention, all the love. Happy childhood, happy adulthood, happy married life. I had Sunday clothes, play clothes, school clothes, church schools.

I was kept away from negative things. I couldn't even listen to the blues at that time. Now they say that's our legacy, and I go the blues festival here every year, but I was brought up not listening to the blues. I was brought up listening to classical music, hymns, church music, and when I played the piano, I practiced classical music. I could play the piano all day, but as soon as I started on "Saint Louis Blues," I'd have to get up from the piano to put some coal in the oven or take some ashes out of the fireplace, anything, any chore that would take me away from the piano. They didn't want me to be a part of the blues because blues represented people who were having hard times, it meant that somebody had stolen the woman or the man, you know, they were strugglin' for some reason. I was not exposed to that.

We [my husband and I] met in school, at Sacred Heart. He was twelfth grade and I was tenth grade. He waited seven years for me. I had to finish eleventh grade, I had to finish twelfth grade, I had to have four years of college, and then after I finished college, my mother said, "Well, I think you need one year work experience." So I had to work a year. He waited seven years. Oh yes, I knew he was the one. I guess I just had a feeling, you know. In college I was courting the dean's son and, of course, that's the one my mother wanted me to marry—because the one I did marry was driving a truck—but that wasn't the one for me. His [the dean's son's] family wanted me to marry him, too, but my husband waited for me for seven years and we were married for 58 years, 58 happy years. He was just a kind person, very, very smart, handsome, and oh, he loved me dearly. He respected me in every way. My husband was very, very fair. He could have been considered another race. Whenever we went any place, he always had his hand around me so that everybody would know that he was with me, that I was not the maid, you know? That he was with me.

"'Your word is your bond.' When I give you my word, that's what I follow."

GRAM, ME, AND RICK JAMES

Mrs. Turney, raised by her grandparents, wasn't allowed to play the blues when she played the piano growing up. They said it was music that wasn't uplifting and symbolized hard times.

As a young girl, I had a major crush on Rick James, the king of funk. He was wild with long braids, tight jumpsuits, and always sang about drugs and wild sex. I had no idea what he was singing about, I just liked his voice and the way he looked. I was in love. When I was old enough to buy records, I saved my money to buy his album. The first album I snuck into the house was Rick James's *Street Songs*. It was released in 1981. I was 11 or 12 years old. I loved the very grown-up song "Make Love to Me." The album also included the songs "Super Freak" and "Give It to Me Baby." You can gather what they were about just from the titles.

My grandmother heard the lyrics and took the album from me. I was crushed when she took it away. I thought she was so mean. "You never let me have any fun," was a sentence I used a lot.

Rick had a concert in Harrisburg around that time. My older cousin Bunny went. I idolized how grown up she was. I fought with Gram for hours, trying to talk my way into going to the concert with Bunny. Gram stopped listening to me. "The answer is no. That's the end of this."

I'm sure I'm stomped upstairs to my third-floor bedroom. I did that often. I didn't talk to her for days. She didn't care.

When Gram would punish me, she would whoop me on my rear end, usually with her hand or a belt. One time she whooped me, I cried, "You're like the evil step-grandmother of Cinderella." She whooped me longer. I called Mom sobbing.

"What did you do?" Mom said. When I told her about the evil step-grandmother comment, Mom said, "You can't talk to her like that."

"Why can't I come live with you? Why do I have to stay here? Don't you want me?"

"Lisa, yes, I want you. I love you, but your grandparents are raising you. Be good and stop getting spanked."

I periodically asked Mom why I wasn't living with her, but as I reflected on these memories brought back to life because Mrs. Turney's grandparents did not allow her to play the blues, I realized it was always when I was in trouble that I would call and beg to live with Mom.

Cousin Bunny told me Rick James threw out marijuana joints at the concert. I was doing documentary work in Kenya in 2004 when I heard he died. And yes, I cried, because when I was out of the house, old enough to buy—and keep—my own music, I had bought every Rick James song I wanted.

MS. RENA BUTLER, 72

CLARKSDALE
BORN FEBRUARY 1943
SINGLE
1 DAUGHTER

Ms. Butler sounds cheerful, enthusiastic, youthful on the phone. I am relieved. Some church mothers I've talked to by phone are hesitant to talk to me, and rightly so. When I tell Mrs. Overton, another mother in the book, that I've added Ms. Butler, she joyfully says, "She'll be a good interview. She's a dear friend of mine."

Ms. Butler agrees to meet me during her lunch hour. She is a bailiff at Coahoma County Circuit Court in Clarksdale. She retired as an educator after 42 years, but a judge asked her to become a bailiff. "Do you have a college degree in law enforcement?" I ask, confused.

"No, I got my bachelor's degree in business from University of Kansas and my master's in elementary education from Mississippi State University. I know a judge, who told me I would make a good bailiff. So when I retired, I started this career."

Our plan was for Ms. Butler to come home during her lunch hour to meet me, and I worried I wouldn't be able to get specific stories in under an hour. My experience was that it takes longer; I have to explain the project and show the Jewels photos of other mothers. They like to compare one another's clothes and hats.

Ms. Butler greets me at the front door with a big smile and she's eager to share stories. She isn't guarded, which thrills me. Running around her feet is her beloved dog, Max. She caters to this spoiled little white dog. I can tell they are buddies. As she talks to me, Max is pawing at her legs. She picks him up and holds him as she answers my questions. Then she does something unexpected. She corrects me when I keep calling her Mrs. Butler. "Ms. Butler. I've never been married," she says, sharing with me that she never planned to get pregnant in high school, but she did.

When I graduated from high school, I became pregnant with my daughter, Sharon. I was totally hurt when I got pregnant. I said, "How am I going to finish my education?" I wanted to get an education because my desire was to become a teacher. At that point I didn't want to have any children. I was torn with the idea of being pregnant. I wanted to commit suicide. I wanted to jump into Desoto Lake.

A mother of a high school friend, Mrs. Christine Colburn, would take me fishing to relax my mind. I told her I wanted to commit suicide: "You know, I don't want to have this baby, it's gonna cause me to not get an education and everything." As we would talk about fishing, she would talk about how dangerous the water was. She said, "You cannot kill yourself because you're pregnant." I said, "Okay." I thought about it and I thought about it. I came home and prayed about it.

I ended up going to Coahoma County Community College. Once they found out I was pregnant, the dean told me that I had to go home. So I went home. I had Sharon. Then I had to take a job. My family, we were poor. I went to work when my daughter was just about

Rena Butler

you had a baby that's just been born." I said, "Yes, I do have a baby." He said, "Well, one thing I wanna know is where is that nigger that got you pregnant?" I said, "Well, I don't know where that nigger is, but I need this job. I need to work to help my mother with expenses and help take care of my daughter." I was so hurt. Tears formed in my eyes but I had to fight it back 'cause I didn't want him to know he hurt my feelings, because he was racist. He was very much racist. I didn't want him to know I was very hurt by what he said.

When they first integrated the schools, it was a horrible experience for me. I was attending the classes and I worked very hard in the classes and did everything the teacher would ask me to do, but I couldn't make anything but a D or an F. I stayed at Delta State for one year. And I will never forget that one year. It snowed, and as we walked across the campus, the white children would call us little black specks in the snow. I said, "I'm getting out of this place!" I decided to ask my father if he would help me with my education. My daughter and I moved to Kansas City, Kansas, and I received my degree from the University of Kansas. Once I got there, I had to stay at the university for almost a whole year on probation before they let me in. I didn't have anything but D's and F's on my transcript for that year I was at Delta State. I was very excited when they told me I was going to be entering as a regular student, because I worked very hard so I could get that probation stuff off my record. I finished at the University of Kansas with a degree in business and a minor in business administration.

3 or 4 months old. I took a job at a manufacturing company; I was on the night shift. There were three young ladies; we all had babies. We made heaters to be shipped overseas. We would walk home every night after 11 p.m.

One of the most hurting things, what really got me on that job—and I needed the job— is that the old man who owned the company called me into the office one night and said, "Oh, you a pretty, young black woman. I heard

MRS. IVEY B. ANDERSON, 73

MOUND BAYOU
BORN JANUARY 1942
MARRIED, 21 YEARS, TO DAVID ANDERSON
3 BIRTH CHILDREN, 3 STEPCHILDREN
15 GRANDCHILDREN
10 GREAT-GRANDS

When I was growing up on the plantation, we had to pick cotton and chop cotton. And there was one occasion there when we had been in the field all day long, one extremely hot summer day. It was one of those days that they say you can see the little monkeys in the air. It was so hot. There were times when the heat gets so hot out there that there are little figures that you can see in the air when you lookin' in the heat. And we called them heat monkeys. It comes from the heat from above, meeting the heat below, and it just makes a little design in the air.

There was a great big ole shade tree we had in our yard. I had been workin' that day and I looked up and one of our dogs was layin' under that tree. And that dog had just sprawled out, bottom uppers, enjoyin' that shade. I looked over there and I stopped what I was doin'— I was choppin' cotton—I stopped and I stood up the end of my hoe and just looked up under there in that shade tree.

My mother said, "What is wrong?"
I said, "I wish I was that dog."
She said, "What?!"
I said, "I wish I was that dog."
She said, "Why?"
I said, "So I wouldn't have to be here choppin' this cotton. It's too hot to be out here."

My kids [when I tell them that story] ask me, "Momma, why did you want to be a dog?" I said, "Well, that dog didn't have to work as hard as I was workin' in that hot sun." My mother said, "Well, you won't have to do all of this if you get an education. Just do your best and get an education and then you can write your own ticket."

When I fell in love initially, it was with my high school sweetheart. He was handsome. He was an outgoing person, fun loving. I lived on one end of the highway to Alcorn College and he lived on the other end. Occasionally he would ride a horse and come down to the house. He would take me riding on the horse, and that was always so much fun. He was the type of person who was considerate. He was popular, and he chose me over the rest of them, which was a plus in my book. I didn't say I chose him because when I was growing up, I kinda felt a little less than other people. I felt like I was ugly and that nobody cared a lot about me except my parents. My sister was older than I am and was much prettier than me, and it seemed like she always got all of the attention from other people. Now, my parents didn't make a difference, but I had an uncle who would always talk about how ugly I was. That kinda affected my self-esteem as a child so I kinda become a loner. A little withdrawn. My first love kinda saw through that and reached out to me. He made a difference in my life.

Ivey B. Anderson

GRAM MARRIED AT 17

Gram's old-fashioned ways about dating cramped my style. She frustrated me. Everything I wanted to do was a battle. At age 15, I started bugging her to let me date. Ms. Butler's struggles and pain as an unwed teen mother, although she was ultimately triumphant, would have been common in the world as Gram knew it.

I tried to impress her by being more responsible. I did my chores without having to be asked, dusted the furniture and tables, took out the trash. I even stopped talking back. She wasn't impressed. We continued to argue about boys for two more years. I yelled, sighed, rolled my eyes, and stomped away. I liked to stomp up the stairs when I didn't get my way. I wanted to wear blush, blue eyeliner, shadow, mascara, and red lip gloss. I was not allowed to wear any of it.

My best friends had boyfriends, were wearing makeup and kitten heels with skirts. I was still wearing holey jeans, argyle socks, and pink Dexter boat shoes.

Then I find out she was married by the time she was 17. I am mad! "You were *married* at 17. I just want to go out on a date!" I tried to manipulate her, by coaxing her into remembering the good old days when she was young and in love.

She cocked her eyebrows and looked at me sideways. "We aren't talking about me, we're talking about you. Times are different." My grandparents were not going to let me date before my eighteenth birthday.

I was livid. Gram didn't care that I was livid. All I wanted was a boy to come knock on the door and ask for me. I'd snuck and had my first kiss at

15 with the cutest white boy in school. He walked me home from school one day, put his arms around me, and put his tongue in my mouth. It scared me, but I had my kiss. I wanted a full-fledged date. I didn't have a boyfriend, but I wanted romance. I'm sure Gram was worried I wouldn't go to college and make something with my life. She liked that photography kept me busy after school, she was fine with it as an after-school hobby, but she did not approve of it as a career choice—even when I got a scholarship to study photography. My idea of making it was becoming a war photographer, having a boyfriend, and owning a German shepherd as a pet. No one really talked to me about dating. Gram was firm—leave boys alone. Which I didn't.

"Lisa, your body is going to be changing," Mom said, "and we have to discuss it." It was awkward for both of us.

I liked a boy once and told Gram, "He's so quiet. He's a good guy. You'd like him."

"It's the quiet ones you have to watch out for," was her response.

One day Gram sat me down. "Yes, I was married at 17, but I'd finished high school in South Carolina and was done with school," she said. "I was grown. I was getting married. Lisa, focus on school. Get an education. Boys will always be there."

Uninterested in where the conversation was going, I did not listen to her. But later that school year, I try again from a different angle. "How did you meet Pop-Pop?"

She told me she was from Spartanburg, South

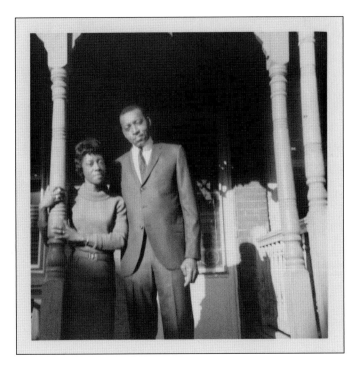

My grandparents in an undated 1960s photo on the porch of their home in Harrisburg, Pennsylvania. This was the first house they bought several years after Pop-Pop's service in the Korean War. They raised three children in that home: Walter (my dad), Marie, and Patricia.

Carolina, and Pop was from Harrisburg, Pennsylvania. "Gram Marie moved up North to find a better job, a better life. Aunt Tiny and I stayed down South to finish school." Gram Marie is her mother, my great-grandmother, Marie Aiken. I called her Gram Ree. She worked as a maid for a white family in Pennsylvania after she moved from South Carolina. Gram and Aunt Tiny would ride the train to Pennsylvania to see their mother. Gram said they would pack chicken and cornbread, or if they didn't have cornbread, they would take cake. Gram used to eat chicken and cake together all the time, out of habit. During the summer months she would visit Pennsylvania, and she met my grandfather. She "caught his eye," he said.

When I asked Pop, during that difficult interview, why she caught his eye, he said, "Because she was quiet. She didn't flirt. She wasn't interested in me. I knew she would be the one to get."

And get her he did. After a couple of years of seeing each other during the summer months, he proposed to her, and she said yes. After she graduated from high school, she moved to Pennsylvania to be his wife. They were married for 47 years when she died of colon cancer. Together they had three children and seven grandchildren.

I wish I could interview her now as I've done with more than 50 grandmothers. Gram was born in 1930, about the same time as most of the grandmothers I've interviewed. But did she have to walk miles to school? Did she grow up in a sharecropper's home? Did she ever see the KKK? Did anyone white ever call her a racist name or push her? What childhood memories did she have? From the Jewels, I have a sense of her time, racial challenges, and social dynamics, but I won't know these answers in her voice. I wish I hadn't been so self-absorbed when I was younger.

Twenty years after her death, I sit, pained. I want Gram to see how I've turned out, thanks to her guidance and boundaries. I want her to see that I appreciate her influence in my life. I want her to see that our family hasn't been the same since her death because she isn't here to keep us together. We don't make time during the holidays like we used to. Everything feels disjointed. I feel like an orphan again.

I miss you, Gram. I miss you calling me on Sundays, asking, "What are you cooking for dinner? Are you warm enough? Are you wearing your hat and coat?"

I miss you standing in the doorway, watching me pull the car up to the curb. I see you now: manicured nails, a sweater with a blouse underneath, dress slacks ironed with creases. I smell your trademark Givenchy Ysatis perfume.

Oh, Gram. I miss you! I'm sorry I was so self-absorbed. I'm sorry I didn't ask you more questions about your life. I'm sorry I didn't just sit down next to you and find out more about you. I'd do anything to read these Jewel stories to you and ask, "Can you relate to them?"

MRS. MILDRED W. LEE, 78

MARKS
BORN SEPTEMBER 1936
STILL MARRIED, 54 YEARS, TO JAMES LEE
2 CHILDREN
4 GRANDCHILDREN
1 GREAT-GRAND

My father had a job at Alcorn [State University] and he carried the family with him because we could get a better education there. That's where we stayed and went to school and that's where I went to college. We lived in a faculty home. I think we were the largest family on campus, there were four of us [children]. We went to school on campus because they had a practice school for practice teachers.

Well, it [the campus] was just bein' at home. We skated and rode our bikes on the sidewalks around the college campus; students got out of the way and let us pass. I guess when you're young, you think you have the right of way.

You know when you go to high school on a college campus, the boys give you the eye. My daddy was kind of strict, not real strict, but kind of strict. We could go to college functions, like movies and if a boy walked you home. He [Daddy] could always tell when the function was over because the boys' dormitory was across the street from our house and you could hear everybody comin' home. So our feet had to hit that step right after he could hear the noise. A lot of boys would get friendly with you because they could come over to the house and eat. And Daddy always made them welcome. So the boys would always get friendly, even if they wasn't romantic, so they could come over to your house and get a meal at night.

My dad always wanted us to be independent. He never wanted, especially his girls, to have to stay in a marriage

The bayou I pass every time I drive to Mound Bayou. I'd been waiting for the right light for months when I took this image at sunset in March 2013.

Mildred W. Lee

because they had to depend on the husband. He would lecture us, "Stay focused on what you're supposed to do. Don't let these little boys swell your head." That lecture came often. We got those real good lectures about that in the 1950s. I never did fall, fall, fall in love. You like a boy, and if something went wrong, you just let him go. There was always somebody else who wanted to come over and eat.

He [my husband] went to Coahoma Junior College and then went to Jackson State. There were two friends of his, a man and a woman, that went to Coahoma. The man went to Alcorn, where I was, and the woman went to Jackson, where my husband was. I became friends with the couple, and the girl said, "Oh,

she needs to meet Lee." The three of them got together and brought me up here to meet this "quiet man," they say. They picked him up and we went to Memphis to visit some relatives of his. On our way back we kissed all the way back. I said, "This is not a quiet man." We dated and got married the next year. I fell in love and he was the one. We had the same dreams and the same ambitions and all that is important. We liked to do the same things and he just look like he was the husband kind, the kind that would be around a long time and would stick by you. I just got that feeling. I told my sister, not a whole long after we met, I said that he was going to be my husband—and sure enough, he did.

"SAY GOOD NIGHT, LISA."

As Mrs. Lee talks about how her father expected their feet to hit the steps after a date on the Alcorn campus, I remember my dad. His name is Walter, but everyone knows him as Rocky. Although I wasn't being raised by my dad—his parents were raising me—he was active in my life, always active and crazy about me. No boys wanted to date me because Dad was fiercely protective. Boys were lucky it was Gram they were dealing with and not my father, although it didn't feel that way because my grandmother was very strict, probably because I was boy crazy. I'd seen too many romantic movies, but because I was not allowed to officially date didn't mean I didn't sneak out with girlfriends to flirt. As a result, there was a boy I wanted. Gram let me date him three months before my eighteenth birthday because she knew "his people" and was okay with his background. He was over six feet tall and had a

My senior year of high school, the year Gram allowed me to date. She wanted me to do the Alpha Kappa Alpha Cotillion in December 1987 because, although Gram was not an AKA, many members of our church were. This is the night of the cotillion with my grandparents dressed up presenting me to the public.

brown complexion. He wore glasses and braces. I liked his small eyes. We didn't travel in the same circles, but we knew about each other. We never even talked to each other, not even a hello, until we were at the same house party one fall night when I shared half a peach cooler with my best friend Shantih and got drunk. I pursued him at

the party. He was shocked I paid attention to him. I found him very handsome. He had a great sense of humor, was well liked among the intellectual crowd—smart, college-driven, good grades. He wouldn't kiss me that night. He said he wanted me to *remember* when he kissed me. I'm sure his boys made fun of me since I wasn't the hot cheerleader type. We decide to date, and when he'd drop me off at the porch, Gram would turn on the porch light. It felt like the brightest light you could have on a porch. He'd get ready to kiss me, the porch light would come on, and she'd open the front door, standing in the doorway wearing her bathrobe with a headscarf. "Say good night, Lisa." And to my date, "Tell your mother hello. You'll see Lisa at school tomorrow."

"Really?" I'd mumble as I trudged inside and she closed the door.

This happens almost every time he tries to kiss me. So we decide to kiss in his car. He parks right in front of our house. (We aren't smart enough to think of going somewhere else to park.) We are kissing in the car when the bright porch light comes on. Gram is walking down the steps and heading to the car, a bathrobed general with a headscarf helmet. She knocks on the passenger-side window. "Say good night, Lisa," she commands. And to my date, "Tell your mother hello. You'll see Lisa at school tomorrow." She walks toward the front door and stands there waiting for me.

"Good night. See you tomorrow." I sigh and walk back to the house, fuming, thinking, *She ruins everything.* I turn 18 and date another boy. Whenever I have a date in the house, Gram sits in a chair behind the sofa to make sure nothing happens. She does it every time.

Whenever I have a date in the house, Gram sits in a chair behind the sofa to make sure nothing happens. She does it every time.

MRS. REBECCA "MA BECK" HAWKINS, 100

INDIANOLA
BORN OCTOBER 1914
MARRIED 40 YEARS WHEN WIDOWED
4 CHILDREN
9 GRANDCHILDREN
4 GREAT-GRANDS
1 GREAT-GREAT-GRAND

Mrs. Hawkins, who was almost 100 years old when I interviewed and photographed her, is the one Jewel who had something positive to say about Whites. None of the church mothers said anything full of hate, but Mrs. Hawkins, who unofficially inherited Mrs. Josephine Turner's catering business after the white woman's death in

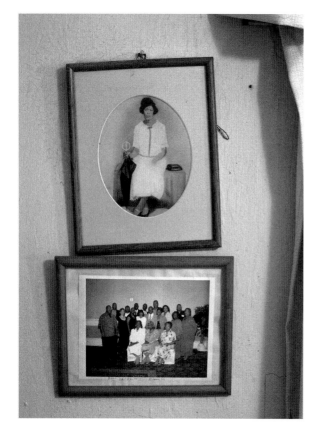

1984, actually said, "I don't have anything negative to say about white people. A white woman taught me how to save money so I could buy my house."

She still lives in that house. It's tiny, and she keeps it cozy with photos on the walls. We sat in the living room, where the sofa fronts a big window backed by a quilt.

I noticed an old desktop computer on a desk in the room. "Do you use your computer?"

"No, but my children wanted me to have it." She chuckled.

Pictures of her when she was younger adorned the walls. When I asked if I could photograph them, she replied, "Of course," then began to tell me about how a white woman taught her how to save her money.

My husband went to service in World War Two. Everybody whose husband was in service, the government was sending them a check to take care of the wife and children. A woman I worked for as a cook trained me. She told me to put my money in the bank and continue to work. Said, "You got a nice place to stay, you're comfortable, and you don't have to pay no rent." She furnished my uniforms, and her daughter, every spring, would give me gobs of clothes for my daughter. I'll tell you another thing. She told me exactly how to do. She said, "Always

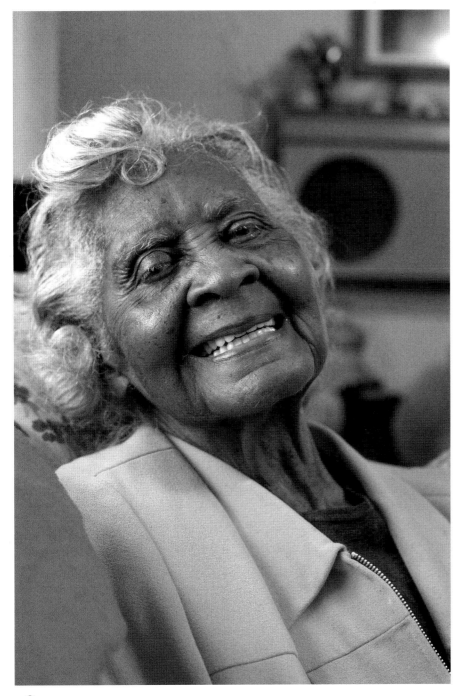

Rebecca S. Hawkins

would ride all over town and look at lots. She would say [at some lots], "No, Becky, you don't want to stay here, that's not a good place to raise your children."

The prefab houses—her husband knew how much you could buy them, for a two-bedroom. He told me to buy my lot and we would buy one of those prefab houses and get someone to assemble it. That's how I got my house. And she knew all about carpentry. She put my curtain brackets up. I'm over in her house fixin' her dinner and she down here nailin' my curtains up.

Near the end of our conversation I say, "Mrs. Hawkins, you are 99 years old. What's it like aging?" I'm expecting her to talk about how hard life is, but instead she says something that surprises me, something so sweet.

I used to hear my mother pray about letting my old days be my best days. I have heard people say, you know, they have pains, aches, and no money, they're not comfortable, you know? Would you know, honest to goodness, I think my oldest days are my best days. I'm not just telling you this. I can think of so many things I'm thankful for. I can't come out with nothin' I regret.

try to put your children in a home. Let them know what it was like to be raised in a home."

I wasn't makin' but $10 a week and $2 of that was going into a Christmas savings. That left $8. [I had] four children. I saved my money.

In the evening, they would take me and we

MRS. ORA D. JACKSON, 85

MERIGOLD
BORN FEBRUARY 1930
MARRIED 17 YEARS WHEN WIDOWED
5 CHILDREN
17 GRANDCHILDREN
32 GREAT-GRANDS
4 GREAT-GREAT-GRANDS

Mrs. Jackson had a stroke years ago and is paralyzed on her left side. She is not feeling her best, and I'm thankful she's made time for me. She has a small chicken coop in the front yard. A neighbor's friendly puppy, which looks like a Lab mix, greets me as I climb out of my car. I pet him, and his tail wags as I walk up a ramp to the door.

I find Mrs. Jackson sitting in a chair. A quiet, pleasant woman, she doesn't say a lot; she's just not talkative. I'm not sure if it's because of the stroke or if that's her nature. She doesn't provide much detail, and I work to get some stories. When I ask about her childhood, she smiles and tells me her grandmother gave her the nickname "Coote" [rhymes with "toot"]. She doesn't know how she got it, but it's stuck with her over the years.

There's a quiet sadness about Mrs. Jackson when she talks about education. "What did you like learning in school?"

"In high school I liked doing algebra. Once I learned how to do it, it was easy." She says she loved learning math, which isn't a subject I enjoyed.

I struggle to find a subject to make Mrs. Jackson more talkative. Then she tells me that before her stroke she loved gardening and cooking—canning and making preserves. "I made the best peach jelly. And I was known for my caramel cake and pound cakes. I liked to do all that before my stroke." She then tells me she retired from driving a school bus for 17 years, and when I ask her what she wanted to be, she's quiet before she opens up about helping birth babies in her family.

I tell them I saw them before their momma did. I had one niece, she was born and wasn't nobody there but me. The cord was wrapped around her neck. I knowed how to take it loose. Turn her bottom over and thump her on her feet and she hollered. You know, just...someone had to do it.

The first baby I helped was [born to] one of my sisters. That was in 1959. I was 29 years old then. This was the first time. She was at our mother's house, she went into labor, and I had to be strong. That was the first time I ever been around it. I smoked a whole pack of cigarettes, a pack of Salem, while she was in labor. Was hopin' she would go ahead and have the baby. She had a midwife. I didn't like the way she [the midwife] had her bearing down. My sister got so weak and the baby's head got stuck. It just stayed there. She got weak and I got aggravated wit' the midwife and I told her, I said, "You do what I say." I set her legs up. I got behind her back and shoulders. I said, "When the pain hits, you bear." She pushed the baby on out, but the baby was dead. I think she choked to death. They carried the baby and

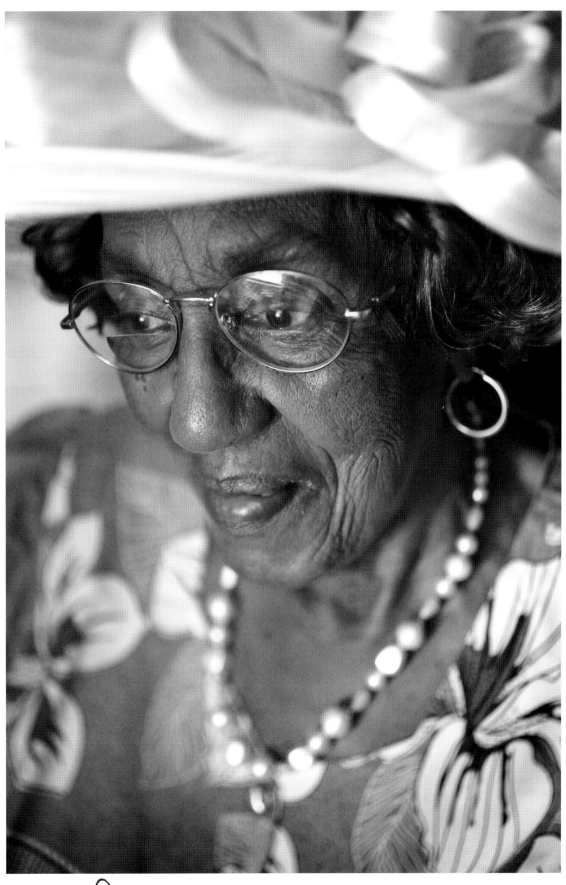

Ora D Jackson

A vintage furniture set in a yard near Greenwood.

buried her. **The doctor had to come do stitches on her.**

The second time, it didn't bother me. No fears. I just didn't fear. I put faith in God. That one came out okay. After the baby was born, I just got everything cleaned up and brought them home.

Then I had to do Christmas cookin'. I had to cook for my sister. This was Christmas Eve. I went home and cooked her dinner at my house. It was kinda tiresome. I just did it. I stayed up all night and just did it.

I stay in the room with Mrs. Jackson, a room I think is her bedroom—bed, dresser, a few chairs, and TV. Next to her room is the kitchen; I can see the stove.

She doesn't invite me to look around the house, and I don't ask, but I'm curious about the rest of the house. When I ask, "What do your grandchildren joke with you about?" she smiles and lets me know it's not only me who cannot venture into specific rooms. I chuckle. It reminds me of my Gram and Pop-Pop, who kept the plastic wrap on their furniture.

They say, "G.G. [Great-Grandma], why you got a room can't nobody go in?" Why? Because I didn't want nobody in there messing it up and making it dirty. I think I have nice furniture in there. The dining room, the living room, and my bedroom—I have other rooms they can go in, but they can't go in there if they gonna play. We eat in the dining room for holidays. My great-granddaughter said, "I be glad when I can go in there and eat."

MRS. VIOLA J. SISSON, 85

GREENWOOD
BORN DECEMBER 1929
MARRIED FOR 51 YEARS WHEN WIDOWED
NO CHILDREN

Mrs. Sisson is the sister of Mississippi Senator David Jordan. Several attempts have been made on his life because of his involvement with the Civil Rights Movement. His house was shot at as recently as 2011. His car was egged and his home has been broken into on numerous occasions. "Has Mississippi really changed for the better?" I ask myself. "Will it ever truly change?" I wanted to hear about this history from Mrs. Sisson, but I didn't want her to think that was the only reason I asked to interview her. I'm curious to know more about this tall and slender woman who walks outside to greet me in her driveway. She's cheerful and happy to see me.

She lives in a big house with multilevels. Inside is like going back in time. She has a formal seating area with a fireplace and adjoining dining room. The house is filled with furniture and decorations unchanged from the 1970s. When I say, "What a lovely home," she tells me she and her husband built it together in 1968. I then ask if they met in school, and she says no, her husband, Roosevelt Sisson, was seven years older. She had wanted to leave Mississippi to go to college and he asked her parents if he could pay for her college education and then marry her. He

sent her to Southern University of Louisiana, where she earned her bachelor's degree in history and minored in elementary education. She takes pride that she married an educated man. "He graduated with a PhD from Ohio University in Athens, Ohio," she says. "Have you heard of it?"

I chuckle. "Mrs. Sisson, I graduated from there with my master's degree. It's a small world, isn't it?"

We laugh and recall hard times. "While girls were out having a good time, I was studying because I wanted to finish and help my parents." When she finished school, she got a job as a teacher and gave her parents money to help them out. "I was the child they could depend on." (She was the middle child of five, the only girl.) "It's

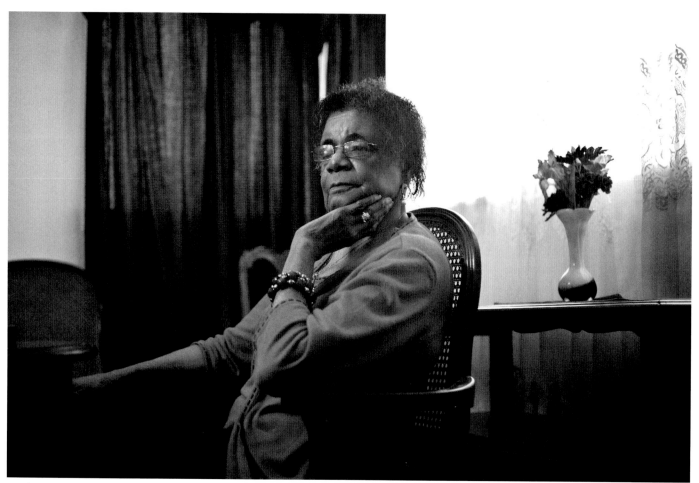

Viola J. Sisson

funny. When I was a little girl, my momma had to tell me I was a little girl. I was a tomboy. I used to swim in the river with my brothers."

"You weren't afraid of snakes or anything?"

"No." She laughs. "My brothers weren't gonna let anything or anyone bother me."

Her mother told her to stop playing with the boys when she was 12 years old, made her wear dresses, and she said, "Brought me Shirley Temple dresses." That's when she realized she wanted to be famous. She loved getting dressed up, was voted best dressed throughout high school.

I wanted to be a movie star and I wanted to open up me a school for teaching fashion. I had so many favorite movie stars—Judy Garland

and Elizabeth Taylor. It would have been different for a black woman. I couldn't go to the school I wanted to go to because we didn't have the money. I wanted to go to a modeling school, anywhere there was a modeling school. I wanted to be like them; they were foxy and they were neat and they wore pretty clothes, and I wanted to be like them. I saw [only] the Whites on television. There weren't many Blacks in the movies. [I liked] Eartha Kitt because she was black and she was a beauty star.

Momma worked for the white people, and they had some nieces would wear dresses just one time. Then they would give them to Momma for me. I was the best-dressed girl

[every year] in high school. Momma got me out of a tomboy early, about 12 years old, and put me on the right track. They [dresses] were pretty; white people bought them for their children and Momma brought them for me. Many black people couldn't buy 'em. They had ruffles around them. They were way out and full dresses. I had blue and pink dresses; they had different colors and the pink one was my favorite. The bow didn't tie behind; that's why I liked it. [No bows.] I wanted to be grown. I used to run from the boys, though. Momma told me they were bad.

Mrs. Sisson is delightful, and we laugh during our time together. However, she is self-conscious, quiet, and still when I take her photos, not the diva I expected. "For someone who wanted to be a model, you are getting shy on me. This is your moment to strike a pose," I joke. I want her to relax and I know she has deeper things to talk about than movies or modeling. "Mrs. Sisson, were times hard for your family during the Civil Rights Movement?"

"Yes." Then she shakes her head while reflecting. That's all she does, just shakes her head. After a moment or two she says that she was an educator for Greenwood School District for 35 years. "Blacks knew what they wanted, we wanted the same salaries. I know we got paid less. I don't know what they [Whites] were paid, but I know we were paid less."

And titles were not used before the black teachers' names. That bothered her. Whites not respecting the Blacks and using their titles—whether Mrs. or Dr.—bothered all of the Jewels.

Mrs. Sisson shares that the principal still called her the "N" word in 1980.

I'm shocked. "Wait, you mean to tell me that he called you that in 1980?"

Yes, she confirms, and informs me that integration came in 1970, but there were still problems in 1980.

When asked if it was hard to teach white students, she replies, "There weren't that many [white students], maybe four or five. Most Whites left the school districts then. They left the schools when Blacks integrated. It was expected."

It was seven teachers and we went downtown one evening after school and we marched. Wasn't nothin' but 180 teachers in the school system, but there were seven that marched. I was marching because the superintendent wouldn't put the title before our name, like Mrs. Sisson. When he got around the white people, he would call me Viola, the nigger girl. We marched for that—one the reasons.

I marched to get equal rights. I didn't like the water fountain when you go in the store to buy somethin'—colored over there, white over here. I didn't like that.

When we walked in a store as a group of girls and there was a group of white girls, they would push us aside and wait on them first. You were standin' there first and the salesman walk around and get someone else first. You be last, and you were there first. Ooh wee. And I'd get mad. Momma told me just be peaceful and don't go around in town actin' ugly. She was afraid I would get hurt. She always said, "Let God fix it.""

MRS. CEOLA L. CAUSEY, 74

DREW
BORN MAY 1940
MARRIED 49 YEARS WHEN WIDOWED
11 CHILDREN
13 GRANDCHILDREN
5 GREAT-GRANDS

Mrs. Causey is a quiet woman, not talkative. I can tell she's lived a hard life by the lack of energy in her eyes. She looks tired. Of all the stories about Jewels working in the cotton fields, she is the only one who talks about a fear I can really relate to.

We was livin' out on the farm, pickin' cotton, choppin' cotton. The white childrens, they would start school August just like they do now, but we, by us having to go the fields to pick cotton, we would start in September, instead of August.

We used to pick cotton, it would be so hot out there. I was 'fraid of the worms in the field and I would always get in trouble 'cause I couldn't do what I was supposed to do for watchin' for the worms. When we pick cotton, we put these sacks over our shoulders and pull and pick cotton, and I looked and worms would be crawling up my sack, coming up to my shoulders, then here I go screamin' and hollerin'. Momma would get on me, whip me sometimes, "Girl, you gotta pick cotton." I said, "But I'm just afraid of these worms." And I really was. I'd do okay until I see a worm, then here I go, standin', lookin' 'cross the field. And one day, I like reach up to scratch my head and came down with a worm in my hand, and ooh, that was the frighteniest thing I had ever went

through, but I was just afraid of 'em. But I could pick okay.

All we went through, to miss out on school to work in the fields.

When her voice trails off, I wonder what she's thinking about. "If I were to ask you about a happy memory, what would you tell me about?"

She is quiet. She doesn't say anything. "I can't really think of one." Then she says, "But the only thing that's been a blessing to me is how my children, after they finished school and got their jobs, they would start giving me money. I guess they thought back to what I didn't have back in those years, and that was really a blessing to me. They help me real good. They have all done for me." She smiles and then tells me about Milton, her son, who gave her money for her birthday and for Christmas.

"Tell me about Milton."

She is quiet again.

We went over there and he [Milton] was layin' on the floor. His girlfriend's two grandsons found him and put a sheet under his head, folded and rolled it up. When I went in there and laid my hand on his shoulder, I said, "Milton?" He tried to turn his head, but he couldn't. And then his lips moved, he was tryin' to say somethin' but he couldn't. They came and got

him. Life flighted him to Jackson, to the hospital. The doctor said he had a stroke, but I have a cousin that's a doctor and she thinks it was an aneurysm.

I'm a firm believer as long as you're breathin', God can do somethin' for you. So I got down there to the hospital. When we went in that night. We were sittin' and waitin' to go in to see him; they would let us go in one at a time. I said, "Let's pray." We start prayin' and I said, "God is gonna save Milton." My grandson was, like, I don't believe that. He wasn't actually sayin' it but the expression on his face said it.

But anyway, he [Milton] didn't make it. It was very sad and the thing that really bothered me most was that I wasn't really sure if he was really saved. And that's the really saddest part about it. And I still, every night, when I go in my room to get in the bed, I always say my prayers, sit up in the bed, and read a Scripture. And every night when I go and sit in that bed, I always think about Milton. Every night.

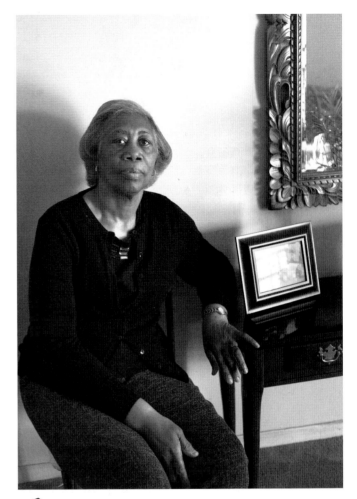

Ceala Causey

"*We put these sacks over our shoulders and pull and pick cotton, and I looked and worms would be crawling up my sack.*"

MRS. OLLIE L. MACK, 76

YAZOO CITY
BORN MARCH 1939
MARRIED 23 YEARS WHEN WIDOWED
6 CHILDREN
7 GRANDCHILDREN
7 GREAT-GRANDS
3 GREAT-GREAT-GRANDS

Rev. Benjamin Hall in Yazoo City tells me, "I have two church mothers who agree to be interviewed." As I drive three and a half hours to Yazoo City, I cannot believe I agreed to do this on a day when I have to drive back and teach an 8 a.m. class. I know I'm going to be exhausted when I get home.

I walk inside the church and two women are seated inside a hall that I can tell the church uses for wedding receptions or dinners. Mrs. Ollie Mack is seated with her cousin, Mrs. Bettie Clark. They came into the interview together. The space is large with tiled floors and an adjoining kitchen. The echo a tiled floor causes is a nightmare for audio, which I will use for more than transcripts. I want to make multimedia videos so people can hear the women's voices because nothing is more powerful than hearing them.

Collecting audio for this project has been a challenge. Some of the women have noisy homes. Air conditioners or fans hum, children talk the background, grandchildren toddle noisily around, microwaves beep because family members are heating up food, but mainly, loud television sets blare. In one Jewel interview after another, I have to constantly address audio problems. I worry about sound quality. I've spent a lot of money on equipment, but when I can't get good settings, I feel frustrated.

I already know I am not going to be happy with the echo in this room, but there is nowhere else in the church for me to interview. I move the microphone closer to them.

Mrs. Bettie Clark is on the right side of the table. She has warm eyes. Mrs. Mack is at the head of the table on the left side, cutting her eyes at me, perhaps judging me. She doesn't look thrilled to be here. "What do you mean by an interview?" is the first thing she says. "What kinds of questions? I don't understand."

I am nervous and intimidated. "I just want to ask you some questions about your life. Perhaps you'll share a story or two. Like, do your grandchildren ask you to tell them a story over and over again?"

She shakes her head no.

"Is there a childhood memory that takes you back to a time?"

She talks about wanting to get out of the cotton fields and get married. Her husband was older than her and her daddy had a fit, but she was over 18 and could do what she wanted. We talk for about 40 minutes. She is an avid sports fan; the Cowboys are her favorite team. I don't dare tell her that my favorite team is the Steelers because the Cowboys and Steelers are rivals. I don't want to have *that* conversation with her, but I am trying to find a way to get Mrs. Mack to share her

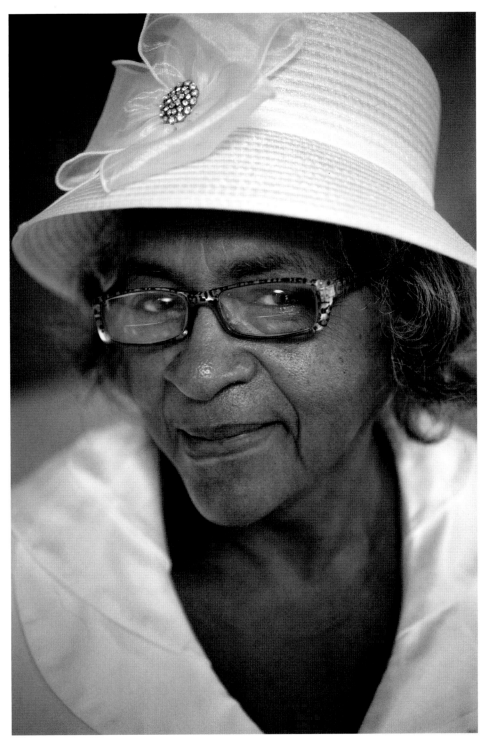

Ollie Mack

I want the young peoples to think of me as the mother of this church, King Solomon M.B. Church, and my family mother. I want to be a good mother for them and a good mother for the young folks here. That's what they call me, Mother Mack. That's what they call me. I've been at this church for almost 50 years. I got married—my husband was already here—and I joined. My children done grew up in this church. And I had no dream I was gonna be a church mother. Rev. Hall called me from the back of the church during church service, to the front of the church to be a mother. I still didn't want to be a [church] mother, but I prayed about it and I accepted. To me, it's a good thing, you know?

What you really do, you talk to the young peoples and you get the communion and the baptizing; you're responsible for that. I work with him [Rev. Hall]. You know when he have counseling, I work with him. I be there with him, that's what I mostly do. You see, I

thoughts. She answers my questions, but I want her to warm up. "What do you want your legacy to be?"

worked and was working on Sundays. I'd just stopped working and I got a chance to come to church. Just started. Thought I was lookin' good, had my clothes, and he called me 'bout the next one or two Sundays and said, "You can't sit back there no more. You gonna have to come to the front. We appointed you to be a mother." I said, "Lord, have mercy. White every Sunday? I can't have it." That just knocked me off my feet. I had to pray about it. That was the main thing, wearing white all the time. But I prayed about it, accepted it, and now I'm proud to be a mother. White dresses while on the motherboard mean purity.

Gram Ree—Gram's mother, who first moved from South Carolina and later brought Gram to the North—was a church mother in her Baptist church in Harrisburg, Pennsylvania. I didn't realize it as a child; I was raised Presbyterian. I never asked Gram Ree why she would wear all white to church sometimes. So I'm glad Mrs. Mack tells me, but I feel regret that I never asked my own great-grandmother about her church life. Mrs. Mack doesn't want to be photographed, but she lets me beam the camera on her and cuts her eyes at me while I do. I always take the photo last because it allows for us to develop some sort of relationship. I know if they do not talk to me first, they may get nervous and refuse to sit for a photo. They trust me a little after we talk.

When I am finished clicking, Mrs. Ollie gets up. She walks down the hall to the church's glass door. I hear her heels click on the tile. Her ride is here. As she's leaving, I run after her to ask one more question. I feel like Columbo, the famous TV police detective from the 1970s, played by Peter Falk. He always had one last question. "Mrs. Ollie Mack?"

She stops walking.

"I'm sorry to stop you, but I have one last question."

"Yes?"

"Where did you get your name? Ollie is unusual."

She sighs. "Two white women named me."

I ask if she will go back into the gathering room and let me record her answer. She is clearly irritated but agrees. I put the recorder back on and again ask her how she got her name.

"Two white women named me."

"Were they family friends?"

"Child, no, didn't you see *Roots*?" She huffs, implying I'm ignorant to ask that question.

I am embarrassed. "Yes, I've seen it, but it's been a long time. I don't remember some parts."

She sucks her teeth and says, "The white peoples named the children. These two white women told my mother to name me after them. Two white ladies give me that name. One name was Ollie, the other name was Louise. They thought I should have been named after them. My parents probably thought there was nothin' they could say. I'm proud of my name, I don't think nothing about it now. If my mother had something else picked out, she didn't say nothing. They was afraid of the white peoples, and whatever the white peoples said, they had no other choice, they had to go along with them. That's how that come about. Is that all?"

"Yes, ma'am. Thank you."

"You're welcome."

When she finishes, she walks back down the hall. I can hear her heels clicking against the tile.

DR. BETTIE L. CLARK, 72

YAZOO CITY
BORN OCTOBER 1942
MARRIED 20 YEARS WHEN WIDOWED
REMARRIED 26 YEARS WHEN WIDOWED
5 CHILDREN
9 GRANDCHILDREN
2 GREAT-GRANDS

Dr. Clark is Mrs. Ollie Mack's cousin. She is quiet during my interview with Mrs. Mack and smiles when things are funny. After Mrs. Mack's exit, I learn that Mrs. Clark was born on Norway Plantation in Yazoo County, where she picked cotton. She has been a professional cake decorator since 1986, and she started college when she was 66 years old. Her words stayed with me long afterward: "It's not how far you go, it's what you do with what you've got."

I was about 9 years old when I started workin' in the field. I stopped when I had finished the twelfth grade. Leaving the field was all I would ever think about. I used to say, "Lord, if you ever get me out of this field, don't let me come back."

The summer when I graduated, I went to Ohio to be with my momma's people. I had broke my teeth before I left for Ohio. My momma and them still had some crops—they were sharecroppers. She told me that if she put the teeth back and buy my senior portraits and stuff, then I would need to help them to finish the crops out. So I agreed. I had to pick cotton. It wasn't a lot to fix [the teeth], but I had to pay her back. I understand 'cause I was taking what little they had. The cotton, they weren't going to get paid for it until the end of the crop time, like November or early December.

I wanted to be a nurse, I really did. I had the opportunity, but I didn't have clothes and stuff to go to college—and I wasn't going to have to pay for it [college]. But it was a long ways from home and my momma and them didn't have money to get me up there at Valley State. It was a program through the employment office and they sent me a letter that I could go to school as a nurse, a LPN. No charges. All I had to do was go, but they didn't buy you no clothes or pay your expenses to get up there and back home. And I missed that opportunity.

When we went to Sunday school, we just read the Scripture and went home. But a lady came here [to our church] from Chicago and she taught a lesson one morning in Sunday school. I said there's more to it than that, but I still wasn't grabbin' it. So the more I went and the more I was lookin' at it, then I wanted to know more. I wanted to go deeper, so I did. My kids was tickled, they was tickled, when I went to college. My first day at school, I said, "Oh, this is great," but I was so far behind, I said, "Oh, I might need to get out of here." But it wasn't bad. I said, "Well, my best thing to do was to just listen and hush." And I started listenin' and they started making me participate and I'm glad I did. So it just got better and better. Doing the bachelor's wasn't as bad as the master's. I have my bachelor's,

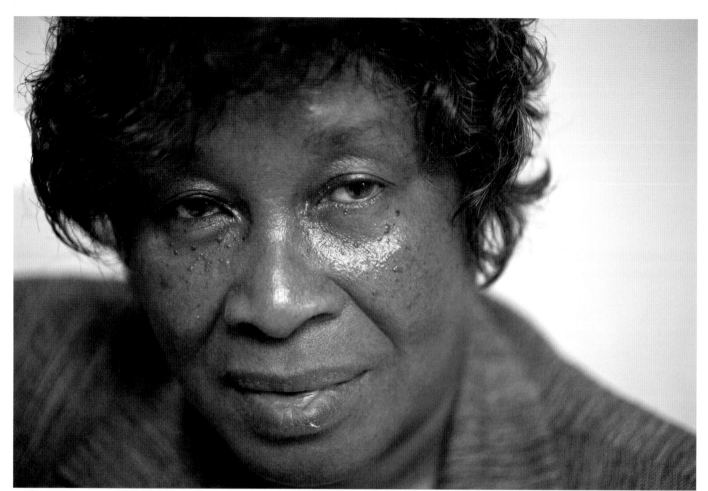

Bettie Clark

master's, and doctorate in theology. We had Old Testament and New Testament.

I'm not a pastor, you know that's a calling—God has to call you to that. As long as I know how to help my children get saved, because it's very important. And if He calls me into it, I'm willing, but I have to wait on Him.

Going to college was my greatest accomplishment. At graduation, I wasn't nervous. I said, "Thank you, Lord." I said, "I hope my kids don't holler like they do at a ball game," but you know they did. My brother, I knew his voice, I knew his voice. I felt great, not too important, but just the idea to know what God wants us to do. I didn't feel too important, like all I was thinking about was a piece of paper. I was just glad to be able to know, like I say, what God want us to do. It's more than just a piece of paper. [On that day], I remember what my brother Leslie said; he said, "I knew you was a preacher all the time." And I say, "I'm not a preacher, but I know what a preacher does."

After my interview with Mrs. Bettie Clark, she asks me if I've heard of Mrs. Dillard. When I say no, she says, "You need to include her in your book. She's over 100 years old and a sweet woman." I thought, *I don't want to make another three-and-a-half-hour drive for one more woman*, but almost reading my mind, Mrs. Clark asks, "Do you have time to stop by her house?" I immediately say yes, she calls Mrs. Dillard, tells her family about my book, and is told to bring me by—Mrs. Dillard has agreed to be interviewed!

MRS. LEOLA B. DILLARD, 103

YAZOO CITY
BORN FEBRUARY 1912
MARRIED 59 YEARS WHEN WIDOWED
8 CHILDREN
20 GRANDCHILDREN
30 GREAT-GRANDS
23 GREAT-GREAT-GRANDS

Mrs. Bettie Clark drives and I follow in my car to a big, two-story home on a main drag in Yazoo City. Mrs. Dillard, who is in a chair, and two daughters greet us. I feel rewarded: I get a third Jewel, a bonus centenarian.

Mrs. Dillard's daughter Shirley tells me that Mrs. Dillard won $10,000 in 2009 for USA Weekend Make a Difference Day. I would learn she got kicked off a plantation, had three daughters in college at the same time—Mildred, Bessie, and Deloris—and paid their tuition because she didn't know about scholarships. She held three jobs at one time—one in an employment office, another at First Baptist Church—all while she taught school. I'm often reminded of her simple words: "I think you just have to work to get what you want," and "I like to see young people get up and do something." They motivated me to continue this challenging book project.

It was pretty rough [in the 1920s] for black folks. We lived on a white man's place. When the voting started, ooh, I went to vote and this white man said, "Leola, if you know what's good for ya, you'll take your name off the voting list." I went on 'cause I didn't want nothing happen to my children. I took my name off. I went back home.

[When she lived on the plantation,] I told my husband, "Now, you tell that white man, you tell 'em when school starts, my children go to school." I don't guess he told him. So when school started, I told my children, "Let's go clean up and get ready for school." So the white man wants to know what's goin' on, children supposed to be in the field. I say, "Mister, I told my husband to tell you when school starts, my children go to school." He said, "I look for the children to work." I say, "They gonna work evenings and any other time, but they goin' to school." Look, I was a cotton-picking person to the fields, but I always wanted some way to school my children. That's my dream. How in the world would I school my children? He said, "Well, y'all have to move 'cause you ruinin' my other people." I said, "You want us to move now or until the crop in?" He said, "You can stay until the crop in."

I had to move immediately when the crop was over. I had come over here [in town] and bought a little two-room building anyway. It pleased me to have done it, so we moved. You see, I knew my children were going to school. We moved. We had a cow, a horse—he took all of that from us.

I started school myself and I finished school with one of my daughters, Mildred.

Leslie B. Dillard

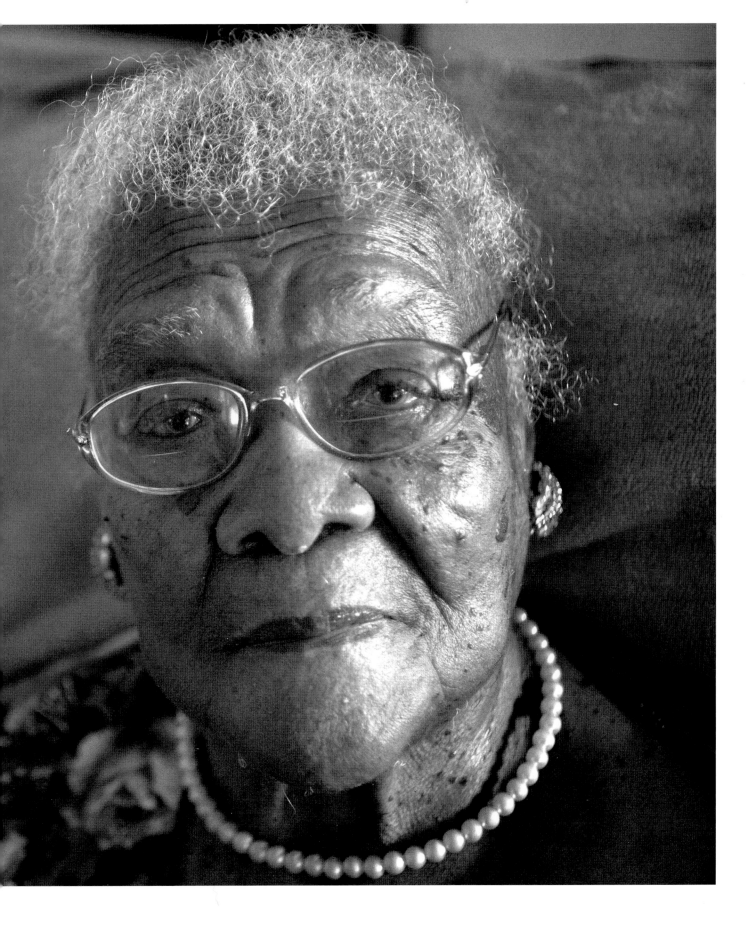

We graduated the same time from different schools. I went to Jackson State. [Mrs. Dillard majored in education and finished in 1960 when she was 48 years old. Daughter Mildred graduated from Mississippi Valley State.]

I never wanted to leave Mississippi. I never yet want to leave Mississippi. I love it here. I just love it here, love it in Yazoo City. They say it's not a good place to raise your children, but look like if you do the right thing, both you and your children, and you take time with 'em, and give 'em love and things they should have, you can bring your children up. Some peoples have such terrible children, they don't think to give 'em love. Let them know, "I love you and let's sit here and turn the TV off. Get your lesson and let's read this book. Let's go to the library together." Read books, read newspapers, read anything. Just read. Try to advance yourself, children, 'cause there are a lot of children in the world doing good. And there's so many darn bad. There's a lot of bad children, bad children.

And if we would try to improve ourselves, parents, take time to sit down—talk to your children, and try to tell 'em what's in life. 'Cause if you experience this stuff, you can talk to your children and tell 'em right. I used to get out there and jump rope and I play right there down on the floor wit' my children.

MRS. ALMA B. TUCKER, 81

WEBB
BORN FEBRUARY 1934
MARRIED 48 YEARS WHEN WIDOWED
5 CHILDREN
7 GRANDS
11 GREAT-GRANDS

I love Mrs. Tucker's attitude. She tells me she was a cook for a white family for more than 60 years. I blink. "Sixty years?" She nods her head. She barely looks 60, she is so youthful. With a light complexion and lots of freckles around her nose and on her cheeks, nothing even hints at her 81 years.

White folk ain't never been a problem with me. The white lady I worked for as a maid. It's the way you go to start workin for 'em. You go in there and she say if she want you to work for her and what she gon' pay and how many hours she want you to do that. I had to let her know I was grown when I went there.

They were nice to me and nice to my kids. They never mistreated none of my kids 'cause they know if they mistreat my kids, they had a problem with me. When I worked there, I didn't have no certain door to go to and no certain bathroom I had to use. A lot of people working there, 20 and 40 years, and got a certain bathroom to go to, certain glass to drink out of. A lady up there in Sumner, I went and told the girl I want a glass a water. She said, "Wait, let me find you a cup." I said, "What you gonna do with a cup with all these glasses here?" She said, "Naw, Ms. So-and-So don't like us to drink out the glass," and I said, "Oh no, then I don't want no water then. I'm not drinkin' out that cup." So the lady must have heard us talkin' 'cause she come in there and said, "Look up there in the cabinet and get yourself a glass." And she in there workin' for her and I'm not workin' for her, so I reach in there and grabbed a glass, rinsed it out, and got me some water. It's the way you start with 'em. So the boy that used to work for them, James, used to do a lot of plumbing, come in and he said, "Ms. Tucker?" I said, "What?" He said, "Can I have some water?" I said, "Yeah, you can have some water, get you a glass." He said, "Which one of these glasses do the black folk drink out of?" I said, "We ain't have no integrated glasses here." She was standing there. And he looked at me funny. He bust out laughin'. James know I'mma have a fit with integrated glasses. I washed them all. Why am I gonna have a certain glass to drink out of? It's just the way you start with them. Me and her got along just good.

Mrs. Tucker, whom everyone calls Puddin, is a no-nonsense woman. She says what she means. I envision her not taking any junk from anyone. There's just a way about her. She said the white woman she worked for now lives in California and they still talk quite frequently on the phone. "We never had a run-in as long as I'd been there," she says, but recalls one day when the woman said, "'I want you to take care of this boy because his mother gotta go to the doctor.' I said, 'Naw, I'm

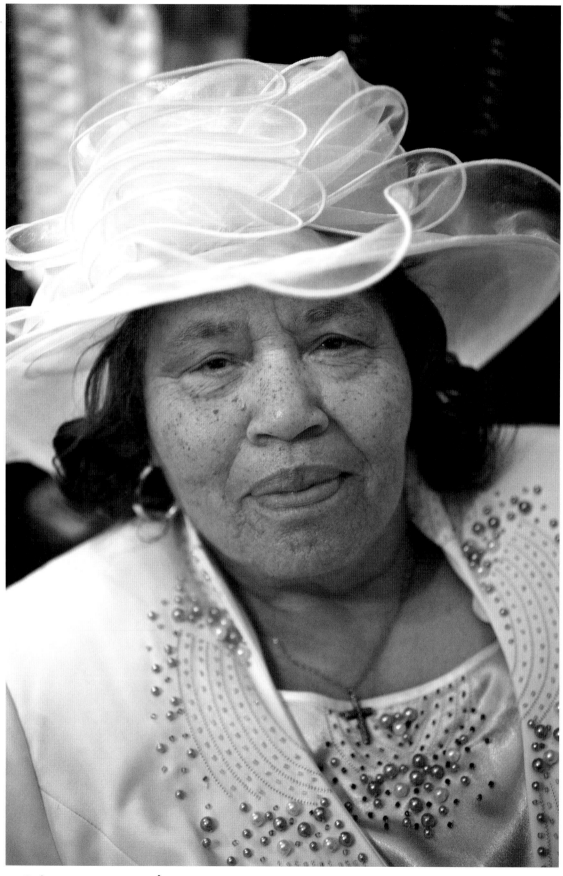

Alma Tucker

not gonna. You see I'm gonna get my hair did.' She said, 'You can call that woman and tell her you'll come tomorrow.' And I put my hands on my hip and said, 'And she can call that doctor and tell them to change that appointment!'" She left and got her hair done. The next morning the white woman hugged her.

After being with her for only 30 minutes, I can envision this exchange like a scene in a movie. As we laugh, she says one of the men who worked there heard about this exchange and told her she wasn't going to have a job if she continued talking to the woman like that. "And I told him, 'I wasn't looking for no job when she called me and asked me to come over and help.' I ain't never had no problem with white folks."

Of the more than 50 Jewels, my husband wants to meet Mrs. Tucker. "Really?" Mary asks when I call to tell her this. I explain that I played Mrs. Tucker's audio for my college students and everyone loved her mom's story. "You know, we almost didn't agree to this book," she says. "Mama has a sixth-grade education. She's not college-educated like some of the other women in the book. We weren't sure what you were going to do with her words."

This hurts me a little. "Mary, your mom's story is very powerful. She's one of the most powerful speakers I've heard. I love what she says. I would never try to embarrass your mom. A lack of formal education doesn't mean your mom doesn't have something powerful to add." I read her what I selected from her mom's transcript and she approves.

I tell her that my husband has listened to her story and he loves Mrs. Tucker's response when I asked her what she wanted her legacy to be.

I pray that I done paid off my house and I want them to keep it in the family. If they don't never come and stay, they have a place to come. And they don't rent it out 'cause they know it's gone, 'cause someone gonna tear it up. I own just the house and behind it. It's somethin' I worked for and I want it to stay in the family. I tell them all, nobody never give you nothing. You gotta work for what you get. And when you get it, you need to hold on to it, especially when you done paid for it. 'Cause most black people, they work hard and they get the land. Then a time come and the white man offer them a couple dollars and it's gone. Then they gonna go rent somethin' from the white man when their momma and daddy done worked all their life payin' for somethin'. They gonna give it to the white man and then turn around and pay the white man rent for stayin' in the grandmomma house. Uh-uh. My daddy never did wanna chop cotton for no white man. He always sharecropped, you know had that land, rent it from him and worked it, and when he got old, he said he wouldn't gonna farm no cotton land, pick no cotton. He just gave it up, retired.

MS. BESSIE M. THOMPSON, 96

CHARLESTON

BORN JULY 1918

SINGLE

6 CHILDREN

16 GRANDCHILDREN, 5 STEP-GRANDCHILDREN

21 GREAT-GRANDS

I meet Rev. Derrick Williams in his office at the New Town Missionary Baptist Church in Charleston to show him my portfolio. He's a young pastor, enthusiastic to help, and he's already talked to Ms. Thompson and her daughter Pat, so they are expecting me. I follow him in my car less than two miles to Ms. Thompson's house.

The TV is on. Ms. Thompson is sitting in her chair. She has beautiful big eyes. I learn she's hard of hearing, so I ask Pat to tell me what life was like for Ms. Thompson, although I prefer to hear the story from the mothers. Pat is eager to talk: "We call her Madea." She says her mom was a good mother and stressed education to all six of her children. Pat went to college but was put on academic probation her sophomore year. Things weren't working out because she was having a hard time adjusting to college life. "I decided I was gonna quit college, that I don't have to be here." She came home and thought she was going to relax.

Rev. Williams starts to laugh when he hears that. "I know Mother Thompson doesn't play!" He made me eager to hear the story.

Pat agreed, but said:

Mom didn't get upset. She didn't fuss. About a week at home she got her cousin and she said, "C'mon, Pat, get dressed." I said, "Where are we goin'?" Mom said, "You can't just sit here, you have to work." My cousin took me to a chicken factory in a nearby county. I started cryin' immediately. You know people are in chicken waste up to their knees in boots. And I go, "Please don't make me work here." She said, "Without a college education this is the best you're ever gonna have." I came back home and she made me fill out that application. The school principal lived down the street. I asked him, "I'm out of school this semester, will you please let me sub and work at the school?" So he said yeah. And he called me every day to sub. That's the way I got out of the chicken factory. I didn't wait 'til the fall. That summer I went back to summer school and I was on the dean's list the following semester. I still finished with my class in four years. That really had an impact on me when she took me to that chicken factory. I don't want the people that work at the factory to feel that they have less. It was just a lesson that she taught me and now I work in education.

"Ms. Pat, I want to put this story in the book. Is that okay?" I ask. She says yes, but with hesitation.

"Listen, I'm not saying working in a factory is a bad life. It's honest work, but it just wasn't for me." She worries that telling me this story will upset people. She worries she will come off as arrogant because she didn't want to work in the factory.

"Ms. Pat, I understand, but it's an important story about life choices and how your mom wanted more for you."

She nods her head.

"How far did Ms. Thompson go in school?" I ask Pat.

"She quit school in tenth grade. She helped the family by picking cotton. Her last child was graduating from school in 1978, so she decided to get her high school diploma, too. She went back and she got her GED. She and my brother both finished in 1978."

I look over at Ms. Thompson, who is looking at me. "Ms. Thompson, you went back to get your high school diploma?"

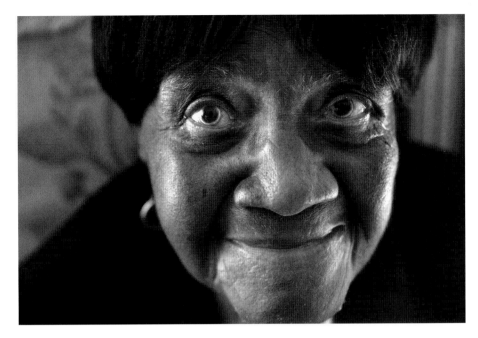

She hears me and nods her head yes. "I had all the children in school. They could think for themselves. I said to myself, 'Bessie, you better try to learn something.' It was better when I went back because I was older, and if I wanted to know, I had to study and that's what I did."

Pat continues, with pride, to help tell her mom's story: "That was one of her greatest accomplishments. She was always good in math. When she was getting her GED, her teacher would have her help the other students."

Rev. Williams, sitting on the sofa next to me, is nodding his head and I remember my grandmother saying, "They can't take an education away from you." I never knew who "they" was, but it dawns on me that Gram meant Whites. Blacks didn't have choices. Ms. Thompson quit school because she did what she had to do to help her parents earn money to keep the family from going hungry. Other Jewels tell me that their mothers would tell them they *couldn't* go to school because they *had* to work. The family needed them. Ms. Thompson had to help her family, but education was so important to her that many years later she went back to school.

She reminds me of my mom. Mom told me that when she was pregnant with me her senior year, the high school rules were she couldn't attend during the day. Even though she was married, the stigma of being a pregnant teen remained. She had to go to night school. Mom worked in a factory most of my life. When she was in her forties, she decided to follow her dream and become a nurse. She worked full-time and went to nursing school nights—full-time. She maintained a 4.0 grade point average the entire time she was in school!

Ms. Pat snaps me back to reality: "She used to tell people, 'Use your head for more than a hat rack, that's why I send you to school. Learn to read and understand things for yourself.'"

Pat adds, "When she told us, 'You go to school and act like you got some sense. If you embarrass me, I'm gonna embarrass you,' she meant that. If she had to come to that school, we knew we were in trouble."

GRAM WASN'T SURE I LEARNED ANYTHING

"Lisa, get an education. No one can take that from you," Gram used to say. My grandmother always instilled the importance of education in me. I could almost hear that refrain as I reflected on the cotton fields while I drove, having just heard that Ms. Thompson quit school in the tenth grade to pick cotton because her family needed her help. She regretted not finishing, so much so that she went back to earn her GED when her youngest child was a senior in high school. They graduated from high school together. I respect what she's done in her life. I respect what having an education meant to her.

Gram always knew education was important. She used to say it all the time. I heard her. I knew the words, but I didn't fully comprehend them until I started interviewing the Jewels. They didn't resonate with me until I heard their stories. I knew that Blacks weren't allowed to get an education, that school was not held for black children during cotton season and was almost nonexistent and woefully substandard even between seasons. I'd heard the stories, but hearing these words, the personal stories from the mouths of these victims of racist oppression, touched me. Hearing the horror stories from the Jewels makes me appreciate the upbringing and lifestyle Gram and Pop-Pop gave me.

I was always absolutely terrible in math. Didn't matter what math—algebra, geometry, trigonometry, calculus. I was awful at all of them. In the tenth grade, I was studying geometry. I wasn't getting it. I don't remember my teacher's name. He was a white man with a mustache, strict, he scared me. I thought he looked like Hitler, because the same semester, I was learning about the Holocaust in history. I couldn't do geometry, but I was not going to him for help, no way.

My aunt Marie tried to tutor me at the dining room table. We had a formal dining room with French doors. I remember her sitting at the head of the table. "Why aren't you getting this?" she used to ask while frowning at me.

"I don't know. I'm terrible at math."

"You can be good at anything you put your mind to," Marie would sternly point out.

I rolled my eyes.

Gram took me to after-school tutors and church tutors. It wasn't sinking in. Gram was convinced I was fooling around in class, not paying attention. I assured her that I wasn't disruptive in class. To this day I don't recall if I was. I remember strolling into class one day, books in my arm, wearing my cute eighties puffy sweater, laughing with my girlfriends. I walk inside the classroom door entrance and freeze in my tracks—just like a movie. Gram is sitting in the back of the room. She's staring at me. She doesn't say a word. She wanted to observe me in class. If I was doing

anything I wasn't supposed to be doing, did she think I would do it with her in the room? I could feel her eyes burning a hole in me. I was so mad at her. I turned and glared at her. She didn't say a word to me and I didn't say a word to her. But my friends knew who she was. Everyone knew who she was.

I earned a C in that geometry class. I was quite proud. I actually passed! But oh no, Mrs. B—which is what Dad called Gram and how I referred to her when I was upset—wasn't convinced I learned anything. She sent me to summer school. My summer school teacher was shocked I was there. Do I really need to tell you the kind of students who typically attend summer school? I was afraid I was going to get my butt kicked daily. I was scared. Surely, I didn't belong there. I came home the first day so angry: "You do realize where you've sent me? I have a target to get my butt kicked and it will be all your fault. Why did you send me there?"

"I wasn't convinced you learned anything." She had a way of shutting you down with a very calm voice, a few certain choice words, and never curse words.

"What?! I got a C in geometry."

"I think you can do better."

I went to summer school. I don't even remember what grade I got, but I was mad at Gram all summer. I can't help but laugh now. I have a poster on my office door that reads, GOOD AIN'T GOOD ENOUGH.

I knew that Blacks weren't allowed to get an education, that school was not held for black children during cotton season and was almost nonexistent and woefully substandard even between seasons.

MRS. MARGIE T. JOHNSON, 79

HOLLANDALE
BORN JANUARY 1936
MARRIED 29 YEARS WHEN WIDOWED IN 1966
14 CHILDREN
7 GRANDCHILDREN
6 GREAT-GRANDS

I am asked to talk to high school students who are visiting Ole Miss. My colleague, R.J., who runs the Mississippi high school program, thinks the visiting students will enjoy hearing the Jewel stories. I am not sure about that, but I agree. R.J. assigns me a small lecture room, where, at most, 20 students can sit. *Perfect*, I think, not expecting as many as 20 kids.

High schoolers start to pile into the room. There are way more than 20. Some start to sit on the floor, others line the walls. The room is full and students are sitting in the hallway outside the door. I'm shocked that so many kids want to hear stories about black grandmothers.

I start with a slideshow of selected Jewels. At Mrs. Dillard, the eldest mother in the book, I talk about how she was thrown off a plantation because she refused to have her little girls pick cotton.

"I know her," says a girl's voice in the back of the room. She is sitting on the floor, so I can't see her.

"Who said that?" I ask.

A tiny brown-skinned girl with her hair in a natural Afro puff raises her hand. *Small world*, I think, and say, "Wow, you know her? That's awesome. She's a wonderful lady."

"Are you done with the book?" the girl asks, which surprises me.

"No, I need about ten more but I'm having a hard time getting women to agree," I say in a private conversation in the middle of this presentation.

"I want my great-grandma in the book," she says. "How do you decide on how to put them in the book?"

I tell her that the women must be over 70, agree to give me details about their life stories, live in the Delta, and let me photograph them.

"I want my great-grandma in the book."

"Talk to me after the presentation."

I continue the hour-long presentation. The kids laugh, ask questions. I am shocked they are so engaged. "You, too, can tell these stories. Go interview your grandmothers and grandfathers. Do it now while you have them. Don't be like me, wishing I had taken time to learn something about my grandmother."

Students thank me as they leave, but three brown-skinned girls stay, eager to talk to me. "So which one of you was talking to me about your great-grandma?"

Alicia shyly says, "It was me."

"Well, where does your great-grandma live?"

"Hollandale."

I've never heard of it. She tells me it's near Greenwood. "It's in the Delta, right? Not just outside it?" She nods her head yes. "Well, I'll tell you what: if your grandma agrees, I will interview her, but only if you're there to listen."

"Can I call her now?"

I nod and think, *This child wants her great-grandma in this book. Let's make it happen.* She calls

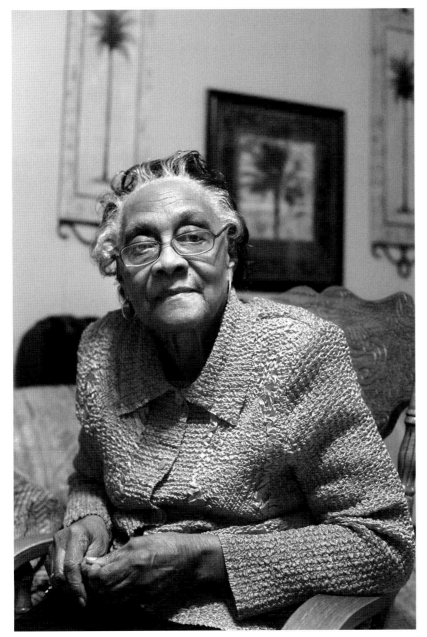

with a tone that says, *What did this child get me into?* I explain and she agrees, but I can tell she doesn't really want to do it. She's only appeasing her great-granddaughter.

The day I am to interview, there's torrential rain. My phone service keeps cutting off and the GPS signal is lost. When I do have service, I call Bobby: "Babe, there are flood waters and I'm lost. I'm nervous. Can you get me directions to Hollandale? I am supposed to be at a mother's house but I'm lost."

"Where are you?"

I tell him and he stays on the phone with me and directs me. "There's supposed to be a gas station on your right. You're going to pass two streets and your turn is the next right." It's getting late and skies are darkening. I don't like to drive in the Delta at night. I am almost three hours from home, and I have to teach the next morning. I don't have the house number in Alicia's text message, nor do I have a description of the house. I call Alicia and finally pull into the driveway, almost an hour late.

Everyone has been waiting for me. Alicia greets me with a hug. I smile and thank Mrs. Johnson for her time. She doesn't smile, but says hello; she doesn't really want to do this. She's seated in a chair and with her are three adorable little boys, her great-grandsons, still dressed in their Sunday church clothes. As I explain the book and show Mrs. Johnson some of the stories, Alicia and her cousins listen.

When I ask her, "Tell me a story that people ask you to repeat. Tell me about your childhood,"

her great-grandma on the spot and she agrees to the interview. Alicia and her two girlfriends giggle. I am delighted to have this bond, and I exchange phone numbers with Alicia. An hour later, I receive a text: "Hi ma, you're now my godmother."

When I call Margie Johnson, I can hear hesitation in her voice. "I agreed to do this for Alicia, but tell me about this book you're doing?" she asks,

I can tell she has something to say. She looks upward, thinking. She decides to talk about the Depression, the only mother in the book to do so.

Back in the day, I believe President Roosevelt was coming into office or something. They called it, I don't know, the panic time. We had stamp books. I think I was 8 or 9 [years old]. Each person in the house had a stamp book. You had stamps for shoes, stamps for everything—gas, flour, stamps for meat, everything you bought, you had to have stamps. Everything was rationed back in the day. And when you go to the store to buy groceries, you couldn't buy Coca-Colas. You could get—they called them soda waters back there then. They were the red, the yellows, and the root beers, but you couldn't buy Coca-Colas, those were for the other color [Whites]. We couldn't afford to buy them. The other pop was cheaper. I don't even remember the Blacks buying Coca-Colas.

Oh, I had a Cola-Cola, 'cause the little white girl that lived on the plantation, she made sure I had a Coca-Cola. She liked my aunt that raised me and she would come up to our house and she'd say, "I'll get you a Coke, Margie." Her name was Eugenia, and she would give me a Coke.

Mrs. Johnson tells me that her aunt raised her. She doesn't go into detail and I can tell she doesn't want to tell me why. She is pleasant, but there's still tension in the air, as if she still doesn't want to be in the book, doesn't trust me, so I tread lightly, wondering if perhaps this is her nature. Alicia is still listening to our exchange. I try to find something to warm up Mrs. Johnson. I ask about the women in her life. Now she smiles and tells me she was raised by her aunt. I love what she says.

My aunt taught me morals. She taught me that whatever you tell somebody, make sure you do what you say. Let your word be your bond. I didn't know what a bond was at that time, but now I understand that if you give somebody your word, you supposed to follow it up. And if you can't, go back and let them know that you can't do it right then and [say] I'll be glad to do it when I can. She gave me that and then she taught me about God—the importance of knowing who He was for myself, not just because somebody else said it.

She's starting to warm up. She smiles more and she's leaned in closer to me. Her eyes show me her spunk. Forty-five minutes into the interview and Mrs. Johnson is enjoying herself. "What else do you want me to know about you?" When she tells me she taught herself how to drive, my eyebrows go up, and Alicia smiles and perks up, too.

I could never figure out why the car sat in the yard and everybody [my family] walked to church. They would walk to church for prayer meetings. They would walk to church for Sunday school. They walked to church for Sunday. But the car would sit on the yard. And the only time they would take the car out the yard was when they drove to town to make groceries.

That gravel road would hurt your feet even with shoes on. Anyway, they'd be walking and leave me at home, so I was to do the chores, sweep and clean. Well, I would go out there, and I would use more gas in the yard than they used on Saturdays for groceries. 'Cause I would back it up and go forward. And then I would take and get the broom and sweep tracks out, sweep all the tracks out and then just wash the car. So then you never could tell I had it. I cooled it down. I learned all my techniques on driving in the yard. I have never had no driving lessons. So that's my driving story. I was devilish, I was very devilish.

MRS. MARY L. CHATMAN, 75

CLEVELAND
BORN SEPTEMBER 1939
STILL MARRIED, 40 YEARS, TO JESSIE CHATMAN
5 CHILDREN
23 GRANDCHILDREN
7 GREAT-GRANDS

I've arranged to meet Mrs. Chatman on a Sunday after church. The night before, Bobby came home from a family visit in North Carolina but had stopped in South Carolina to buy me peaches, which I love. It is too many for me to eat and he doesn't like their texture and won't eat them. I decide to take some to Mrs. Chatman.

When I meet her in the church sanctuary, she's seated on a pew with her thick, silver bangle bracelets shining against her brown skin. Mr. Chatman and Rev. Tinson wait outside the sanctuary.

I instantly like her when she says in a deep, raspy voice that she can tell a lot about a person just by "putting my eyes on 'em." She looks at me intently and doesn't take her eyes off me as I explain the project. It rattles me a little, but I keep talking. When I finish, she says: "I listen real good. In my lifetime, I had to listen to learn something."

"Mrs. Chatman, I have some peaches for you in my car. Please remind me after our interview."

I be tryin' to tell them what's right, what to do right. 'Cause when you teachin' a person, you gotta tell 'em the right way. So if you don't tell 'em the right way, they don't know nothin' no way when you get through talkin'.

When my daughter was dating, her friend had to come meet me and then I had to see if he was all right. I had to look, see if he was all right and I didn't have to do nothin' but just look—put these eyes on 'em. You see, and then I knew. You just know.

It's like right about now, I don't care who I'm talkin' to and I don't care what we talkin' about, I'mma listen real good to you, and if I don't get the Alzheimer's, I come back wit' you and tell you what you said, too. I'm a real good listener. That's how I learnt a few things I know in life, a lot of 'em, really. I had to listen to learn 'cause I'm not educated, I mean tenth grade. I couldn't get no further, because we had little ones, we had to help work and feed them. So we had to work and take care of them and then we had to chop cotton, we had to snap cotton.

We go to school sometimes and then Momma said, "You can't go, you can't go to school today." And you know that would hurt me, but that was my mother. I had to do what she said do and that's how we missed out on our education. But my younger siblings educated. Well, you know, sometime, I feel a little disappointed, sometime. I feel like, you know, maybe if I could have went on, a little further, maybe I could have done some better things in my life. I always wanted something of my own anyway. Look like it took so long for me to get some things of my own. And I know it's not my own, 'cause God gave it to me and he's just lendin' it to me for a while, and so when I leave,

I want my children to maintain whatever we have. I don't want them to give it to nobody out there, 'cause I worked too hard. I say, "I want you to keep what your momma and daddy left for you." 'Cause like my momma, she didn't have nothin' to leave me and I know she didn't and I know she did the very, very best she could for us.

Mrs. Chatman says that her younger siblings received an education, and I can tell she's proud of them, but she clearly has regrets about not getting more education. I hear sadness in Mrs. Chatman's voice, as I have when other Jewels say they are not educated persons. It hurts me to hear them say this about themselves. A formal education doesn't take away from their wisdom, their life experiences. I feel very honored to have my private history lesson from them, and this is what I told all of them. "I know education was denied to you, but that doesn't take away your value. You have something important to add. You're a smart woman. You have wisdom. I'm here because I want wisdom from you. I think there are a lot of people who can learn from you."

There is a quiet moment between us. I watch her fidget with her bracelets. I suspect we are both thinking about what the other has said.

During the interview she fusses about her clothes. The pastor didn't tell her I was going to take her photograph. She wishes she had known. She's wearing a straw hat, a floral knee-length dress, and a half sweater to cover her arms. "I'm usually dressed up for church," she said. "I haven't been feeling good."

"Mrs. Chatman, I think you look lovely. My gram was strict about me dressing properly for church. No pants, always wear pantyhose and very little makeup."

Mrs. Chatman nods her head. Then she echoes others Jewels who have complained that younger women today don't wear enough clothes to church. They are not happy with sleeveless shirts and short dresses.

I know, some years back, I was getting older when I joined the mother board. As I sit there, Sunday and Sunday, whatever we're havin', I'm getting more wiser. I learn more stuff. It's just some stuff I can learn on my own. I'm just glad I can think for myself, a little bit, you know? Although I'm not educated but I can still think for myself. I got a lot of wisdom now, I don't let anybody take that from me either, naw. I just know things, and if you been in this world for 70-some years, you gotta know somethin', don't you think so? I changed my way of living, I changed my way of dressing. I changed because the stuff I wore, the things I was wearing in my thirties and forties, I don't wear that no more. I just wear what we old ladies wear.

The young women today, my advice, for number 1: Be educated. Get your education and you can be just about who you want to be in life. When you go out there to get a job, look presentable. Number 2: They need to learn how to put on some clothes. Them some awful clothes they wear. You don't come to church naked. They be naked. And what I call naked: when you ain't got no sleeves. I call that naked and I guess they think that's right, but it's not. Look presentable.

I nod in agreement with her and feel older than my 43 years. When I see girls on campus wearing short shorts, tiny skirts, or tight, low-cut blouses, I shake my head. I know Gram wouldn't have let me step foot outside my house dressed that way.

Mr. Chatman has been patiently waiting for his wife for almost two hours. Rev. Tinson is waiting to lock up the church. As we walk outside, Mrs. Chatman says, "Lisa, don't forget my peaches."

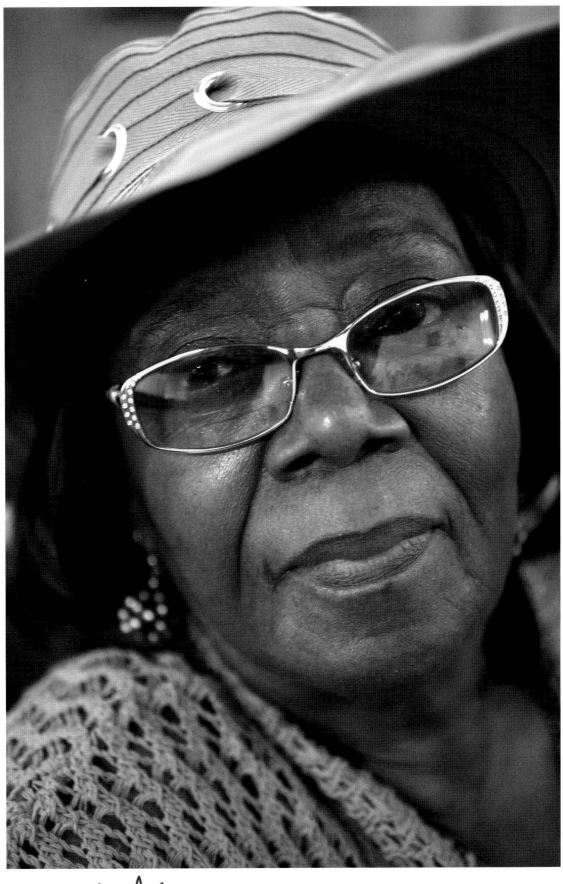

Mary L. Chatmon

POP DIDN'T HAVE TO SAY A WORD

I was a senior in high school when this photo was taken in my bedroom in 1987. I was not allowed to wear colorful makeup. One day I put red lipstick on while we were driving to church. Pop-Pop casually took his handkerchief out of his pocket and wiped the lipstick off my lips. Without him having to say a word, I knew never to wear bold lipstick in his presence again. This photo was taken around that time.

Mrs. Chatman talked about girls coming to church naked. She considers anyone whose arms are exposed naked. Gram was the same way. No wearing pants to church. Always wear stockings and always wear something with sleeves.

I poked holes in my stockings when I didn't want to go to church and said, "I guess I have to stay home." She had a brown complexion, and I wore "tan" or "nude" stockings, colors she didn't wear.

"No, you don't. Get in the car. Let's go to the store and I'll buy you stockings." Gram would drive me to the convenience store, buy me the lightest-colored stockings she could find, and off we went—whether they looked right or not.

My grandparents were proud I was active in our church. I was proud, too, but I had no choice in going. It wasn't up for discussion. I did have a sense of pride as one the eldest children going to church and I especially loved it when the elders smiled at me. I just wished there were more children in the church, so I wouldn't have stood out so much. What I remember most about church was being a teenager and wanting to wear red lipstick.

I idolized a popular 1980s singer named Sade. She was known for her long ponytail, big silver hoop earrings, and the trademark scarlet lipstick on very full lips.

One day, while I was high-school-aged, I put on red lipstick while I sat in the backseat of the car on the drive to church. Pop noticed through the rearview mirror but never said a word. He just looked at me. He parked the car and we walked up to the church doors as a family. Just as I reached for the door handle, Pop took his handkerchief out of his pocket and without a word wiped the lipstick off my lips. After the red was removed, he opened the door to the church.

As a teen, I never wore red lipstick again in front of the family. I knew better. Without Pop-Pop or Gram saying a word, I knew I was never to wear it again. I would sneak it to school, wear it, and then wash my face before heading home.

I am 45 years old now and don't have the confidence to wear it even now. I know it looks good, but my dad and my grandfather always told me that I didn't need to wear "that mess" to be beautiful. "Men don't like all of that mess. Women look like clowns with a bunch of makeup on. When you wear it, we wonder what we're getting. If you wear so much of it as a young woman," my dad said, "you will *have* to wear it as you get older." Dad is right.

Pop took his handkerchief out of his pocket and without a word wiped the lipstick off my lips.

MRS. DELCIA R. DAVIS, 87

INDIANOLA
BORN MARCH 1928
MARRIED 62 YEARS WHEN WIDOWED
15 CHILDREN
40 GRANDCHILDREN
20 GREAT-GRANDS
3 GREAT-GREAT-GRANDS

Mrs. Davis volunteers every day as a senior citizen companion. I find it enchanting that an 87-year-old helps other seniors. She has a friendly face, clasps her hands when we talk, and leans to the side of the recliner chair when she smiles her innocent smile, which I like very much.

One of the pastors told me she was blues musician B.B. King's first cousin, but she said, "No, I was married to his first cousin. They were very close. Almost like brothers." (They were in a singing group together called St. John Gospel Singers.) "You know, I'm in the museum, too. My photo is over there." She's referring to the B.B. King Museum and Delta Interpretive Center. She explains that she; her husband, Birkett; B.B.; and his first wife all lived together in a sharecropper's home when they worked in the field. "His name was Riley, Riley King at that time. But when he started playin' the blues, he changed it. Changed it to B.B. He left us. He moved to Memphis. He and my husband were lovey-dovey, never had a falling-out. They were good to one another. Never told on each other." She chuckles. "When he left to go to Memphis, it hurt him [my husband]. My husband said he didn't know why he left. But he got famous. Played and got famous. Broke my husband's heart when he left. He stayed down to earth. He stayed the same."

"Do you still see Mr. King?"

"He still sees me when he comes home. He was really close to my family. When he came home, he came to my house and his auntie's house. When they passed, he just came to my house. He liked my cooking. I used to cook peas and okra for him. Right out of the garden. It would be some good eatin'—nothin' like straight out of the garden. He used to love my pies and vegetables. He knew I could cook when we all lived together."

"Well, how did you meet your husband?" I ask, and she smiles.

I first came to Indianola to visit my sister and I met this young man and his name was Birkett Davis. After I stayed awhile, I went back to Kosciusko in Attala County [in Mississippi], and then after that he came up there and asked my mother for me. I really was amazed because I didn't think he thought that much about me.

When I met him, he was a singer, sang quartets [St. John Gospel Singers]. I was sittin' in a chair listenin' to him sing, and when he finished singin', he sit down beside of me and asked my sister could he take me to the picture show. She said, "Yes, if she wants to go." We went to the picture show and we talk and talk.

After he asked for me, my sister brought me

back to Indianola and we got married. I was 15 years old, should have been in college or at least in school, you know. My father died when I was 9 years old and my mother married again. I had a stepdaddy and I didn't like him. I wanted to visit my sister so I can leave home. After I got acquainted with this young man, I said this is my time to leave home for good. And I got married. I liked that singin' he was doin' and he was just so nice and mannerable. His mother was so nice to me. I liked that about him—he loved his mother; that means he love his wife. He was a good husband to me, my goodness. And we were together for 62 years before the Lord called him home.

When we were wrapping, I asked if there was anything she wanted to tell me that I may not have asked, and she replied, "Oh, I have a story. I need to tell you this."

A car wreck in 1975 killed two of my sisters and hurt four family members of mine. Killed my oldest sister and my only brother on the spot in Lexington, Tennessee. My mother was in there, and my sister-in-law was in there, and my other

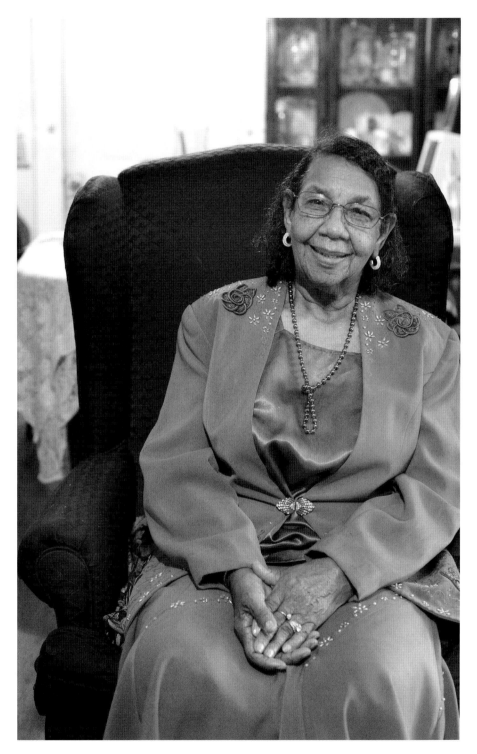

Delcia R. Davis

sister in there, and a grandchild. They survived. They came to visit me right here in this house. They were on their way to Cincinnati,

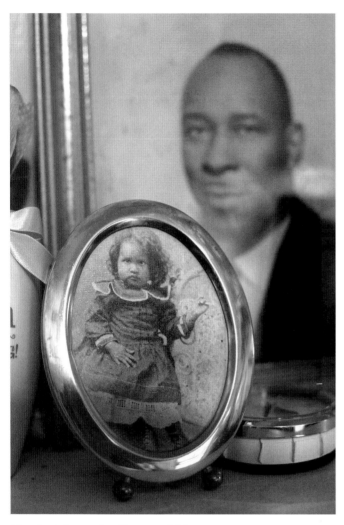

Mrs. Davis's grandmother as a child.

to Lexington. That's where he had the wreck. It was a Jim Crow town, and they were so mean to my mother and my sister.

That was a rough time in my life. She [Momma] had collapsed lung, cuts on the back of her head. She had to have surgery. They put a hole in her back and got that water out of her lungs so she could live. Then they put my mother out of the hospital. My mother had Medicare, and I asked, "Why can't y'all keep her?" [They said,] "Well, her hours are up here. She can no longer stay here." The black folks that saw the wreck said they were lucky to put her in there at all. They didn't like black folks. The hospital in Tennessee put her out, put her out completely, and my sister and my momma's grandchild out. God, it was rough then—1975. You know it was rough. We cryin' day and night, just cryin', tryin' to get my momma somewhere. My sister had her back broken and her arm broken in three places. They sent her to a hospital in Jackson, Tennessee. Everybody got injured. The black folks that saw the wreck, I didn't know them, they helped us, told us it was a Jim Crow town. I said, "What?" I didn't know what Jim Crow town was. They said, "They ain't gonna keep your momma." I said, "What's I gonna do? She ain't able to go back to Indianola, that's too far. My son-in-law live in Cincinnati and won't be here until tomorrow. What am I gonna do?" Woman said, "We gonna find somewhere." And she found a place for Momma to stay. They was some good peoples.

Ohio, and an 18-wheeler jackknifed, fell up on the car, and mashed it down. I tell you that was the roughest thing in my life. I got home from church that night. My daughter was here [at home] with some little ones and she told me about the wreck and everything. My husband and I got in the van, got ready, and went

MRS. EASTER LEE SHARP, 75

SHAW
BORN MARCH 1940
STILL MARRIED, 49 YEARS, TO PETER SHARP JR.
2 CHILDREN, 1 STEPDAUGHTER
3 GRANDCHILDREN
13 GREAT-GRANDS

Rev. Hawkins has referred me to Mrs. Sharp. She agrees to the interview and we meet at her sister's home in Shaw. Her sister Ethel Taylor opens the door and welcomes me in. She's cooking dinner; it's fried and smells good. Mrs. Shaw is tall and has shy eyes. She's wearing her Sunday best, with a hat. Her sister leaves us in the living room and I break the ice: "Your first name is unusual. Where did you get it?"

My daddy named me Easter because I was born on Easter Sunday. We never had a lot of money, but we were never hungry. You know my mom was resourceful. She did a lot of canning in the spring, so in the wintertime we had food because she had already prepared. She raised a garden and raised chickens, hogs, and stuff. We always had plenty to eat; we just didn't have a lot of money.

Mrs. Sharp is serious with little visible emotion. I can't read her. She's very polite, but unexpressive. I search for a topic that might get her to smile. She admits that she is shy and, when asked about her greatest accomplishment, states she wanted her children to have more than she did, and not to grow up shy like her. They are well-adjusted adults.

I'm proud of my two children. When I was coming up, a lot of things I didn't do because I was shy or didn't learn to do. I guess, I tried to live my life through my children. I made sure they learned to do things that I wanted to do and didn't do. Simple things like, everybody could ride a bike. I never rode a bike, so I made sure both of them rode a bike. My daughter didn't have any problem but my son said, "I don't wanna do it." I just had to keep after him. I took music lessons, but I didn't learn [the piano] as well as I wanted to, so when my daughter learned her ABCs, I started her with music lessons. She didn't want to do it, but she learned. She's just that type that she would learn anything. And my son, ooh, he hated music, so his grandma got involved. "Let that baby alone." I took them to swimming. I never learned to swim but wanted them to swim. My daughter can swim but my son can't. When the instructor looked around, he, my son, was sitting on the floor of the pool, underneath the water. It just frightened him so, and when he got home and we put him into the bathtub, he was shaking just getting into the bathtub. So then again his grandma said, "Don't you take that baby back there." My life was influenced a lot by her. I felt like I should have taken him back, but my sister-in-law said, "No, don't you take that child back." He's not afraid of the water. He'll go out there and wade in the water, but he never learned to actually swim. I just didn't

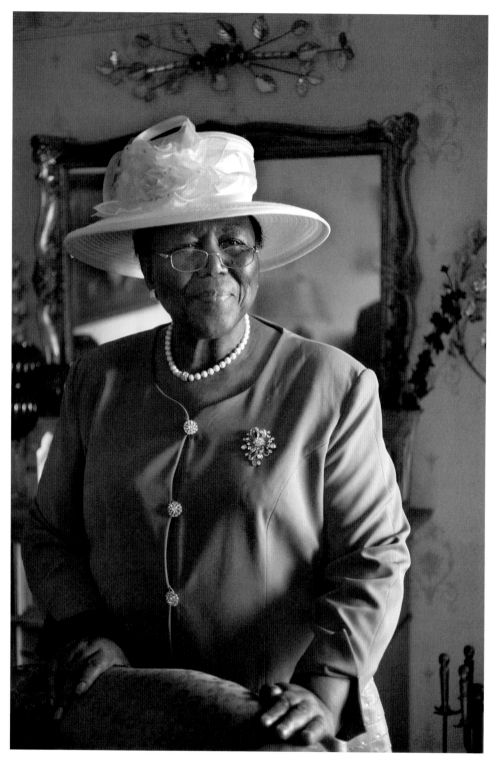

Easter S. Sharp

want them to be shy like I was. I thought I was too shy. When you get older, you don't like to go out and start things, but when you start young, you learn a lot at a certain age and other folk don't say to you, "You just now learning how to do that?" A lot of things I could have done, I guess, but I just couldn't lend myself to get up there and learn how to ride a bike.

I want my legacy to be that I've been fair and I tried to instill in others around me to treat others the way they want to be treated. It's important to me to have folk do things decently and in order. I mean it that way because a lot of times we do things and we say, "That'll do," or "That's all right," or "We don't have to do it that way." It bothers me that you don't care enough to try to do the right thing.

DECENTLY AND IN ORDER

Mrs. Sharp is a very proud woman and very elegant, graceful, and tall, albeit a bit shy. I smile at her words "decently and in order." She reminds me of my gram and how we would fight about how to do certain chores. Gram was a tiny thing, but strict and firm in her beliefs. She ran the household. What she said went, and I knew that in order to get what I wanted, I needed to do what she told me to do. That didn't mean I always got my way—I hardly ever did—but I would appeal to her.

Sometimes I tried begging Pop-Pop to talk to her. "What did your grandmother say?" he'd ask. When I recently talked to him about it, he laughed. "I wasn't getting in the middle of you and your grandmother. I knew better."

In order for me to go out with friends, I had to do two things: perform my weekly chores of sweeping, vacuuming, and taking the trash out of all the rooms in the house, and go to church on Sunday mornings. If I didn't do those things every week, I could forget about going to the mall with my friends or doing anything fun. During the week I also had certain days to wash the dishes, as we did not have a dishwasher.

During the warmer months my job was to rake and sweep the leaves. We had three old, large trees in front of our house. We didn't have a driveway. We lived in the city, and our house was on one of the main drags. I hated raking leaves. Gram would stay in the doorway and watch. "Stop sweeping like that," she'd say. "Do little piles so you're not sweeping dirt everywhere."

"What differences does it make if it gets done?" Looking back, I'm amazed I didn't get slapped.

She sucked her teeth and said, "Do as I say. No arguments. I want it done my way."

I vividly remember wanting to say, "Then you do it." But I was smart enough not to say a word. I'm positive I would have been slapped and then grounded. Gram liked things done her way. Decently and in order.

"Do as I say. No arguments. I want it done my way."

MRS. DAISY IDLEBURG, 88

MOUND BAYOU
BORN JANUARY 1927
MARRIED 14 YEARS WHEN WIDOWED
1 CHILD
5 GRANDCHILDREN
7 GREAT-GRANDS

Mrs. Idleburg lives in a ranch house on a large plot of land, a security camera by the garage door. Rev. Tony Anderson referred me, and mentioned he sometimes parks the church van at her house. "One day I came over to get the van and she pulled a gun," he said, laughing. "So I always make sure I call her beforehand." I park in front of her house. I see the church van. I call her: "Mrs. Idleburg, I'm here. I'm getting out of my car now." She says okay and opens the door. "I heard about you and that gun. Rev. Anderson told me. I just wanted to make sure you knew who I was. I'm not trying to get shot." She laughs and hugs me. The house has a sweet, aromatic flower scent. It smells fresh and comforting. "Ooh, it smells good in here!" I say.

She thanks me as we walk through the red and white kitchen. In the living room an old Bible, its edges tattered, sits on the table. Her sofa is adorned with quilts, and a corner wooden shelf displays family photos.

On the wall above the big window is a picture of White Jesus.

"Mrs. Idleburg, may I photograph this beautiful Bible?"

She nods her head, "Go 'head," and she sits on the sofa, watching me. I ask to photograph White Jesus, too, and she gives me permission. When I sit next to her on the sofa, I begin to make conversation: "You have long hair." Her shoulder-length hair is combed to the side. It looks hot-combed and waved.

She nods.

I set up the microphone to start the interview. "Are you nervous?"

She shakes her head.

"So Rev. Anderson tells me you're a handful."

She giggles like a schoolgirl, covering her mouth with her hands, before I can say anything else and soon admits: "I was devilish. I was always in trouble." She continues to laugh through this fun interview.

We didn't have no boys in our family. Just the two girls—me and my niece. I was about 11 years old and my niece was about 15, so we grew up together and we did a lot of devilin' together. When Momma whipped one, both of us cry. We plowed, we chopped, we picked cotton. Didn't go in with nobody else; we had to do it ourselves, but we made it. Thanks the Lord. And we got to pickin' cotton. We'd get out on the ground and pack our cotton with our feets. We packed it so heavy. We'd get to the cotton house, just a laughin' cause he [her dad] had to empty them sacks, and we was packin' 'em wit' our feet—the bottom to the top. There was nothin' between his shoulder and shirt and the sack. He'd have a fit. We'd put him to work. We'd laugh and keep on doin' it. We said, "You won't do nothin', we give you something to do." We made him empty those sacks. Yes, indeed.

My niece and I got into all kinds of trouble. We'd picked peanuts. We'd put them on top of the house and let 'em get dry. She [niece] went up on the ladder and got her some. I didn't eat no raw peanuts but I just doin' it, and went up there and got me some and I heard him [dad] comin' through the house. There was a nail in the side of the ladder and I was comin' down that ladder and that nail struck me in the hip. Ripped my hip. I got down before he got out. That didn't stop us, though.

Darly Iddleburg

They'd be in the front of the house and we'd be on the roof eatin' peanuts. We'd always do somethin'.

When they be grindin' and makin' molasses, Daddy would come, bring that alcohol, whatever they called it, and bring it home. I would get some and mix it in the slop for the hogs. We'd get behind the back and put some in the trough, let hogs drink it and get drunk and fall out like crazy. We'd fall out and laugh. We got the hogs drunk. They'd be so drunk. We got into all kinds of stuff. Yes, indeed. You should have seen the hogs, staggering out. We'd be out there laughin'.

I NEVER SKIPPED
SCHOOL AGAIN

I call Mrs. Idleburg the "bad girl" in the book. She was head cook for 22 years at Mound Bayou Heart Start, yet the stories she shared were all mischievous. Her giggling, as she recalled them, made me smile. She reminded me that neighbors who paid attention to us kids were important when I was growing up. I don't know what it was like in white neighborhoods, but in black ones, neighbors watched out for one another's children.

When I was in middle school, Gram, Pop-Pop, and I moved to a mixed-race, middle-class part of town from our previous neighborhood, which was on the northeast part of town, just north of downtown. Our old street was tiny; if cars parked on both sides, it looked like cars could sideswipe you. When cars weren't coming down the street, my dad would race me down the street. Trees were planted on the sidewalks in front of brick row houses. Neighbors swept in front of their homes. It was an all-black street in an area of town Pop-Pop says Blacks could buy homes—one of few such places back in the day. Our old neighbors were seniors, who watched the neighborhood kids. They made sure we didn't do what we weren't supposed to and they made sure we were safe. We knew if we did something we weren't supposed to do, our parents would get a call if the neighbors didn't spank us first. We played jacks on the porch and caught lightning

bugs in old Hellmann's Mayonnaise jars. It was a good childhood home. I always drive down the street when I visit. Most houses are abandoned now. I get tears in my eyes when I look at our old house. I don't see my grandmother's white flowered curtains.

Most of our new neighbors were white, but there were a few black families. Our house was about a mile from school.

One of my best friends, Shantih, and I decided to skip school and watch *Oprah*. We were art students. Our high school had a partnership with an arts magnet school. We would take academics in the morning at the traditional school and ride the bus to the art school in the afternoon. We decided to skip art school this day. We were even bold enough to have a pizza delivered. My grandparents were at work. I thought we were free and clear until in walks Gram. Shantih and I were lying on the floor having a good time when Gram casually walked into the house and said, "Hello."

"We don't have school this afternoon," I lied.

"Okay," she said, and went upstairs and evidently called the school, because she very calmly came downstairs and politely told us: "Get up. I am driving you back to school."

We didn't argue with her. We got up and went. There were no fights in the car, no talking back. When I came home from school, Gram didn't

I was 18 years old when this photo was taken in 1988. My mom and grandfather Harry Larson are in the picture with me. This was taken in Grand Rapids, Michigan. During this time, I would argue with Gram Burton about chores. I had to do them just as she wanted or I would be put on restriction.

punish me. She didn't give me any restrictions, which is what she would have normally done. I knew how fortunate I was not to get punished, but her disappointment was enough punishment.

I knew who called her. It was Ms. Ruth, an older white woman who had the most beautiful brownstone across the street from our gray and white stone house.

I never brought it up and Gram didn't either.

I never skipped school again either. I knew Ms. Ruth was watching me.

I think back to all the devilish things I did and giggle now. As mean and strict as I thought Gram was back then, I am grateful for her. I wish I could tell her that now. It's an empty feeling. People tell me she's with me. Yes, she is, but I wish she were here in person, so I could tell her that I hold close what she instilled in me.

MRS. RUBY STEIN PERRY PATTON, 86

SHELBY

MARRIED 25 YEARS WHEN WIDOWED

BORN JULY 1928

5 CHILDREN

15 GRANDCHILDREN

11 GREAT-GRANDS

3 GREAT-GREAT-GRANDS

Her answers are short and sweet, no detail, and I can tell she doesn't think she has much of importance to share in the book. More than an hour into the interview, " her son Robert says, "Mama, did you tell her about how you helped people to vote?"

I just stare at him, my mouth open.

"She took 100 people to register to vote—in one day," he continues, and explains that it was in the 1980s when he was running for alderman in Shelby, Mississippi.

"Mrs. Patton, you helped people to vote?"

"Oh yes, yes I did," she says, her voice livening up. "I drove a shuttle to the polling center, back and forth all day. Taking peoples both Blacks and Whites to vote. I didn't care what race they was, if they wanted to vote, I'd help them."

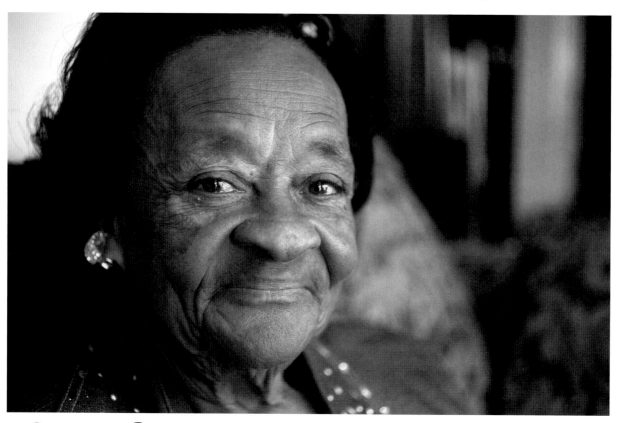

Ruby S. Patton

I was very political not just during election time, but year-round. I hauled 100 peoples in one day to vote. Carried them to the poll to vote. It's been years ago. It was in the eighties. In one day. I started picking them up at 6 a.m. I would have them lined up. I'd go through the community and campaign and talk to the peoples on who I would support, ask them what did they think about this candidate.

One of the reasons I got started in the 1980s, door-to-door, talking to the peoples [was] because my son Robert was running for Shelby alderman.

My name got so famous, so popular, among people by helping so many people, didn't nobody wanna ride anyone's bus but mine. They would say, "I'm waiting on Ms. Patton." I bought a van and would go get people and take them to vote and make another run—all day. So many times I would help them, even to bathe, old ladies. I would help wash them, dry them off, and then come back and pick them up and take them to vote. I could go to the poll and have them line up outside the door, sometimes to across the street. They would say, "I want Ms. Patton to assist me."

It was important to me. I would tell them who is gonna run for mayor and they would have their cards in their hand and say, "This is who I'm gonna vote for." I never had a hard time voting from Whites. I would rehearse with my peoples before I got there. It was just the way you would carry yourself a lot of times and not try to take the election over. I would say to my peoples, "We gonna be very cooperative now. Don't make nobody mad. It may take a little while." So many times I'd take extra chairs for them to sit down and rest. There'd be that many people wanna vote. I was trying to help our poor black peoples get elected. I had white and black peoples that I would help. I wouldn't just say black all the time. It was who I thought was the best person.

I worked for Barack Obama. I campaigned. I started out in daylight. I went from door to door. When he won, everybody could hardly make it, so excited. I was excited. My candidate had won. I'll tell you what, I'd be so tired, I couldn't even go to victory ball. Be done give out. When you haul 300-some people a day, by yo'self, you give out when night come.

[During the 2012 presidential election] I got excited. I said "Our president playing basketball and he need to be tryin' to win." I went to cryin'. I was worried because he talkin' about playing basketball. I said, "That man need to be workin'. He gonna mess around and lose this election." I said, "Oh, Lord have mercy." I was excited, I ain't gonna tell no stories.

Now I'm 85, I done retired from politics now. I go in and vote and that's it. But everybody wants to know, "Ms. Patton, who you votin' for?" I want my legacy to be that I always want to help somebody in the polls. That's what I do.

Mrs. Patton reminds me of the time when I was in high school that Gram campaigned *not* to have our street named after Dr. Martin Luther King Jr. It was Market Street, but it came up at a city meeting to change it to MLK Drive. Gram was adamant about keeping the name. Black folks wanted to know why a black woman would oppose the change. Gram—never one to sit back and not voice her opinion—said during a television interview that after a certain point down the main drag, the "element" changed and it wasn't the nicest street. "Dr. King would be embarrassed to have that street named after him, looking like it does." She said it was named Market Street, had always been named Market Street as long as she could remember, and she didn't think changing it, when it got shady just north of downtown, was a good thing.

MRS. ANNIE McFARLAND MISTER, 77

GRENADA
BORN OCTOBER 1937
MARRIED FOR 34 YEARS WHEN WIDOWED
4 CHILDREN
7 GRANDCHILDREN
4 GREAT-GRANDS

Mrs. Mister was sick when I traveled to Grenada, and I interviewed a Jewel she recommended, Mrs. Fox, instead. But I can't stop thinking about Mrs. Mister's interesting name and call her a couple weeks later: "Mrs. Mister, how are you doing?" She's fine, back home after a short stay in the hospital. "I haven't forgotten you. Do you still want to be in the book?"

"I thought I missed my chance."

She lives in a neat community of brick ranch homes. Everyone has a carport, and all the yards are neatly manicured. I drive down her street and a male neighbor waves to me. That's one thing I love about the South—people wave and speak. Black angel figurines populate a table in front of the living room window. She sits in a wooden rocking chair by the kitchen. The tidbit she most wants me to know about her is this: "I won an oracle contest in 1955. I was a good speaker." As I show her the book pages, she sees a quote from one of the women. "I want my quote to say, 'I can do all things through Christ, who strengthens me.' I want my legacy to be that I inspired young women by leading them to Christ and being a role model for them. You know, Lisa, I feel like a grandmother to you." When asked to share a story to educate people about life in Mississippi, she's quiet for a minute, looks me in the eye, and says, "I can't forget about how I grew up and how we went to school." She goes on to say her father was a deacon and her mother was a church mother who baked the communion bread. "I used to like to watch her." She says it seemed like she was in the spirit.

We lived on a farm and we were sharecroppers. We didn't have any tractors; we had mules. My daddy plowed mules in the field. We chop cotton. And we picked cotton. We walked two miles to school while the white children would ride the bus and pass by us and throw the mud on us, and all that kind of thing. But what I can remember about going to school and being a sharecropper, I tell everybody now, that I attended private school because it was segregated. I just make a joke out of it, sayin' that it was private because it was segregated. We had black schools and white schools and everything was different about everything. I can remember walking to school. I was the youngest, and the big boys would have to carry me because I couldn't keep up. I was in the first grade, six years old. Everybody on the farm would gather together and walk to school, the two miles to school. It would be cold, ice spewing up out of the ground, but we would make it to school.

My uncle had an old pickup and he covered it over and he would pick up the children near him. And we would all ride on the back of Uncle

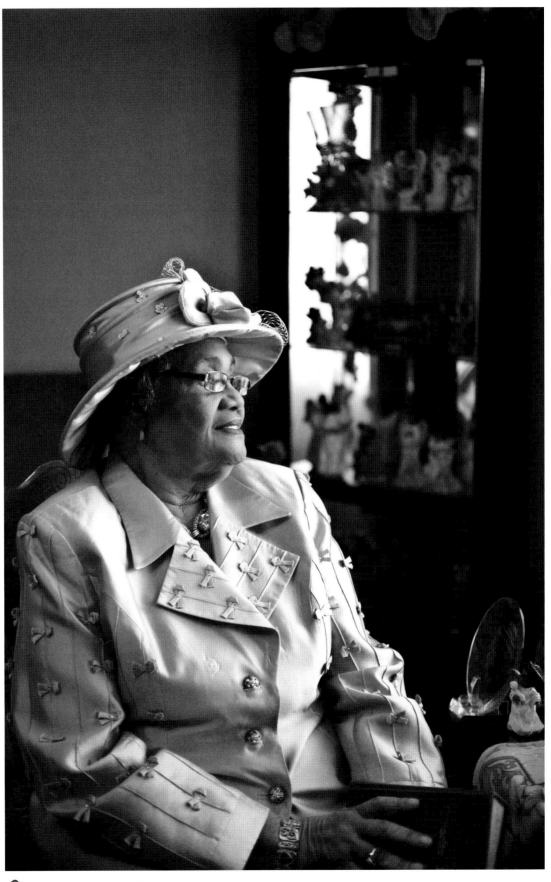

Annie M. McFarland Minter

Sylvester's old truck and we thought that was a luxury to get to ride to school.

My mother would have special wood, oak I think, that my brothers would chop, to burn in the wood stove, to cook her communion bread. She felt like it was sacred. She would go and make her fire and she didn't want to be bothered. She just wanted to get in the spirit while she was makin' that bread. I never shall forget. If you go near her, you could see not to disturb her while she makin' that bread. She didn't make loaves. It was just like piecrust or somethin'. Real thin. And she would just lay it in the pan and cook it. And then she would carry it in a whole piece. It would kinda curl up when it was cooked in the oven. A whole piece. She would not break it. The pastor would break the bread. When she'd take it there, it would be in this cloth and he would break the bread. He would break it in small pieces, then he would serve it.

She home made wine. She used it for communion. I do it now. Make it from muscadines and grapes.

I would have liked to be a social worker or midwife. [When asked if there is any regret in her life, anything she wishes she'd done, she says:] I wanted to be a midwife, really, to deliver babies. I was with my sister before she could get to the hospital and I helped her deliver the baby. I guess we bonded with that baby. I felt so good about it. I wanted to help others. Before I could pursue it, it became so controversial. You had to go to school and get a license, and all that kind of stuff. You had to have so much training. All of my mother's children were delivered by midwives. I still regret I didn't do it. I still try to teach women now how to have a baby naturally. They need to exercise and breast-feed, and all that kind of thing. I want them to let it be natural.

MRS. EMMA EUDORA McGEE HORTON, 76

CHARLESTON
BORN OCTOBER 1938
MARRIED 34 YEARS WHEN WIDOWED
3 CHILDREN
4 GRANDCHILDREN

"If you're in front of Mrs. Smith's house, you can see mine," Mrs. Horton says as she gives me directions to her home. An educator, she is a graduate of Piney Woods College with a master's degree from Tuskegee. She also lives across the street from another Jewel, Mrs. Florida Smith. At her front door, wasps are swarming from several nests. I walk to the door, ducking wasps. She hears me and peeks her head out the carport door.

"Hello, Mrs. Horton, I'm Lisa. It's nice to meet you. Be careful because there are wasps' nests outside your front door." She tells me she doesn't use the front entrance. "Is there someone who can spray those for you?"

"I'll have my son do it next time he's here." Inside, in the family room, are a built-in bookshelf, fireplace, sofa, recliner, and coffee table. Above the fireplace, family photos hang on wood paneling. "You know, I almost didn't let you in," she says nonchalantly. I'm offended. Does she not know how long it took me to get here? I would have been so upset had I driven all the way for her not to answer the door. But I can't say I blame her for being skeptical. "But I called Mrs. Smith, who said you were a good girl and to let you in." Right away, she lets me know her husband of 34 years died a few years ago. "My best friend is gone," she says, and looks down at her fingers.

I can tell she was deeply in love, so I ask, "What did you like most about your husband?"

"Well, he was honest and said he'd always prayed for a good wife—and he just figured I was meant to be his wife."

"Tell me about your first date. Do you remember it?" She sucks her teeth.

Our first date? He told me he goin' to a movie, and we got there, I looked, I said, "This not a movie, this look like a hotel."

He said, "We goin' in there, baby; we gonna love it up."

I said, "Not me." I said, "Only man I gettin' in the bed will be my lawfully wedded husband, and you can take me back on home now."

He carried me back on home. He said he woke his daddy up. He said, "I have met my wife." 'Cause, he said, any lady who would jump in the bed with him, he not marryin'. Put an X through her name and moved on to the next one.

Yeah, I was offended he did that. I went out with him again because he changed. He respected me. He honored me 'cause he said I was the first lady who put him in his place and that's the type of lady he was lookin' for, not one to jump in the bed and have babies and all that mess. I put him in his place.

So he started plannin' a big wedding with me. We got married—December 22 in Yazoo City—after dating for a little over a year. We came back here [Charleston]. He got a travel house for us to stay in and he told me this

when he was ready to get in the bed: he said, "We married now."

I said, "Get on your knees."

He said, "Get on my knees?"

I said, "Yeah, 'cause you do not know who you just married and I don't know who I just married, but we gonna get down on our knees and pray that we be nice and good for each other."

So he bent down on his knees and I got down on my knees. I stayed there a long time and he got up. He said, "Eudora, get up off your knees. I'm a good man and I'mma be nice to you." And I got up.

I had prayed about it [going to Piney Woods College] and so I caught the old yellow school bus with a old raggedy suitcase. Got on it and rode over in town and my brother got out the bus and walked me to the Greyhound bus station. I go from the Greyhound bus station, get a cab, and go over to the Trailways bus station and then Trailways would carry me on to Piney Woods. And when I got to Piney Woods, I said, "Lord, if it's not Piney Woods, I ain't got enough money to get home," but it was Piney Woods.

I heard one day down on campus someone say, "Y'all see her?"

I was 22 years old when I started at college. I heard one lady say, "But doesn't she look like she gonna be somebody one day?" That's what I heard her say. And, you know, most of my students, those that made doctors, lawyers, and what have you, they give me credit.

I always wanted to be a schoolteacher. My second grade teacher said I went to her desk and said I was gonna be a schoolteacher. I just

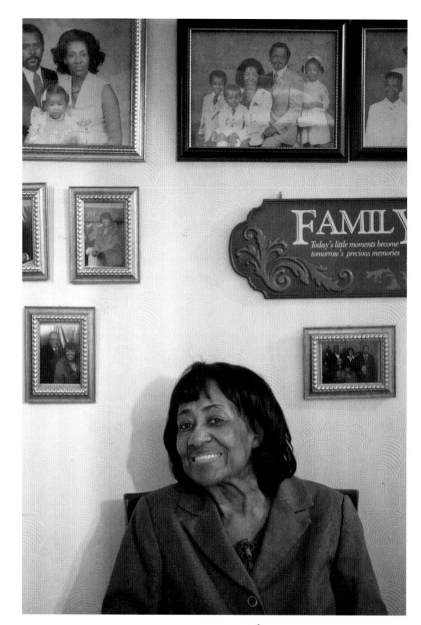

Emma Eudora McGee Horton

worked toward that goal. I sent myself to college. I worked. Reading *Up from Slavery* from Booker T. Washington, was some of the reason I end up goin' to Tuskegee. 'Cause that was one of the most fascinating books I read. So when I made it to that campus, I broke down and cried 'cause I'm at a school that the founding father inspired me to come on and go to that school.

MRS. LILLIE V. THOMPSON DAVIS, 85

MARKS

BORN JUNE 1929

MARRIED 21 YEARS WHEN WIDOWED IN 1973

3 CHILDREN

5 GRANDCHILDREN

5 GREAT-GRANDS

Mrs. Davis reminds me of actress Cicely Tyson. She is cordial, but serious, soft-spoken. She wears cat eyeglasses, which were popular in the 1960s. I love the style, and bought a pair of imitation retro ones several years ago and refuse to change my frames; I just keep updating my prescription. She has the real deal and I check out her glasses with envy.

"Excuse me for a few minutes," she says, "I'm going to change into my outfit for the interview."

It is significant to me that she trusts me enough to leave me alone in her living room although we've just met less than five minutes ago. I walk around the plush sofa in a room where time has stood still, full of photos in frames on a metal bookshelf near a wall clock that chimes, next to a curio full of knickknacks. There are glass candy jars and photos of her family on the mantel. A postcard of President Obama hangs on a mirror.

She comes back wearing a metallic gold two-piece skirt suit and a gorgeous hat with a big tulle bow in the front. "Is this okay?"

"You look beautiful!"

Soon she has told me that she wrote a book, too. "It's called *Drifting into Falcon*, a story about living in the all-black town in Falcon, Mississippi." Later, when I look it up, the census records only 317 people in the year 2000 and the last recorded statistics report 159 people in 2013. The town is 14 miles north of her home in Marks.

I came to live in Marks with my aunt in 1943. I was 14 years old. I lived with her and went to school here, the ninth grade and the tenth grade, and this was junior high school. There were nine of us in the ninth grade, about the same number in the tenth grade. My principal was Mr. Victor H. Williams, from Memphis. He said if y'all come back another year, I will add eleventh grade, so about five or six said we would come back. And the next year he said, if you come back, I'll add the twelfth grade, so about four or five of us came back and he added the twelfth grade. When we marched, there were three of us to march—the first graduating senior class in 1947. I was the valedictorian. I was so happy and proud because if he had not added that, I don't know if I would have gone any farther than the tenth grade.

My mother passed away when I was young. It affected me emotionally, it did, but one thing about it, it gave me a determination to try to go on and do something for myself. I didn't ever forget my mother telling me, "I want you to go to college. I'm going to send you to Rust College." She would tell me that so many times. And when I did go to Rust College and I finished at Rust—it took me about seven years 'cause I had to work and save my money, work and save my money, until I did finish. I went to my mother's grave—sometimes I get so

Lillie V. Thompson Davis

emotional—stood at the head of her grave and I said, "Mom, I went to Rust College."

I believe my mother's in heaven, looking down on me, and I think she's very happy and proud that I did do what she wanted me to do.

Her story touches me. I then learn she earned her bachelor's in elementary education from Rust College and later her master's in elementary education from the University of Mississippi. Education and her mother are, I believe, on her mind, but when I ask Mrs. Davis what she wants to talk about, she talks about her daughter Wanda, who passed away in 1995.

She was a wonderful child. One morning when she was maybe about five or six years old, she came to our bedroom door and knocked. Her father and I were in the bed. She said, "I can't get my breath." He told her, "Get back in the bed, nothin' wrong wit' you." And she turned around, such a humble child, and went back and got into the bed. The next morning she said, "Momma, I can hardly get my breath." I said this child here has asthma. I just dressed right then, said c'mon, and took her to the doctor. I said I know that's what she has, asthma.

She had asthma and we started giving her treatments. Doctor said, "Now if you don't do something for her, when she gets to be an older woman, her lungs will not be able to make it." He sent me to the doctors in Memphis and they found out what she was allergic to—gave me a list of things. She was even allergic to us! So I built a room for her and put her bath in there. There would be a long time before she would

have an attack or anything. She did quite well for a while.

She said, "I want to be in the band."

Well, I said, "You can't be in the band." So I went to the instructor to see if he would let her be in the band, and he said that he would. She has to do nothing that would cause her to breathe deeply—like the trombones or clarinets. She played something that she beat [I can't remember the name], but she was in the band, and she was able to walk. She liked that so much.

One day she went to a college fair and wanted to go to Hampton Institute [what it was called at the time]. I said, "If you want to go, I will see that you go." She went there and I told her I really wanted her to go into the medical field, because she had asthma and she could always be able to help herself if she needed to. She graduated and she was a registered nurse.

She went to Chicago for a while and then got married. She moved to Gary, Indiana, and she worked at that hospital for 16 years before she passed. I can remember her telling me—and I didn't even question it—she said, "Momma I am going to have a short life. I want to raise my children." She was the mother of three children.

I said, "You gonna live to raise your children."

She said, "But, Momma, if anything happens to me, I want you to come up here and help my husband raise my children."

She died at the age of 39—the twenty-first of October 1995. When she passed away, I remember what she said, so I went to Gary, Indiana, and I stayed up there with them for 2½ years until their father got remarried.

FUNNY, I'M JUST LIKE GRAM

Gram died of colon cancer in 1994.

It runs in our family. She was diagnosed on her sixty-second birthday and died 96 days later. The cancer had spread to her liver. I remember her in a hospital bed at home. We removed the furniture in the formal dining room to make it her makeshift bedroom. She wouldn't eat. I heated up some chicken noodle soup. "Gram, please eat," I begged, fighting back tears. "Please. Just one spoonful."

She looked at me. Like a little mummy— skeletal face, dentures barely fitting inside her mouth—she takes a spoonful. It took everything for her to lift her head. I believe she did it to appease me. I was 25 years old and home from college in Pittsburgh. If she could just get the nourishment in her body from the soup, I thought, she could fight it.

That day, not long after I tried to coax her to eat, my aunt Marie pulled me from the dining room. "Lisa, don't cry in front of Mom. You'll upset her. Be strong," Marie said. "I'm calling the ambulance. She's not getting any better. Be strong."

Tears flow down my cheeks. Marie frowns at me. I trudge upstairs, pull the curtains back, and watch the paramedics arrive and load Gram into the back of the ambulance. The rest of the family is downstairs. I am upstairs. Alone. Crying. Sad. Angry at myself. *All those times I fought her.*

All those times I was hardheaded, I think. So many regrets. I know the end is near.

I never see her alive again.

Such sadness. I regret not being strong enough not to cry in front of her. I regret not being there with the rest of the family showing support. I couldn't do it. Feeding her that chicken soup was the last time I saw her alive. She died not seeing me again. I never forgave myself for being weak, for not being braver for her. I do not have the words to describe my pain. The day of her funeral, I asked, "Pop-Pop, do you think Gram knew I loved her?"

"Yes, Peach. She knew you loved her."

"I was so hardheaded. I know I gave you guys a rough time over the years."

"You didn't give us any harder of a time than the kids. You were just a kid. You did normal things."

What he says didn't comfort me. I felt like the most ungrateful child. I talked back, pushed the limits with curfew, fought her old-fashioned ways every chance I got.

Now those memories flood my mind again. My time with the Jewels has done a funny thing— shown me I'm just like her. I don't have children, but I teach my classes the same way she taught me: no excuses; don't be late; meet deadlines; follow directions. I have little patience for nonsense, little patience for excuses. Just like Gram.

MRS. MAGOLIA M. FOX, 92

GRENADA
BORN MAY 1922
MARRIED 58 YEARS WHEN WIDOWED
8 CHILDREN
19 GRANDCHILDREN
26 GREAT-GRANDS

Mrs. Fox is a quilter. It's winter when I meet her. She has a heater in the front room with her quilting loom set up. I see a thimble on top of the quilt that is midway finished.

When I asked her how many she has made, she says she has no idea, maybe hundreds.

When I think about quilting, I'm just concentrated on my work. I want all of my children to have a quilt, a nice quilt. It's just something I want to do for them. I know they can remember me without the quilt, 'cause like I told them when my mom died, "I can remember her without anything you give me. I'm not worried 'bout nothin' you give me." Back then I was afraid of dead people and I didn't want nothin' of no dead person. I was so afraid of them, I couldn't touch my mama, wouldn't touch my daddy, my sister died in 2006, I didn't touch my husband—none of them. I just could not.

And when my son Robert died in March of 2012, that's the first time I was able to touch one. Now, I'm not afraid of dead people. I was afraid of them, dead people. I loved them to death, but when they died, I was done with them. When my son died, I was there holding his hand when his last breath left him. I got on the bed with him when he died, and I closed his mouth and eyes and I rubbed him until he got cold. They let me stay on the bed with him until they got ready to give him a bath. They dressed him and then they let me get back in the bed with him until the funeral directors came and picked his body up. That was my oldest son. That mother's love changed everything. When he passed, I was holding his hand. I held my hand on his chest. I felt his chest when it opened up. You know when a person die, their chest opens up and I felt it.

I told my daughter, "This is it."

She said, "No, Madea."

I said, "Oh yes, this is it."

And his hand just give way. He opened his eyes and looked at me. Looked like he smiled and it was gone that quick. So I knew he was gone then. Something took all the fear away. I didn't want to leave him, although he had left me, but I didn't want to leave him.

We are both crying. And then she continues with two more powerful remembrances.

My grandmother Maggie looked just like a white woman, long black hair. Her daddy was white. Her momma was a slave for him. Her momma had 12 children; had one of them by a black man and that white man beat her so about that. Told her she better not never come up there with another nigger baby. All the rest of them was his children, they all was white.

Magalia M. Fay

A man had this horse; he would get down for you to get on his back, and when you get on, he would get up. He let me ride that horse to church all the time.

My momma and daddy and them—the other children—they went in the wagon, but I wanted to ride that horse. I put on some pants. Back then girls didn't wear pants, but my daddy always let me wear a pair—overalls of my brother's. I'd get on that horse and have my clothes in a sack and I'd ride to the church and go down in the woods, hitch my horse, and re-dress.

So this special Sunday, the first Sunday in May, I went 'cross the churchyard wit' that horse and he was runnin' so pretty. And I was likin' the boys then. I called myself courtin'. Some of the boys had nice horses, too, but mine was the prettiest.

My granddaddy was sittin' out there, and when I come up, he said, "What in the world you come across this church ground wit' them britches on?"

I didn't say nothin', I just went on down there and I changed my clothes. Now, I had on this white organdy dress. My momma made it. It was so pretty. And I got back up there and

he was standin' out there wit' his whip. "I'mma learn you how to come across this church ground wit' britches on."

I said, "Poppa, I had to change my clothes. I had to ride the horse and change my clothes."

He hauled off and hit me wit' that mule whip and he pulled the plug out of my hip with that mule whip and blood shot out of my leg and all on my dress. There was another lady out there by the tree. I told her to go in and tell Momma to come out the church right quick.

So Momma got up and come out there and said, "What's wrong, Mag?"

"Poppa hit me."

He said to my momma, "Hush up, don't say nothin'. I give you some. That gal came 'cross that church ground with britches."

Mom said, "Mag, go on and go back home."

I went over there and put them overalls back on. I came across that church ground and said to the horse, "Get down, Dan." He squatted down. When I said, "Get up, Dan," Dan raised up and he lit out. Granddaddy embarrassed me because he know the guy that called himself courtin' me was lookin' at all of that and that just like killed me. I was 16 or 17 then.

When I'm ready to go, she hands me a jar of muscadine jelly that she's made. "What is muscadine jelly?"

"It's a form of grapes. Try it." I'm not a jelly person, but when the Jewels give me something, I simply take it and say thank you.

A few weeks later I buy bread specifically to try her jelly and right away call to tell her, "I love your jelly!"

MRS. MARGARET HENRY, 92

MOUND BAYOU
BORN SEPTEMBER 1922
MARRIED 35 YEARS WHEN WIDOWED
11 CHILDREN
45 GRANDCHILDREN
120 GREAT-GRANDS

Mrs. Henry's son Roland tells me to cross the railroad tracks after a certain turn when he gives me directions to her home. I call him: "Mr. Henry, I think I'm lost. I don't see the railroad tracks." I went several miles out of the way—heading away from town—when he says, "Well, there haven't been tracks there for years, but we all know them as the old railroad tracks." The tracks are now a small grassy bump I drove over several times.

Mrs. Henry is in a wheelchair when I enter her home. She looks me up and down. I know that look by now. "What do you want to know?" she asks. She crosses her arm across her lap. "I don't have any stories. I can't remember."

I sigh and look at Roland, who asks, "Mama, what about the mules you used in the fields?"

She says she doesn't remember and backs her wheelchair away from me. I laugh and grab the wheelchair arm and pull her closer to me. "Where do you think you're going? Come here and tell me a story. Tell me something about yourself."

"I don't know what's wrong with her today because she has a good memory," Roland says.

"I retired as a cook the I.T.M. Elementary School. I worked there 20 years." She tells me the number of children and grandchildren she has, how long she was married, and then as I ask her a question, she says, "When are you leaving 'cause I'm tired of you?"

My first thought is to remind her I hadn't been there long, but instead I reply, "I'll leave when you tell me a story."

"Well, you can stay here all day then."

"Okay, perfect." I look her in her eye. "I have several hours of free time."

She cocks her eyebrow. I cock mine. It's a standoff for more minutes than my schedule can accommodate.

"If you want to be in the book, you have to tell me a story. If you don't want to be in the book, I will leave. I don't want to trouble you."

"I want to be in the book." A smile forms at the corners of her mouth. I have just been punked by a 90-year-old. I don't want to bully. I can find other mothers, even though I am falling in love with this feisty one. "Will I be in the book?" she asks after my long silence.

"No, because I don't have any stories from you. I'm going to have to call Rev. Hawkins and tell him you're playing with me."

"Call him."

I pull out my phone.

"You callin' him?"

"Yes, ma'am."

She slowly backs the wheelchair up.

I grab the wheelchair, pull her closer to me, and wink at her. "Rev. Hawkins, I'm at Mrs. Henry's. She says she wants to be in the book but she doesn't want to talk. I'm going to leave unless you can talk to her."

margret Henry

"Oh no, she's not cooperating?" He chuckles. "Put her on the phone, please."

I hand Mrs. Henry my phone. "Hello, Rev. Hawkins…," she says. I don't know what he says to her, but she listens, and after a few minutes, they hang up. "Go ahead and ask your questions," she says.

"How did you meet your husband?"

When I started school with my husband, I wasn't liking him then. It had to come to me, though. I didn't like him too much; I didn't like his looks; he wasn't handsome enough. Well, he had long legs. We used to play ball. I used to call him Long Legs and he used to call me Long Hair.

During that time, [when] we were little girls, when we was growing up, we wasn't likin' boys. Boys started to like us. So finally we got together. So things changed then. I was about 15 or 16. How he started to liking me: We go to church around Bayou. Finally he started to just come see me. From then on we started a dating each other until we married. I married him when I was 19 years old.

When he first started coming by my house, he never did come in the house. He'd just come, you know, to the steps. We'd stand on there, talking. Finally we started dating one 'nother and then he would come in. I wasn't nervous [dating him]. Wasn't no need to being nervous. I wasn't scared or nothing like that. We just stood there and talked until 9 o'clock then he had to get away from there. He couldn't stay no longer than 9 o'clock because my parents didn't allow him to stay longer than 9 o'clock. If he would have stayed longer, I would have heard them hittin' on the wall—knockin' because it was time for him to get up an' go. You see, parents then were more strict on children than they is now.

I don't think myself beautiful. I ain't ugly, am I! I just try to fix up when I go out. Now, I ain't goin' nowhere out unless my powder and lipstick on. I'mma put that on, through the week and everything. They [home attendants and family] come in and be waitin' on me. You gotta keep yo'self up. When you go out, fix yourself up. I try to do that now. I be clean. When I go out, I be sharp. I don't brag on myself. I want to look presentable. I put on my dress and my hat and my shoes, powder my face. Oh, I wear my jewelry. I got jewelry for Sunday and for every day.

When I walk in church, they lookin'. They say, "Don't your daughters sho fix you up?" They look at them bad hats. I got so many hats. I got them hang all upside the wall closet full. When we was comin up, we go to church, you didn't have to wear no hat. But [when] they have testimony service, they put a hat on your head then, some of the mothers will. You ain't dressed up unless you got a hat on. I don't care what you put on. Go to church, if you ain't got a hat on, you still ain't dressed. I heard a preacher say that. But I was wearin' my hat before he said that. He said, "A woman ain't dressed up when she come to church unless she have a hat on." But now you see more folk barehead. I wear my high heels, too. Not too high, about an inch or two. I always liked high heels. I dress when I go to church.

GRAM—SWEATPANTS, A BLAZER, AND HIGH HEELS

Gram loved her high heels. That's all she wore. She's the only woman I've known who could rock sweatpants, a blazer, and high heels. The only pair of shoes she ever wore that didn't have a heel were her bedroom slippers. She wasn't more than 5 foot 2, maybe 110 pounds.

She always wore conservative colors—blue, black, and brown, maybe tan. I don't recall an extravagant color like red. She believed in wearing the classics—A-line skirts, wide-legged dress pants, a blouse, and always a blazer. She was a sharp dresser, always well put together with a little Fashion Fair makeup—powder, blush, and lipstick. She was always a lady.

She liked a certain Revlon nail color. It was a sienna brown mixed with a deep maroon. It went nicely with her medium brown complexion. Her nails were rounded and immaculate, maybe a quarter inch in length. If one nail broke, she filed them all down to match. She always told me to make sure the tip length matched for each nail. If the polish chipped, she would paint over the one that was

My grandparents William and Althenia Burton, with Gram Ree. Date unknown. Taken in Harrisburg, Pennsylvania.

chipped or take the color off every nail and redo them all. I used to sit and watch her nail ritual. She would file her nails and slowly run the nail sideways against her jawline, checking to make sure the nail was smooth. She could tell when she ran her nail gently across her cheek if it needed to be filed some more. Watching her was entertaining.

To this day, it irritates me if there's a tiny chip in my nail polish. As a photographer and professor, I'm always typing. I hate chipped nails, so I rarely paint them. But when I do, I like Lincoln Park after Dark by OPI. It's my go-to color, like Gram's Revlon, except mine is dark purple, almost black.

I wish I remembered the name of her color.

Gram had habits that would irritate or mesmerize me. She would drive about two miles north of our house to the Kline Village farmer's market for fresh lunchmeats, cheese, and UTZ potato chips, still warm and in freshly packaged buckets. At the peanut shop she would buy fresh-roasted peanuts, still in the shell. She would break the shells, eat the nuts in the car, and leave the shells all over Pop's Buick seat and floor. It used to make him fuss, but she didn't care. She never stopped doing it. She never cleaned up the shells either. Gram would ask me to ride with her, to keep her company. I still hate the smell of peanuts or peanut butter. I also associate the smell of peanuts with the time I threw up from eating too many of those peanuts.

Gram could not parallel park. She would back in, then pull out. In, then out. She'd do this several repeatedly and it would get on my nerves. As a bratty teenager I would ask, "Gram, please let me out," while she continued to back in, then out, and so on. I'd have time to walk from the sidewalk to inside the house and she'd still be trying to park.

The day of her funeral, my three cousins and I sat in the swing on the front porch—where I used to sit in my two-piece halter-top pajamas enfolded in Pop's arm and Gram holding my hands—and laughed about how she couldn't park. We found laughter after our tears that sad day. All of us girls talked about how Gram used to run her nails over her cheek to make sure she'd filed them smoothly. She'd do that in the car while she was humming and driving. When she parallel parked, she would blow air out of her mouth, like a little toot-toot. She'd turn the steering wheel, hum and blow air out, then back in. Then she'd turn the wheel the opposite direction, hum and blow air, and pull out. Again. And again. I find myself humming when I park, but I can parallel park with one attempt.

We found laughter after our tears that sad day.

MRS. DOROTHY A. KEE, 69

COFFEEVILLE
BORN FEBRUARY 1946
STILL MARRIED, 47 YEARS, TO NATHANIEL KEE
2 CHILDREN
2 STEP-GRANDCHILDREN

I met Mrs. Kee in the Pleasant Grove Mission-ary Baptist Church office in Coffeeville. She has a warm disposition but seems nervous about the interview. She tells me education is important to her family. She has multiple degrees—a bachelor's in social science with an emphasis in history from Alcorn State and two master's degrees from Mis-sissippi State University in education and social work. "It touches me that people still stop me and tell me I made a difference in their lives," she says when asked about her teaching. She is a retired seventh through twelfth grade teacher who taught social studies, history, and economics. But Mrs. Kee wants to talk about her childhood. She was a daddy's girl.

I am the oldest of seven children, born to Clara and Clemmie Smith. We were reared in a God-fearing home and we were always taught to put God first in our life. We were encouraged to read the Bible daily. We attended church every Sunday. Daddy was a landowner and we lived on a farm of 160 acres. We were in charge of working every day to just live. My daddy grew everything, the animals, the crops, and the staple crops—like corn, soybeans, and cotton. He grew truck crops like watermelons, can-taloupe, and peanuts, too. This was for mere survival. We would pick blackberries and dew-berries for survival. That was what we called for extra money. We depended on the cotton, the corn, and the soybeans for our staple crops—major crops. If he didn't sell enough, you know, in the fall, then he would borrow money and then we would start over each year. But he was on his own. A lot of times he would have to make a loan for us to live. But we basi-cally made it. My mom was a good homemaker. She made our clothes. She kept us lookin', we thought, pretty good. She would put bows in our hair and all that kind of stuff. My daddy was very outspoken and a lot of times he got ridiculed, by even his own color. He had a dark complexion and my mom was real light. And a lot of his own peers thought he was some-thin' because he had a wife that looked like she was white. As a matter of fact, my mother's father was half white. She would put bows in our hair, and with him [Daddy] being a small landowner, they said he was somethin' else. My daddy didn't take anything off anybody. He would speak his peace. We did pretty good in school and we got whoopin's if we didn't do pretty good in school, so we were ridiculed a lot. You know, a lot of people would say things about us because we had certain standards we had to keep. Daddy, I don't mean he was mean to us, but he wanted us to be somebody— that's what he said.

She tells me that her father was well respected in the black community especially, and then she tells

me there was a hit out on her father. Rev. Larry Hervey is in the room with us. I look at him incredulously. He nods his head yes. My mouth opens.

An individual was released from Parchman State Penitentiary, with intent to kill my father. That ain't good, is it? My daddy was upset with injustices in our little community. My daddy was very outspoken and sincere with his work in Civil Rights. Many abhorred his efforts with Civil Rights; therefore an effort was made to get rid of him. A prisoner was brought from Parchman with intent to end his life. He [Daddy] was the first president of our NAACP. There was a march downtown for integration for schools. The individual from Parchman was given a gun on each hip, a rifle in his hand, and told to go down there and break up the march. He didn't succeed.

"Do you remember any more?" I ask. She tells me no. I am just stunned law officials would do something so heinous as this. I've never heard of such a thing. I am just in shock.

Oh, yes, that's true—and worse," says Rev. Hervey. He's leaning against a cabinet in his office. He's been listening to the interview with his arms crossed across his chest.

Dorothy A. Kee

I Google her father when I get home and don't find any stories about this incident. I suppose if you talk to the locals—and they trust you— they'll talk about stories news organizations didn't archive online.

MRS. LELA J. BEARDEN, 88

SUMNER

BORN APRIL 1926

MARRIED FOR 56 YEARS WHEN WIDOWED

3 CHILDREN

5 GRANDCHILDREN

1 GREAT-GRAND

My habit is to print copies of directions, not relying solely on the GPS of my phone. I've learned that while driving in the country, my phone service will drop. It's early on an August day. Humid, like it always is in August. I schedule the first interview around 10 a.m. because it allows me to start the day early and I can schedule multiple interviews. Most women are at least two hours away, so I try to make the most of each trip. I'm going to interview a retired educator, a home economics teacher who graduated from Tuskegee Institute, Mrs. Lela Bearden.

All I know is that she's in her eighties and lives in a town where the elementary school named for her husband is directly across the street from her house. Google Maps told me to take Route 49 East to her house, but there was a street I was supposed to make a right on that I never saw. I keep going straight instead, am somehow on 49 West, and pass Parchman prison, officially called the Mississippi State Penitentiary. Google says to make a right down a small road. I hesitate because I am no longer in Sumner.

I start to worry. I know Mississippi history. I know there are still places I wouldn't feel comfortable in—even during daylight. When Bobby and I first moved here, I didn't want him to get a job outside Oxford. I was afraid something would happen to him just because he's black. I begged him not to take a job outside Oxford. What if his car broke

down? Would someone act like they were going to help him, only to kill him because of the color of his skin? Would a cop stop him for a bogus driving violation just to harass him? We talk about it and he agrees to work in town. While I'm driving and getting lost, I look around and see plenty of places where someone could hurt me and no one would ever find my body.

When I turn down this two-lane dusty country road to see Mrs. Bearden, the hairs on my neck stand up as I remember my conversation with Mrs. Florida Smith about white men who rape and kill black women, tie bricks to their bodies, and dump them in Whore's Lake. I know something is not right—nothing about it is right—but I still keep driving down that road. *I've gone somewhere I'm not supposed to be*, I think. There aren't any Confederate flags or signs, but I have a feeling. The road starts out with gray pavement, then turns into Mississippi red clay. On my left is a farmhouse: American flag hanging; a big, manicured yard; patio furniture. On my left is a field of corn: tall corn, almost as tall as my silver SUV. I think about Whore's Lake. I get a funny feeling that I have gone somewhere I shouldn't. I sense it. I panic and look at my phone to make sure I have service.

I always get lost trying to get to the mothers' homes. I forewarn the Jewels. "I'm a Yankee and I almost always get lost. Listen for your phone to ring in case I get lost," I tell them. I call Mrs. Bearden.

Lela J. Bearden

"You went straight when you should have made a right turn. You passed me miles ago."

I tell her the road I'm on and she says, "Oh no. I'll stay on the phone with you. Turn around and come back right now." She doesn't sound alarmed, but she stays on the phone with me until I arrive in her driveway. There's a little sign in the front yard that reads, THE BEARDENS. She has a two-vehicle carport. I pull up to it. She doesn't hang up until I'm getting out of my car. She greets me at the garage door, which is protected by bars.

She is a beautiful woman, jazzy for an 80-something-year-old. Modern-looking glasses and she smells like a perfume I recognize from the 1980s. It smells good on her. She gives me a hug and says, "Come in."

Entering her home through the carport leads to a kitchen, and through the kitchen are the dining and the family rooms. I can't help but notice how she adored her husband, Rogers, because his four-foot framed picture hangs behind a middle seat of the rectangular dining table. I walk into the back room, the den area, and see that it's dedicated to his accomplishments. His and her plaques decorate the wood-paneled wall. Photos of the family from the 1950s adorn

"Helllooo." She sings every time she answers.

"Hello, Mrs. Bearden, I'm lost. I'm on such-and-such road and I don't think this is your neighborhood." What I don't tell her is that my insides are cramping. I know this isn't the right place.

A hallway in Mrs. Bearden's home shows Mr. Bearden's ancestors.

built-in bookshelves. The respect she has for her husband is obvious. She affectionately refers to him as "Mr. Bearden." And easily shares this powerful memory about boarding the plane to Frankfurt, Germany, in 1953.

The officer said, "We're gonna get you all seated." It was 40 mothers and 60 babies [boarding the plane to Frankfurt, Germany, in 1953]. All of us there with babies. I had one six-week-old and a two-year-old. I was the only black one. They said, "We're gonna seat you according to your husband's rank." They were talkin' amongst themselves, [saying,] "There's some captain's wife on here. Wonder who she is. Wonder where that captain's wife is." They were so sure it wasn't me. So then: "Seat number one, the dependents of Captain R. H.

Bearden." I said, "Excuse me, please." We had seat number one going over on the plane. You could have heard a pin fall. They were quiet. Let me tell you something, they hardly spoke. After that they got so friendly. After that it got very warm; they got very cordial. You see, that's how they behave.

"You know, you should call your husband Mr. Steele, Lisa," she says.

I don't reply, but giggle, thinking, *Oh, I am SO not going to call Bobby "Mr. Steele."*

We sit down in the dining room, and a few minutes into the interview, she says, "Well, you aren't white. Rev. Hawkins said you were a white lady."

I'm taken back by this and chuckle. "No, ma'am, I'm not white."

"Well, I can see that. It doesn't matter."

Now, I'm puzzled. I don't look white; at least I don't think so. I laugh and then I start to feel offended. Why would Rev. Hawkins think I'm white? I wonder. He's sat across from me. He's seen me. He knows I'm not white. Maybe he told her that before he met me? More than a few people in the Delta say I sound white on the phone. This concerns me. So I make a point to use more dialect that I grew up with. Maybe that will make a difference in how I'm greeted when I call.

Mrs. Bearden tells me that when Mr. Bearden cut grass while working on a plantation as a teen, "He noticed that white women wore wedding rings and black women didn't. He told himself that he was going to save up and buy his wife a ring one day. He made change while cutting the grass, and saved his money over the years."

She said when they met at Tuskegee Institute and he asked her to marry him, he used the money he'd saved up to buy her rings. She still has the original set, even though he bought her a diamond—over two carats—for their fiftieth anniversary. Her daughter Cynthia Bearden McAdory wears her mother's original set on her pinkie finger.

While we are seated at the dining room table that seats six, she talks about how her husband couldn't dress. He didn't grow up with a lot and then joined the Army, where they provided uniforms. He couldn't match clothes, so when they were dating, he asked her to pick out his clothes. She was happy to do so and said he gained all the attention of the college girls. After they married almost three years later, she continued to buy his clothes throughout their 56-year marriage.

He [her husband] was always so well versed and everything, but he didn't know how to dress. One night he said something about his dress, and I said, "I really don't like that, what you have on."

He said, "These are new things, what you talkin' about? What do you like? I don't know how to pick clothes out. I left from high school and I didn't have anything and I went in the service and I wore my uniforms, and I came out. I don't know about clothes, why don't you go with me to the store?"

I said," Oh, I would be delighted to go." We went down to the men's clothing store in Tuskegee, and he bought two suits, a blazer, slacks, shirts, ties to match. I told him what I liked. I was picking them all out and he paid for what I suggested.

Nobody on the campus wasn't lookin' at him. They used to say, "Lela, you talkin' to Farmer Brown." Before then. When he dressed up, I like to nearly have lost him. The girls were lookin' at him—so nice looking and everything. And he was enjoyin' it, too.

I said, "Isn't this somethin'?"

They told me, "Lela, your boyfriend talking to so-and-so."

I looked around and saw he was talkin' to them. So what to do? I went to talk to somebody else who was tryin' to talk to me. By that time, he found himself, he found me.

A GRAM LEGACY

Gram bought clothes for Pop-Pop, too. He hated shopping. Gram even bought his shoes. She would bring a box home, and he'd try them on and decide if he would keep them or not.

He still has the powder blue, lightly pin-striped suit that she bought him almost 30 years ago. Pop is tall and slender and he's had that suit for as long as I can remember. It's his go-to suit for funerals, weddings, anniversaries, you name it. It matches his blue eyes. A caramel-colored black man with blue eyes! The family used to joke that he was the mailman's baby. Pop was a mailman for 25 years.

When my aunt Marie, my grandparents' youngest child, died from Lou Gehrig's disease at the age of 53, 14 years after Gram died, the only suit in Pop's closet was that powder blue suit. I combed through his clothes trying to find him something to wear to Marie's funeral. I most remember his scent, one I've known all my life. When people die, you go through a closet, and always notice the smells.

Pop was Marie's primary caregiver. No one looked after the state of his clothes. The day she died, he sat on his bed. I sat next to him. "I don't know what I'm going to do now," he said. "She was my baby." My heart aches for him and I start to worry about him. Feeding and helping Marie gave Pop a sense of purpose.

My gram would have been upset if she knew he didn't have a good white shirt.

This photo was taken at my Harrisburg High School graduation in 1988. This is the suit Gram bought Pop-Pop in the early 1980s, and the one that he wore to his daughter Marie's funeral in 2008.

His ties were so old they were becoming tattered at the edges. Gram would have said, "Go to the store and get your grandfather a respectable shirt and tie." I know she would have yelled at us for neglecting to see what he had in his closet. He's the kind of man that you buy a pack of underwear or a packet of socks and he leaves them in his drawer, unopened, until the holes in his current underwear or socks are too big. He always says, "I don't need no more things. My dresser is full." I went to a local department store and bought him a white shirt and a tie. I fretted over the tie. It was days after Christmas. Sales were on and I decided on a blue tie. It was a bit fresh and modern for an 80-something-year-old man, but I couldn't resist. That powder blue suit may be dated with big lapels, but he would have a crisp white shirt and a sharp tie. No problem in spending a little more to make sure he looked good for his baby girl's funeral.

He knows every time I come home I will go through his drawers and threaten to throw away his holey socks. It's a fight we have every time I check out his apartment to make sure he has food and a clean house. My aunt Pat and the rest of the family do a really good job of checking on him, but I believe no one really checks on his dress clothes. Gram wouldn't have been happy. She would have sucked her teeth and shaken her head, mumbling to herself.

No problem in spending a little more to make sure he looked good for his baby girl's funeral.

MRS. LILLIE M. ROBERTS, 84

COFFEEVILLE
BORN AUGUST 1931
FIRST MARRIAGE 6 YEARS; SECOND MARRIAGE 16 YEARS
NO CHILDREN

Mrs. Roberts is wearing a tailored white jacket. It's hard to imagine this is a woman who says she loves to ride in trucks and worked tractors. She retired after 23 years working at Randall Textron, a local factory. She's most proud of being active in the NAACP.

"I am still an active member. I was the treasurer for over 50 years." Civil Rights are important to her; she was first Black to register to vote in Water Valley.

One day out of the blue sky, we fittin' to vote. The white peoples started talkin' about they wasn't gonna let the Negroes vote. They told us, "Better not go up there, to the courthouse." My husband and I worked together in Water Valley [Mississippi]. Our supervisor came to our house and said, "You know one thing? You know, I want to be the one to tell y'all to go vote. I gotta right to tell y'all, you must go vote. You know why I'm comin' down here to tell y'all to vote? Because y'all got land. Anybody that got land and property, 'specially black peoples, need to go vote." He said, "Now, I'mma tell y'all, my skin is different from yours, but they been taking black folks' money and they pay taxes and they not allowed to vote. They was not doin' nothin' but takin' the black people's money, paying tax, but they would still tell you wasn't able to vote." So that supervisor told us that story that he had in his heart.

Folks wasn't votin'. They was scared. I was kinda scared. He [the supervisor] said, "Promise me you'll go vote."

We told him yeah.

And the next day, he pulled back up. He said, "Lemme tell you one thing, y'all. Now if y'all scared, go 'head on. I'm gonna be around that courthouse when y'all come. Tell me what time you comin'."

We told him. My husband said, "Well, I can't read as good as you, but I'mma put you on front line."

We got up there next day. We got dressed casual. We went up there. He [husband] had on a khaki pants, and then he turned around and put on some overalls. He said, "I'm puttin' on my overalls, 'cause I'm puttin' this .38 down here." He put the overalls on top of his pants and put that .38 in his pocket. That's where all mens carried their pistols then. He said, "I'mma pop anyone, they look at you."

I said, "All right." I'm brave.

We go. We had a li'l ole pickup. He [husband] said, "I'mma drive this pickup up to the front door. Since this man told us to vote, I'mma show him, we gonna vote."

We got out and went on in. This courthouse had three floors. And when we started in, those peoples who were workin' in those offices, every one of them, came out in the hall and stuck their head out, lookin'. They asked, "Who is that goin' down through there?"

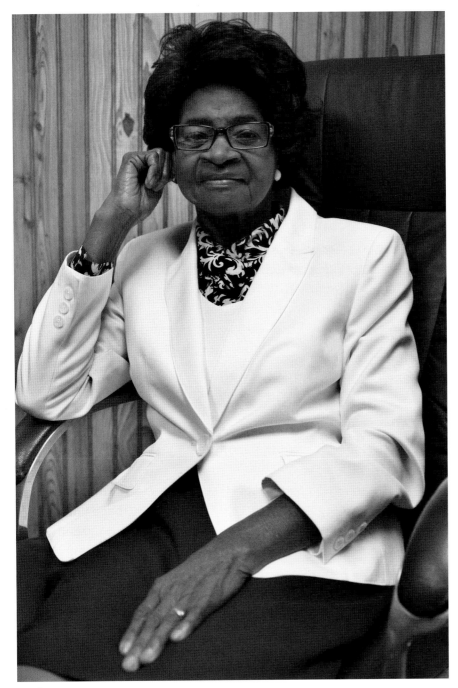

Lillie M. Roberts

We walkin' side by side. My husband never took his hand out his pocket. He had both hands in his pockets. We went on in there.

A man took a book out of the cabinet and laid that book on the table. He opened it out and he asked me, did I know the Constitution of the United States? I said yeah, I did know it. I done forgot it 'cause I hadn't went to school in a long time. He said, "Well, you gotta read these three or four." I'm lookin' at it and lookin' at it. So I marked what I think and pushed that book back. He looked up at my husband and said, "Well, you said you can't read and write, so it wouldn't be good for you to vote, 'cause you got to know the name of who you votin' for and that's why you won't be asked to vote, but I got her registered."

We came on out. When we came out of there and started back down the street, all those white folks in the offices was still lookin'. They stood at the door. They wondered what we was doin' in there. My husband and I still walkin' together. He said, "Well, I'mma open the door for you [for the truck]." He walked around and opened the door for me, like I was somebody.

The picturesque town of Water Valley in Yalobusha County is being revitalized, with art galleries and independent restaurants in its town center. Its many beautiful old wooden homes attract Ole Miss professors, who commute the 18 miles north to campus. Currently, 3,300 people live in the town, and 42 percent are black.

MRS. BEATRICE P. SMITH, 87

CHARLESTON
BORN NOVEMBER 1927
MARRIED 15 YEARS WHEN WIDOWED
3 CHILDREN
2 GRANDCHILDREN
3 GREAT-GRANDS

Rev. Hawkins tells me that a retired educator, Beatrice P. Smith, lives on property once owned by the mother of Roy Bryant, the white man acquitted of the cold-blooded killing of 14-year-old black youth Emmett Till in 1955. She lives near Mrs. Florida Smith and Mrs. Emma Horton.

Mrs. Smith has a small home near an open field of farmland, with neighbors across the street. I knock on a door that opens to a screened porch that leads to a living room jam-packed with furniture, and behind it is the kitchen, where a TV produces a low mumble of voices. I ask her if we can turn it off, and she slowly walks back into the kitchen while I barely find room for my tripod and microphone stand.

She sits in her rocking chair against the wall and I sit in a chair across from her in the tiny room and dig right into the Emmett Till story: "Mrs. Smith, did you know you were buying the home from the Bryant family, who was connected to the killing?" "People knew about this house for sale, but were afraid to talk to Mrs. Bryant. I didn't know any better," said this proud woman who grew up on the T.C. Buford Plantation in Glendora. She explained that she had asked people to let her know if they came across homes for sale because she was ready to buy. Everyone seemed to know it was the Bryant home, but no one told her. When asked if she's willing to sell, she expresses irritation that so many asked to buy

from her *after* she bought the house. She isn't interested in selling.

I was still living on Buford Plantation and I talked with one of the bus drivers from school and I asked him if you hear talk of someone wanna sell a lot or somethin', I said let me know. One day he came to me and said, "Ms. Smith, I got what you wanted." After school I came to talk to the neighbors. I asked, "Who is it that wanted to sell the lot?"

They pointed me to the house. The neighbor said, "Now, the lady is named Ms. Bryant." The neighbors knew who she was, but I didn't know. Her house burned down and she left. She told them she wanted to sell the lot and that's when they told me about it. She was the only white family here. The people in this area, they was afraid to contact Ms. Bryant to buy the lot. After I bought it, the neighbor said, "Now people is 'fraid to buy 'cause of her sons killed this Emmett Till." But I didn't know who she was. Then after I purchased the lot, four or five black families in this area wanted to buy the lot from me. They were afraid of the Bryants. But it didn't bother me because they weren't living here anymore. They didn't charge much of anything. Look like they wanted to get rid of it. I didn't have to pay much. It was very cheap. I bought it in 1962. I had this house built. I enjoy

living here. I have about an acre. I've been in this house in 52 years.

The plantation [Buford in Glendora, where she grew up] owner built the church and we still go to that church as our home church. It's old, way over 100 years old. I go to that same church. I saw the owner last week. The son owns it now, and he came out to be with us. That's the only church that I've ever been a member of. I am 87 years old and I was born and reared in that church. My children was born and reared and baptized in the same church. We still go to that church. I just don't want to leave.

It's a Methodist church and I'm still here. We enjoy it. It has never burned; it has never been torn down and we still have service. It's not in real, real good condition, but it's good enough for us for us to still hold on to. And since I've been there all my life, I still want to remain at that church. My son is still a member there. Right now we don't have over five active members, but we have a pastor and other people come and help us. In October we had the pastor's appreciation. The churches in the community, they furnished the food for the occasion and we appreciate that so very much, yes indeed.

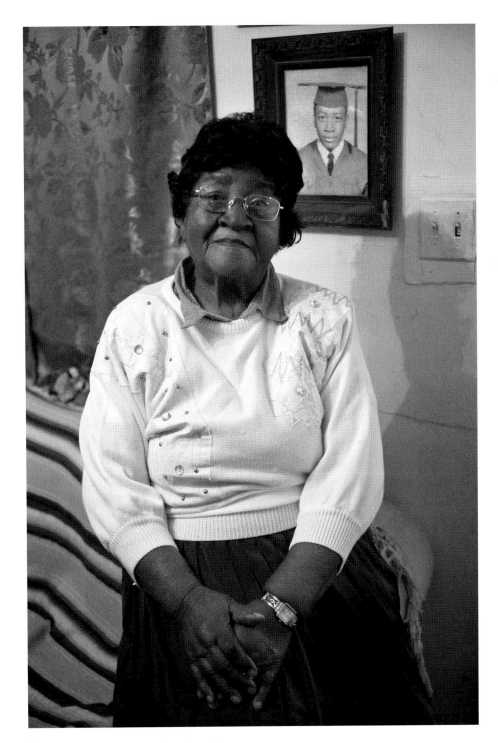

Beatrice P. Smith

MRS. LARVARAH JONES, 89

RULEVILLE
BORN JUNE 1925
MARRIED 40 YEARS WHEN WIDOWED
14 CHILDREN
23 GRANDCHILDREN
7 GREAT-GRANDS
5 GREAT-GREAT-GRANDS

Mrs. Jones, an educator for the local Head Start for 15 years, was referred by another mother in the book, Mrs. Hooper-White, who told me that Mrs. Jones literally walked the streets of Ruleville to raise money for the headstone for Civil Rights icon Fannie Lou Hamer.

Mrs. Jones is eager to talk. When I arrive, she's wearing a canary yellow skirt suit and hat. Mrs. Hooper-White joins us a few minutes later for the interview.

I worked from 7:30 a.m. 'til 3:30 in the evening and then I got out and walked all around Ruleville raising money. 'Cause I looked out there and just it's sad they had a lady like her [Mrs. Fannie Lou Hamer] and they didn't even have a tombstone. I couldn't take it. So my aide at Head Start would be out there wit' me. We went every which way. Some peoples was nice, some peoples wasn't.

I went to this lawyer, a white lawyer, and I told him what I was doin' so he give me the first $25 and said, "Go 'head. I want you to go to every place in Ruleville and tell them I sent ya and ask them to give you a donation." Some of them did; some of them did pretty good; some of them didn't.

I went to the bank and some of the stores. I went to the lumber company and they said

"no." I looked at them and smiled and pushed the door and walked out. But I kept movin'. When I got through, I called the funeral home place in Grenada and told them what I needed and what I wanted. They brought it to me. We did it. We was tired. Sometimes I had to be late comin' home, cookin' supper for my husband and children, but I did it with God up above. I put that tombstone down about five years after Mrs. Hamer's death.

She had been buried there for some time. That's what got on my heart. I couldn't take it. She was a great lady and a lady with love and she's buried out there with no tombstone. I was a hardworking senior citizen. It was a great accomplishment, very great. It was just somethin' I needed to do. I raised over $800. It took me at least 8 or 10 months to raise the money.

Not very many Whites wanted to contribute, just a few of them, that lawyer. I put money in myself, you know. And that girl that worked with me put money in. I had about $500 and then she [my aide] and I went together and my family and I put the rest together to get that $800. When they put the tombstone down, we had a prayer and were singing. Some of the church people, some of the preachers were there—did some prayin', did some remarks. But anyway, it was nice.

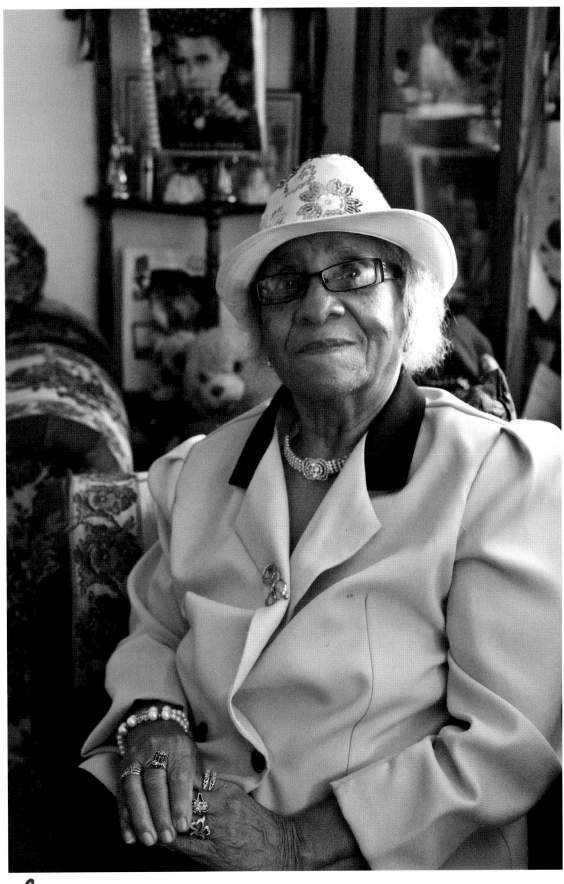

Larvarsh Jones

MRS. HERMA S. MIMS FLOYD, 75

SUMNER

BORN OCTOBER 1939

2 MARRIAGES

2 CHILDREN

6 GRANDCHILDREN

When I first saw Mrs. Floyd in church in Sumner—a short little something with piercing eyes who wears her hair short and natural in a small Afro—I couldn't stop looking at her. Something about her pulled at me. I needed her in my book. I didn't know her story, not even her name. Bobby and I were at church with Mrs. Bearden, another mother of the small church, sitting in the first pew on the right side. Mrs. Bearden introduced us and told the congregation I was doing a book about grandmothers.

Mrs. Floyd led the service. She has a fantastic voice, deep, strong. She commands attention. This little woman is strong. I leaned over and whispered to Mrs. Bearden, "I want Mrs. Floyd in the book. I know she has a story."

Mrs. Bearden told me Mrs. Floyd would be a good one for the book. "We'll talk to her after service."

I warmly approached Mrs. Floyd, told her I wanted her in my book, and she said she knew about the book but didn't want to be in it. I gave her my card and asked if I could call her. She looked me in the eye and said, "I said no. I have your card. If I change my mind, I'll call you."

I was devastated. I wasn't expecting that reaction. I immediately went to Mrs. Bearden, who grabbed my arm as I helped her walk out of the church. She would talk to Mrs. Floyd. Mrs. Bearden told me to call her in a couple of weeks. She'd work on Mrs. Floyd.

Several weeks went by and I called Mrs. Bearden in between classes while in my office and prepping for two independent studies. Mrs. Bearden had talked to Mrs. Floyd, thought she would agree, and gave me Mrs. Floyd's phone number. I asked her again, for reassurance: "You're sure I can call?"

Mrs. Bearden: "Yes."

"Mrs. Floyd, this is Lisa Steele. I met you at church. I am the woman doing the book on grandmothers. Mrs. Bearden gave me your number. I'm hoping you'll agree to be in the book."

"I know who this is. Didn't I tell you I didn't want to be in the book?" Before I can answer, she continues, "I took your card. Did I not? I said I would call if I changed my mind. Did I call you? If I wanted to be in the book, I would have called. I don't want to be in the book. I don't appreciate you calling, bugging me about this book. I don't appreciate you calling. I didn't tell Mrs. Bearden she could give you my number."

I can't get a word in edgewise. When she stops, all I can say is, "Yes, ma'am." I hang up feeling like a schoolgirl. I am upset that I have upset her. I worry she and Mrs. Bearden will have words. I immediately call Mrs. Bearden. "Mrs. Bearden, she said no. She is not happy with me for calling her. I'm letting you know because I'd hate for you two to have a misunderstanding."

Mrs. Bearden is not worried about a misunderstanding and tells me to call her later.

My two students arrive for their private lesson, and ten minutes later my phone rings. I don't recognize the number and I don't recognize the voice, but I answer. "Why, Lisa, of course I will be in your book." That's all I hear. My students are watching my confused expression. I don't recognize the voice. It's so sweet. Surely this isn't Mrs. Floyd.

A week later I drive to Mrs. Floyd's home. I stop by to see Mrs. Bearden first for encouragement. I'm intimidated by Mrs. Floyd. I do not want to cross this woman. This little short bit of a woman—small but mighty like my gram. Mrs. Bearden can see Mrs. Floyd's house from her front door. She directs me and then gives me a hug. I take a deep breath, back out of the paved driveway, look at the little sign that reads, THE BEARDENS on the front lawn, and cross the two-lane road.

Mrs. Floyd is waiting for me at the front door. "Hello, Lisa."

"Hello, Mrs. Floyd."

We end up talking for more than three hours. She has more than a couple of stories; she tells me eight. When I tell her I will have a hard time picking several for the book, she tells me to run them all. I jokingly tell her the book isn't about her and she replies, "Well, it should be."

I've chosen her remarks on unwed mothers testifying in church, going back into the cotton fields with her younger son to pay her older son's college tuition, and her baptism experience.

I tell these girls now, "You throwing your life away. Babies having babies."

Because [in the past] reverends, pastors would have you stand up in church and testify and beg the church for a pardon for having a baby out of wedlock. You had to get up and do that. But I tell you one thing, didn't no lot of girls have no babies out of wedlock. If you had a baby before you were married, you had to get up in church and beg for forgiveness. I don't remember too many girls having babies. It was just a different thing than what it is now. More respect, I guess.

I thought it was good Rev. Parsons did it. I must have been about 15 or 16 years old. It inspired me. I remember two girls getting up and begging for a pardon. They were forgiven but Rev. Parsons told them not to do it again. I thought it was good, 'cause it scared the rest of them. Momma always say, "Keep your dress down and your drawers up."

One summer, Jerome and I had to chop cotton, in order for Tracy [her son] to go to Coahoma Junior College. There was one summer, one chemistry course he wanted to take, and I didn't have the money to pay, so we had to go to the field. This was in 1983 and it paid $30 a day a person, and that was a lot of money. It paid for the course, but I had a little more. I had a little somethin' else on the side. I didn't want all my whole saving to go, but we got enough money to send him through.

Jerome was 14 and said, "Momma, I don't want to do this. It's too hot out here." I said, "We got to do this." We did it for about a week. Jerome helped me to put Tracy through that class. Tracy said he was sorry we had that I had to go out there and work for him, but I told him I didn't mind it because I wanted him to be successful and it paid off. He's now Dr. Tracy Mims. Sometimes I cry. Tracy said he appreciate it. Ain't that touchin'?

The day I was converted, it a Sunday afternoon, two o'clock. It was the greatest experience my soul ever had. A sunshiny day. [She sings:] "Give me that old-time religion, give me that old-time religion, give me that old-time religion, it's good enough for me." I was about 8 or 9 years old in about 1948 and I was baptized in a white gown with a white bandanna 'round my head. And I remember Rev. Parson

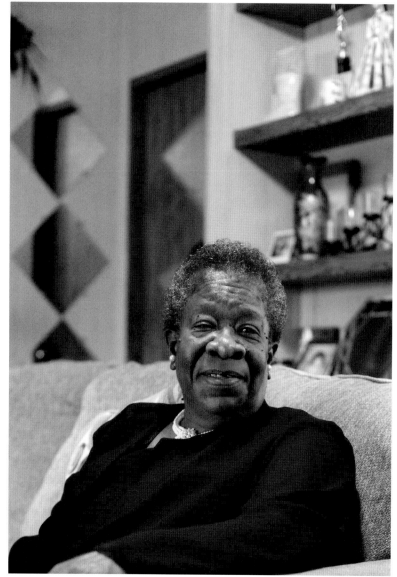

Herma S. Mims Floyd

but I was baptized in a riverbank on Egypt Road. It was this one Sunday and it was a gorgeous experience. It had, you know, snakes and frogs, but you know God didn't let 'em bite us. [She sings:] "Give me that old-time religion, give me that old-time religion, give me that old-time religion, it's good enough for me." I can hear them sing that now.

I joined our all-black Presbyterian church in Harrisburg when I was 12. Our church was small and conservative. My cousins and I made up most of the children activities.

I felt so grown up. I had to do classes and ask questions of the pastor to join. Much different than what the Jewels describe in their bayou baptism experiences, but I remember being so proud when I got my own red Bible with my name engraved on it.

And I cannot sing. It was embarrassing to be in the children's choir knowing I couldn't carry a note. (My singing was so bad that my aunt Marie would ask me not to sing in the car while she was driving. She found it distracting.) I used to mouth the words in the church choir. I wish I had a soulful voice like Mrs. Floyd.

I love Mrs. Floyd and have a girl crush on her now, too. Our interview time was lovely. I often call one of the 54 church mothers to see how they are doing, but Mrs. Floyd called *me* after Mother's Day 2014, a month after I'd last seen her. "Lisa, girl," she said in her soulful singing voice, from her heart, deep from her gut, "I just saw myself on something called YouTube. I hollered the whole time. You are really doin' something for us. Thank you."

Her words bring tears to my eyes.

today. When he did his command and put my head under water and brought me up, then the sisters would sing, "Father, I stretch my hands to thee, no other help I know. If thou withdraw thyself from me, oh wherever shall I go."

Those were some good days. It was a beautiful time, people shouting on the riverbank. You know every time one go down, another come up, they would shout. They would baptize in a bayou.

Now they got a little pool in the churches,

MRS. CORINE THOMAS, 94

LAMBERT
BORN ON DECEMBER 1920
MARRIED 62 YEARS WHEN WIDOWED
10 CHILDREN
14 GRANDCHILDREN
6 GREAT-GRANDS

I was going to church to photograph two women in Lambert. The pastor, Rev. Reginald Griffin, had arranged for me to interview them after the 9:45 a.m. church service. Lambert was only 45 minutes from my house. I was relieved. I wouldn't have to get up super early. It took a lot of gas to drive to the grandmothers and I didn't have grants, and often I didn't know where I'd find gas money. Sometimes I had to decide between buying fresh fruits and veggies or spending that money on gas. I always chose the interviews, my own private history lesson.

It was a larger church compared to some of the others, and newer, too. The choir was large and their singing was beautiful. I pulled out my recorder to get some of the ambient sounds in church—the hum in the air.

I didn't know the two women, only their names. Every woman who walked into the church, I wondered, "Is that her?"

Strangers said hi and I smiled brightly, happy to be there and even happier when I heard the choir sing. Hymns always make me cry.

I am sitting alone near the back on the left side on the sanctuary, on a cushioned maroon pew, a hymnal in front of me, thank God. I grew up Presbyterian. I know our songs by heart. "Pass Me by Ole Gentle Savior, hear my humble cry…" But here in the Delta, I don't know most of the old black hymns. I'm alone in the pew and thankful for a hymnal because I don't know the songs and most churches don't have books. They expect you to know the songs.

At the end of service, Pastor Griffin approaches me. We shake hands and he introduces me to two women: Mrs. Thornton and Mrs. Thomas, best friends. Mrs. Thomas is very warm and welcoming. Mrs. Thornton looks me up and down and says hello, resisting the idea.

The pastor's office is large with two chairs and a sofa. Mrs. Thomas is wearing a brilliant all-hot-pink dress and coat. It's stunning on her. Silk. Mrs. Thomas's daughter is sitting in during the interview, along with the pastor, his wife, and the reticent Mrs. Thornton.

I interview beautiful Corine Thomas first. She is pleasant and eager to talk. She's in her nineties. When she gets excited about what she's saying, she taps her feet and claps her hands. She is precious.

"Do you remember the day you were converted, Mrs. Thomas?"

"Oh yes. I remember," she says. She perks up and gets excited. The foot tapping gets louder, along with her voice, and she talks faster. She claps her hands and rocks in her seat.

To my right, Mrs. Thornton is rolling her eyes and mumbling, "We're going to be here all day. She talks so much. You've started her now." She doesn't want to do the interview, but she's humoring me because Pastor asked her to. I can hear Mrs. Thornton huffing.

Connie Imms

I was baptized in a bayou. When I got baptized, I didn't make no mistakes. I was in prayin', goin' in the fields with tall cotton. I was layin' on the field prayin' for the Lord to hear me and give me religion. I prayed, and that Friday, the Lord heard me. When I got there, looked like I was goin' on upstairs—just walkin' up stairs. And when I walked out the church, when I got out, I looked, looked [like] the world had changed like gold. I just clapped my hands, runnin', prayin', thank the Lord. I was tellin' 'em, I was tellin' everybody, "I got religion!" Tellin' it [now], I gets happy and I can't help it.

I stayed at home until I got 17 years old. My daddy died when he was 46 years old. After he died, I stayed by to help. It was hard on me when he died. I was his favorite child. I would help him saw wood and tote that wood in. He was proud of me. We would stack it up on the porch. Helped him until the boys got big enough to help him. When I was little, and was coming up, I had a big ole stomach and he called me Frog. I didn't want him to call me that 'cause he called me that when boys come around and I didn't want him to call me that.

Mama and them said they won't never let me go. When I was at home, I stayed at home. They said, "You won't go nowhere but to church," and "We gonna keep you at home. We not gonna let you marry. You gonna stay here." That's what they told me. They didn't want me to leave them, they said, "'Cause you so good. You don't do nothin' but to stay here with us. You don't go to those places..." And I didn't wanna go. Boys was not likin' me, well, I didn't like 'em. I liked the boy that go to church. The boy I was likin', his name was James, that's what I like, and that's the one that I married. He was a junior deacon in church. He was likin' me, James Thomas. I was 15 when I was likin' him. I was 18 years old [when I married him]. He was nice. And that was my husband. I was married to him for 62 years and we never separated, never did leave. I loved him 'cause he always laid the money on my lap. And he was always nice. He was like that 'til the day he died. We had all them children, and he was nice to all my children.

"I was layin' on the field prayin' for the Lord to hear me and give me religion."

MS. IRENE THORNTON, 88

LAMBERT
BORN FEBRUARY 1927
SINGLE
1 CHILD

When Mrs. Thomas's interview is done, I say, "Mrs. Thornton, if you don't want to do this interview, I understand. I don't want you to feel uncomfortable."

Looking at the pastor, not at me, she says, "No, I'll do it. Let's just not take all day."

"I promise I won't take much more of your time."

She shares two stories of her fighting in school, once when a teacher hit her sister for misspelling a word that her sister actually spelled correctly and once when a teacher tried to call her bluff for fighting. I jokingly say, "Mrs. Thornton, it appears you're the fighter in the book. Those are the two stories I have for you. Is there anything else you'd like to share?" The pastor starts to laugh. He calls her Muhammad Ali.

We all laugh. She smirks and she gets up to leave.

"Wait, Mrs. Thornton. I have to take your photographs. Let's do that in the sanctuary."

She huffs, and when the photos are over, I ask, "Mrs. Thornton, may I have your mailing address—just in case I need to send you a letter or card?"

"No, you don't need my address."

I don't know what else to say.

Mrs. Thomas says, "Irene, just give the girl your mailing address. It ain't gonna hurt anybody. Stop being difficult."

My sister was goin' to school and they asked her spell. So she spelled. They told her if she didn't spell that word, then they were gonna whoop her. Her teacher was there. So she spelled every word. That teacher told her to hold her hand out and she was spankin' her on her hand and I told my sister to take it [her hand] back. To all the children, I said, "We get up and go home. All of us." And all of us went outdoors to go home. I led a revolt.

All the teachers said if we didn't come back in, they were gonna tell our parents. I said, "Well, we better go back." I was about 10 years old. She spanked my sister and my sister spelled every word. I didn't get along with that teacher 'cause she drank. One day she had a bag that she took to school and I asked her if she had a bag she wanted me to carry to school. She said yes, and I did. We walked fast and got in the school and opened the bag and inside was her whiskey. I didn't have a good opinion of her at all.

I was about 12 years old. I was fighting with a girl at school. She didn't always bother me and she wasn't a bully, but she hit me and I hit her back. The teacher told me, "Irene, you want to fight somebody, fight me. I'm big enough." That's what she said. We was outdoors and there were some bats out there and I grabbed a bat. I was gonna hit her. A boy behind me, he grabbed the bat to keep me from hitting her. Nothing happened after that. I got over it. I was easy to get along with as long as you didn't bother me.

Irene Thornton

MRS. MARY ELLA YOUNG, 93

RULEVILLE
BORN AUGUST 1921
MARRIED TWICE; MARRIED 27 YEARS WHEN WIDOWED
7 CHILDREN
34 GRANDCHILDREN
40 GREAT-GRANDS
16 GREAT-GREAT-GRANDS

Mrs. Young was also referred to me by Mrs. Hooper-White: "Lisa, I have a mother, but she lives in Memphis now with her family so they can help her. Will you consider her if she lives in Memphis?" I was happy to include her since she lived in the Delta most of her life—38 years in Drew—and was eager to talk.

Mrs. Young lives just across the Mississippi line in Tennessee. Bobby drops me off at her house on a sunny Saturday afternoon and will pick me up in two hours; if it's earlier, I'll call him. "Please keep an eye for your phone," I advise him as he leaves to run some errands.

Mrs. Hooper-White tells me that Mrs. Young's husband was the first black police officer in Drew (1967). When I ask her about him, she says he was killed in 1972.

He was sick, said he was taken with a cold. He was off that week, being with the police he had vacation days. That Sunday, he said, "I'm goin' back." So he laid around all day. I said, "Why don't you eat?" He said, "I ain't got no appetite." I fixed the plate, he just sittin' there, pickin' at the plate. I said, "You ain't eatin'? You sick, you ought not to go back." He said, "I ain't sick, but I gotta funny feelin'." He said, "I don't feel right. I don't know what it is." So he laid down all that Sunday. He laid the uniform on the bed. He laid there 'til 5:30. He got up and got dressed. When he left the house, I got up and watched the car until he got out of sight. That night my sister came to the house and told me, "Mary, Lawyer just got shot." I said, "Shot? What happened to him?" What happened that week [he was off], a black girl was married to a Mexican. The police took his license and everything. He drank a lot. [So that week Lawyer goes back,] the wife comes running to tell 'em he [her husband] was comin with the gun to kill the officer. She was tryin' to stop him. She didn't make it there before the Mexican did. So he had his pistol in his hand. The officer put the gun at the Mexican to shoot him. Lawyer jumped in the way and said, "Don't kill him." And the officer shot Lawyer, he was meanin' to shoot the Mexican, but he shot my husband. I will never forget the day. I had cooked some chicken, dressing and greens, and a coconut cake. He loved coconut cake. It was my birthday. Every birthday I think of him. Every birthday.

When Mrs. Young finishes this story, her family is crying. They are sitting behind me. It breaks my heart. "How do you handle your faith?" I ask.

My mother would tell me you have to pray to get converted. My friend, she had joined

chimney in the middle of the house. I would go in the closet and climb up behind the chimney and pray. So my two little sisters say, "Where she is?" Another would say, "I don't know." I was justa prayin', "Lord, please free my soul." My sister said, "I hear her, she's somewhere, but I don't know where she is." So they lookin'. One say, "She in the closet." I'd hush and be quiet. One yelled, "Mama said come here, she want you to do somethin'." I wouldn't say nothin'. She'd say, "I don't know where she is." So I come out the closet. We had chickens. Poppa done made a big ole coop for the chickens. So I went out there and I moved the coop. I said, "They ain't gonna find me out here. I raised it up and got under the coop. I was just a prayin'. They would look for me. I didn't hear them comin' and I was just a prayin'. Sister said, "Hush. Hush. I hear her." I hushed. I kept quiet. So when I go back to prayin', one say,

the church. And I said, "Now, Willie Mae done joined church and I'm still a sinner. So I said I gonna pray. In the house, there was a

"She under this coop. 'Cause, see there, she done moved it." So they came in, found me under the coop.

MRS. GLENNIE MAE HOUSTON, 96

TILLATOBA
BORN SEPTEMBER 1918
MARRIED FOR 51 YEARS WHEN WIDOWED
7 CHILDREN
13 GRANDCHILDREN
12 GREAT-GRANDS

Glennie Mae Houston

Mrs. Houston was at one time the only member of NAACP in her community and was its treasurer for more than 20 years. She is proud to have served as the grand marshal for the MLK Parade in January 2014. She is known for her chowchow recipe. When I show Mrs. Houston mockup pages of the book and read Ms. Tennie's story about not being able to buy a Cadillac in her town, Mrs. Houston says, "Well, I have a story similar to hers."

In 1966 I worked evenings as a nurse's assistant for an elderly woman who was sick. I worked 5 in the evening to 7 in the morning. I stayed all night. I had a room there. My husband was at home with the children. That was my first job. I stayed with her until she passed. They paid me $125 a week, which was big money at that time.

In the mornings I would get a guy who drove taxis to bring me back home. I asked my husband, I said, "Let's get a car, not a new car, just get a used one." I said if I continued to work, I could pay the note.

He said, "I'm not gonna buy a car."

I said all right and from that I learned that you don't have to wait on a man. I thought I couldn't buy anything without my husband signin', but I learned that I did. This family sold trucks. I saw an advertisement in the paper; it was a Chevrolet and it wasn't a big payment a month. Before

that, I talked to the car dealer here about it and this salesman tried to discourage me; oh, I had to have so-and-so much down.

So, all right, the next day, I decided to go to Memphis and try again. I wasn't sure I could without my husband signing. I took my clothes one day and instead of coming home I got dressed and caught a bus to Memphis. I told the people who I worked for what I was going for and that I would be back at 5 o'clock to go to work. I went straight to the Chevrolet place and told them what I wanted and the car I wanted. That particular car had been sold, but they had another one with the same price. It was nothin' down and $130-something a month. They was supposed to get the car cleaned up and ready for me. They called me in first and asked what I did and what my salary was. They didn't hardly believed that, but anyway, they were gettin' the car cleaned up. Anyway, they were so long. And they called me back in and requestioned me, some of the same questions. I said, "Man, do you think I came up here to lie?" But what had happened, the man I was working for had gone out of town that day and he didn't get back in until about 4 o'clock. That's when they called me back in and requestioned me. But I didn't know what it was. I said, "I'm supposed to be back at work at 5 o'clock and y'all holdin' me up." He said, "We gonna getcha back on the road, gonna getcha back on the road." I wasn't sure I could make it. Had an older son who lived in Memphis and I called him to ride home wit' me. So he and his wife did.

I still didn't know what was happenin' until the next mornin'. My boss called me in. He said, "Glennie Mae, they made you kinda hot up there yesterday." And that's when I knew he had information.

I told my chil'ren then, I said, "White people can help ya and then they can harm ya."

CHOWCHOW

I was first introduced to chowchow during my interview with Mrs. Houston. Hers is one of many ways of preparing a traditional Southern pickled relish made from a combination of late-season garden vegetables. Stored in a canning jar, chowchow could be part of a family's food supply during the non–growing season. It is served cold as a condiment or as a sweet-spicy side.

4 C. ONION, CHOPPED
4 C. CABBAGE, FINELY SLICED
4 C. GREEN TOMATOES, CHOPPED
5 C. GREEN PEPPERS, CHOPPED
1½ C. RED BELL PEPPERS, CHOPPED
½ C. PICKLING SALT
6 C. SUGAR
2 TBSP. MUSTARD SEED
1 TBSP. CELERY SEED
1¼ TSP. TURMERIC
5 C. APPLE CIDER VINEGAR
1 QT. WATER

Combine the vegetables in a large bowl, sprinkle with salt, and let sit overnight. Rinse and drain the vegetables, then place in a stockpot.

Combine sugar, mustard seed, celery seed, turmeric, vinegar, and water. Pour over vegetables and cook at medium heat until tender.

Spoon into canning jars and seal according to directions.

Makes 9 pints

MRS. VIRGINIA HOWER, 94

CLARKSDALE
BORN APRIL 1920
MARRIED 30 YEARS WHEN WIDOWED
NO CHILDREN

Mrs. Hower was referred by Francine Luckett, wife of Mayor Bill Luckett of Clarksdale. She said I must interview a woman she loves dearly, and when I tell her she has to be an elder in the church, she replies, "Oh yes, she's an elder. She's adorable. I just love her. She reminds me of my mother." Francine is white.

"Francine…this is a book about black grand-mothers…"

"Oh, she's black. I met her at a church one day. I just love her and it's so funny, she looks just like my mother. I just love her so much. She's such a sweet woman. Please just go talk to her."

I agree to meet Francine on a day she can take me to Mrs. Hower.

After riding the elevator, we knock on Mrs. Hower's door, which bears a sign stating NO SOLICITATION. She's seated in the tiny living room, watching her favorite judge, Judge Judy. Next to her on the TV stand is a pistol—a .38—in case someone tries to burglarize her. She looks white. I wouldn't have believed she was black, had Francine not told me. She talked about passing for white, saying, "And if you could pass for white, all was well," but also, "We [Blacks] always had to be better." She advised me, "Don't get mad, get smarter."

One Minute Café was on Issaquena Street and they had the best burgers. They just didn't allow us [Blacks] to go into that hamburger place. We had to go into the alley to get a hamburger. You began to wonder why. My grandparents used to send me in the restaurants to get the hamburgers if we didn't go in the alley, and they never knew the difference.

Going to the café, I felt dirty. If you could pass for white, all was well. I guess you got acclimated to the condition. I used to come down here [from Indiana] on the white coach [train]. My grandmother would meet me downstairs. She didn't want to let anybody know. It was horror. You felt bad because you couldn't be with your grandmother or your grandfather. You just accepted it. I couldn't be with them because they were darker. Sometimes you felt bad because you could ride in a clean coach and just to think that your grandmother couldn't kiss you as you stepped off the train. But they accepted it, so why not enjoy the clean train? And then when I got down on the streets, we all kiss and carry on. Those were happy moments.

And then you got to thinkin' how foolish this life is, how foolish. Then you got to thinkin' about it and say take advantage of it and a lot of people down here in Clarksdale, they went to Chicago in '41 and never revealed they were colored.

If you were colored, that's what they used to call it long years ago. Now it's black or African-American. I'm used to colored because all the signs were on the restrooms, I think even at the courthouse they had a sign that said colored and you couldn't drink out of the fountain in

there. You just, you accept it, the situation. If you wanted to live peaceful, you just accepted it. You accepted the signs.

This is our second time going to see Mrs. Hower. Bobby and I love her. We love all of the women, but we are especially close to several. A few days prior to a trip to Clarksdale to go to a blues club, I call Mrs. Hower, whom I affectionately call "Bad Butt," and tell her we want to see her.

"Come on by, baby. I'll be home," she says.

"Do you want anything? Do you need me to bring you anything in particular?"

"Some mangoes. I love mangoes."

"Okay, I'll try to find some mangoes." I can't find any mangoes and I'm not sure I can make it to her house today, after all. I have an appointment in Clarksdale and I'm running late. I try to call. No answer. I give her a few minutes. I call back. No answer. I shift in my seat. Maybe she has company. I wait another 10 minutes and try again. No answer. Mrs. Hower has a one-bedroom apartment filled with quality antique furniture. She

Virginia Hower

sits in the living room, not even a foot away from the tiny television set.

I chuckle when I remember when I first took Bobby and my mom, who was visiting, and a former student to meet her. Bobby reached for the remote to turn the volume down so my mother could hear Mrs. Hower talking. Bad Butt stopped

talking midsentence, turned her head to Bobby, looked him dead in the eye, and said, "That TV hasn't been cut off since President Obama was elected. In 2008."

He sat still. "Can I just cut it down so I can hear you? It's a little loud."

She nodded.

I'm sobbing. I don't know if I can handle the loss of 54 grandmothers.

It's after 4 p.m. and the front door to Mrs. Hower's building is locked. There isn't a buzzer for her to let us in. No one is in the hallway to open the door. I call her apartment. No answer. I call again and her niece Benita answers. "Ms. Benita, this is Lisa Steele. I'm the woman doing the book. You met me, my mom, and husband a few months ago."

"Oh yes, I remember you." Ms. Benita is probably in her fifties, youthful looking, funny, and has no filter when she talks. She is a Jewel in the making, pure comedic relief.

"Ms. Benita, my husband and I are downstairs. I've been trying to reach Mrs. Hower for over an hour. I've been worried. I'm downstairs. No one is in the hallway to let us in. Can you?"

"Yes, I can come down. I was worried when I couldn't reach her, too. She's fine. She was across the hall at the neighbor's. She was using bleach to clean her stove and the fumes made her sick. She's been across the hall for a couple of hours."

"Can you let me in? I just want to see her. We won't stay long."

"Sure, I'm on my way down."

We make it to her apartment and Bad Butt is sitting in her chair. I am happy to see her, but I'm upset. Tears are in my eyes.

"Why are you crying?" she asks.

"I thought something happened to you. Don't scare me like that again." I look her right in the eye. I'm worried that I'm being morbid, but scared that something might have happened to her. I'm not ready to let any of them go.

I smile and tilt my head to direct Bobby to the gun next to Mrs. Hower. I've told him she has one and is not afraid to use it. She keeps it in case anyone tries to break into her home.

The day I am trying to reach her, I know her apartment is only so big. She said she was going to be home all day. I call at least five more times in 45 minutes. No answer. My chin quivers.

Bobby is driving. He looks over at me. "Babe, maybe she went on an errand." "No, she has trouble walking. If she said she's going to be home, she's going to be home." Mrs. Hower is 94. She has fallen before. "I know I said I was calling to tell her we can't make it, but I have to go by."

Bobby says okay.

Tears are forming in my eyes. "What if something happened to her? What if she fell? What if she passed away and she's just lying there?"

After a few minutes, he asks, "What are you going to do, God forbid, when these grandmothers start to pass away? Are you going to be able to handle it?"

"I have been thinking about it. I am still grieving Gram and now I have 54 more grandmothers." I look out the window.

He looks at me.

ACKNOWLEDGMENTS

I know this book couldn't have happened without God's blessing. This is so much bigger than me, and I believe the ancestors are walking with me, smiling down.

To Bobby, my rock, my best friend, the one who has always believed in me. I know I couldn't have done this without you. You have loved this project almost as much as I have, and you know the stories better than anyone. Thank you for pausing the music and television when I wanted to read something to you. I love you.

My grandfather, Mr. William L. Burton, you and Gram were married for 46 years when she passed away. She would be so proud of this book. Thank you for raising me and for being a good role model while I was growing up.

To my father, Mr. Walter "Rocky" Burton, who has always loved me very deeply and who has been fiercely protective. You taught me to say, "Yes, ma'am" and "No, sir." I thought for years you could only count to 1, because that was the only number you were going to count to when you told me to do something. I treasure the races down the street (thanks for letting me win) and for my love of sports. I hate that you still mess up my hair, but I always want to hold hands with you, and I always will. I love you, Dad.

To my uncles—Joe Duncan, who introduced me to photography, Bill Duncan, Richard Larson, and Ian McCargar—for being constants in my life; sister Angela Burdick and brother-in-law Philip and their family; cousin Monica Scott Sheppard and her husband, Reginald—I love you both. Reggie, your mom will always be the good in

you; Cousin Theresa Aiken Hill for family history; mother-in-law Esterlyn Mendez and sister-in-law Amber Michael, who have always been loving; in-laws Bobby and Kande Steele, and family—thank you for always supporting me. I have a very large family and I cannot name everyone, but to all of my relatives and loved ones, thank you.

To the Bearden family: Mrs. Lela J. Bearden, Dr. and Mrs. John McAdory (Cynthia Bearden), and Drs. Lloyd and Marilyn Robinson (Marilyn Bearden), and James Bearden, Esq. What love, support, encouragement, and counsel, just to name a few, that I have gotten from this incredibly loving family. I know Hawk is smiling down. So proud to know you all and so honored to share these stories. Thank you for every single thing you have done to help make this book a success. My cup runneth over.

To Dr. Samir "Mr. Magazine" Husni: Thank you for believing in this project and the generous donation. Thank you for the kind words of encouragement and support. Your support means so very much and I'm very grateful.

To friends Paul L. Newby II, we have been friends more than 20 years and I love and respect you; Jason Johnson for making me laugh; and John Patterson, who took my phone calls when I was in the Delta. You've been right there with me. Love you. To Michael and Patrice Christian, thank you for the love and friendship. To Raymond Snyder, my first photography teacher. Good teachers change lives. Thank you for believing in this city kid when she didn't believe in herself.

To Curt Chandler and Martha Rial, my first

mentors. You both made time for me and you paying it forward reached me. I hope I am leading by example. To Barth Falkenberg, who allowed me opportunities for growth. To William Snyder, who was hard on me for a reason and I loved working for you.

Stan Alost, I could not have done this without you. Thank you. You were the best graduate committee chair a girl could ask for and now you're my friend. Thank you for your photographic eye and kind words when I was doubtful. The picture editing is superb and you created a wonderful map of Mississippi.

Seann Anderson, you did a great job on the family tree. Thank you. You and your lovely wife, Carissa Anderson, are two of my favorite people on earth.

To Ohio University's Viscom program and professors, especially Terry Eiler and Julie Elman.

Larry Wells, this project would not be what it is today without your constant guidance. *Southern Living* would have never seen it. Thank you believing in me and trusting your gut. I love you dearly and am proud to call you a mentor and friend.

To all of the Jewels in the book, thank you for sharing such personal stories so that others could learn. You are giving, strong, independent, and loving mothers. My life has forever changed. How lucky am I? And to their families who have helped along the way. Your knowledge and encouragement made huge differences in this work. Could not have done it without all of your support.

Rev. Juan Self and Rev. Andrew Hawkins, I know for sure that this could not have been done without your guidance, patience, and love. Thank you for praying with me and for me. I love you both dearly.

To all of the pastors who guided me to the Jewels, a special thanks to Rev. Tony Anderson, Rev. Albert Calvin, Rev. S. L. Blake, Rev. Mark Buckner Sr., Rev. Benjamin Hall, Rev. Calvin Collins, Rev. Reginald Griffin, Rev. Larry Hervey, Rev. Clarence Hunt Jr., Rev. Jessie Payne, Rev. Lorenzo Robinson, Rev. Edward Thomas, Rev. W. E. Tinson, Rev. Clarence Tolbert Sr., Rev. Derrick Williams Sr., Rev. Jerry Walker, and Rev. Freddie Wince.

To Mrs. Myrlie Evers-Williams, a legend. It took me nine months to get your interview. I bugged everyone. They say the best things in life are worth waiting for, and you, my dear, were worth every minute. Thank you for the knowledge. To Mrs. Reena Evers-Everette, you are the next generation of Jewels. What a heart of gold. Stay strong and steady because your work is important.

To Veronica Fields Johnson, who so kindly introduced me to my agent. To my agent, Janell Agyeman, of Marie Brown Associates, I heard passion in your voice and am so very thankful that you love this project and wanted to take it on. I am in good hands. To Ms. Marie Brown, thank you for the support. To Adrienne Ingrum, a sharp editor who kept me on my toes and made this book better. Thank you for pushing me. I've learned so much from you. To Mr. Rolf Zettersten, publisher at Hachette Book Group, thank you seeing the value and importance of this work. I'm so thankful to you. To the entire Hachette crew, especially Jacob Arthur, Laini Brown, Andrea Glickson, Melanie Gold, Virginia Hensley, Joan Matthews, Antoinette Morgan, Andrea Santoro, Alexa Smail, Erin Vandeveer, Jody Waldrup, Danielle Young, and everyone else who was instrumental in making this a success, I'm honored to be a part of the team.

To Samuel Freedman, what a beautiful column. I am forever grateful and I will never be able to adequately and properly thank you for changing my life. One man, one column in the *New York Times*, and this project took on a life of its own.

I am blessed to work for, and have worked for, wonderful bosses, including Will Norton and Charlie Mitchell. Thank you for everything. You are good men. I am proud to be a part of the Meek School of Journalism and New Media at the University of Mississippi. Ed Meek, who supported me and made a donation that allowed me to continue interviewing women. To all my Meek School colleagues, especially John Baker, Shannon Dixon, Scott Fiene, Paula Hurdle, Darrel Jordan, Cynthia-Cynthia Joyce (you know I had to do it), R. J. Morgan, Mykki Newton, Charles Overby, Evangeline Robinson, Darren Sanefski, Chris Sparks, Pat Thompson, Mike Tonos, Curtis Wilkie, and Kathleen Wickham. To Vanessa Gregory for the brainstorming, Mikki Harris for the introduction to Dean Norton, Bill Rose for the introduction to the Delta, and Deb Wenger, you made this rookie professor better by example. Thank you for the constant shoulder to lean on and for the donations. Nancy Andrews Mitchell, you gave the best Southern reception a Northern girl could ask for. I love you dearly. Susan Glisson, thanks for all the help and support, including the William Winter Institute grant and for connecting me to Mrs. Evers-Williams. To Billy Meyers, a kind man who also has a wonderful spirit and listening ear. You've helped me find peace within stressful moments.

I have been blessed with friends and supporters along the way: Marie Antoon, Michel du Cille, Jennifer Cole, Scott Colwell, Kim Cross, Breanna Edwards, Amy Evans, Tom and Joyce Freeland, Emily Gatlin, David Gibson, Johnny Hayles, Jean Nash Johnson, Myrtle Jordan, Teresa Kamins, Suzie Katz, Syreeta Kee, Lynda Kraxberger, Jeremy Lasky, Bill and Francine Luckett, Homita McDonald, Karen Mitchell, Alan Moore, Bruce Newman, Ted Ownby, Susan Puckett, Tamara Redfern, Ruth Robertson, Lucy Schultze, Joe Starita, James Thomas, Aaron R. Turner, Edward Vaughn, Lucia Vinograd, John Wall, David Wharton, Rhea Williams-Bishop and Marilyn Weston Williams, and Margaret Wrinkle. Thanks to the staffs at *The Daily Mississippian* and Hottytoddy.com.

To Ole Miss students: Jared Boyd, Alex Edwards, Jhesset Enano, Imani Flowers, Logan Kirkland, Giana Leone, Aniah Lust, Jared Senseman, and Katie Williamson, you keep me young. To Sha' Simpson, you are my "adopted daughter." Bobby and I—along with Gigi—love you. Welcome to the family, baby girl.

To anyone I've missed, please hold it to my head and not my heart.

INDEX